CW00553493

THE ART AND MAKING OF

THE BOYS™

Well, well. What have we here? More self-congratulatory bollocks from the cunts at Vought? This should be good for a laugh...
— Butcher

THE ART AND MAKING OF THE BOYS

Printed Edition ISBN: 9781803360164
Ebook Edition ISBN: 9781803360881

Published by Titan Books
A division of Titan Publishing Group Ltd.
144 Southwark St.
London
SE1 0UP

First edition: October 2022
2 4 6 8 10 9 7 5 3 1

Did you enjoy this book? We love to hear from our readers.
Please e-mail us at: readerfeedback@titanemail.com or write to Reader
Feedback at the above address.

To receive advance information, news, competitions, and exclusive offers online,
please sign up for the Titan newsletter on our website: www.titanbooks.com

A CIP catalogue record for this title is available from the British Library.

Printed and bound in China.

THE ART
AND MAKING OF

THE BOYS ™

WRITTEN BY **PETER APERLO**

TITAN BOOKS

CONTENTS

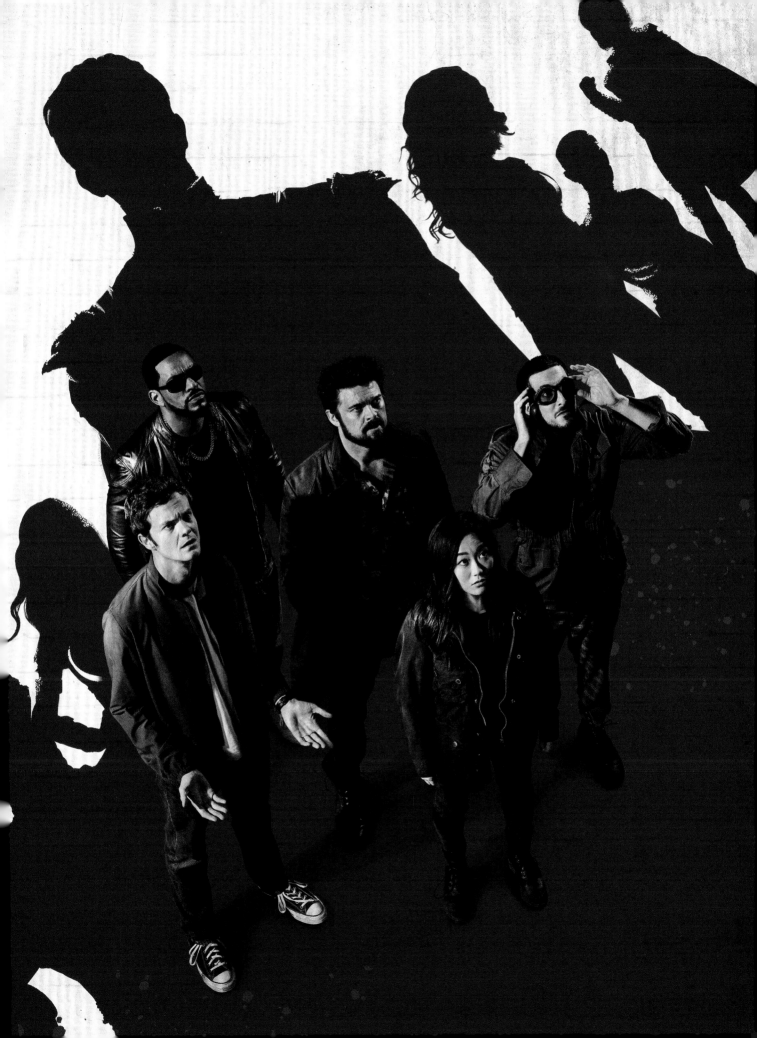

FOREWORD

FROM SETH & EVAN

Movies used to be the coolest thing out there. Then it became TV. But now, we've gone back to the FUCKING BEGINNING. That's right. THE BOYS: THE BOOK!!! All the gore, excitement, action, and emotion, but with no BULLSHIT moving images or distracting sound. Simple, safe, still photos, words on the page that STAY on the page, plus the proprioceptive thrill of turning LITERAL PAGES!!! You've tried drugs, sex, and rock and roll, maybe even a little Compound V, but you're a pathetic piece of shit who doesn't know a FUCKING THING until you've experienced the unrelenting insanity of the written word UNLEASHED!!! So buckle up, strap in, strap on and step up, 'cause SHIT'S ABOUT TO GET REAL.

Sincerely,
Seth and Evan

"TALENT IS FOREVER."

HOMELANDER

ORIGINS

INTRODUCTION

In 2006, amid the post-9/11 madness of a misnamed and misaimed "War on Terror," Orwellian surveillance, extraordinary rendition, a sub-prime mortgage bubble primed to pop, and the festering rise of talentless reality stardom, writer Garth Ennis and artist Darick Robertson unleashed *The Boys* on an unsuspecting world.

Here was an irreverent look at superheroes who were anything but heroes. These were corporate shills out to make a buck off branding, shag anything that moved, and live a life free from consequences. Enter the Boys (Pro Tip: The lack of italics means we're talking about the group of characters, instead of the comics or TV show), a shadowy CIA-backed group of misfits tasked with keeping tabs on, and more often than not canceling with extreme prejudice, any and all "Supes" that got out of line. (Any guesses what "Supes" is short for?) Headed by Billy Butcher, a caustic Cockney hell-bent on revenge, the group roped in a Scottish lad

they called Wee Hughie after a supe killed Hughie's girlfriend by accident. Rounding out the gang with their own unique sets of skills were Mother's Milk, the Frenchman, and a mute woman known simply as the Female. "We really didn't know what to expect... The reaction to it was surprisingly positive," says Robertson.

After a six-issue run at DC imprint WildStorm, *The Boys* jumped to Dynamite Entertainment for the rest of its lifespan: 72 total issues over six years, plus an epilogue in 2020. As popular intellectual properties tend to do, this and the rest of Ennis' impressive body of work quickly attracted the attention of Hollywood. As Neal Moritz, executive producer and founder of Original Film, tells it, "I was lucky enough that somebody in my office familiarized me with Garth's work, and was so enthusiastic that I started to read through a bunch of books. The first one I read was *Preacher*, which was just incredible. I was lucky enough

to go to Garth and get the rights to do that show. Originally, I was going to do it as a feature film. Sam Mendes was involved. For a number of reasons, it just didn't happen, and we thought, 'You know what? Maybe it would be better as television.'"

To do so, he enlisted the creative talents of fellow Garth Ennis enthusiasts Seth Rogen and Evan Goldberg, with whom he was shooting *Green Hornet* at the time.

"Garth's material just makes great entertainment because it's very adult. It doesn't pull its punches," says Goldberg. "It's not a kids' medium. It's for everyone. He was one of the first people who, I felt, really said that to his readers. Like, 'I'm going nuts here, and you're adults. You can handle it.'"

When the *Preacher* series took off, "we got to talking about doing another thing with them and Garth," explains Moritz. "I just loved the idea of what *The Boys* was. I just loved the idea of the people charged with trying to keep the superheroes under control. It was a fantastic idea, and we were talking about doing that as a feature with Adam McKay." History repeated itself, however, and that project failed to take off. And like déjà vu all over again, Moritz, Rogen, and Goldberg eyed television as a possible home for these scrappy anti-heroes.

THIS PAGE: Producer and showrunner Eric Kripke explains a shot to the crew while Tomer Capone (Frenchie) and Laz Alonso (M.M.) take a breather.

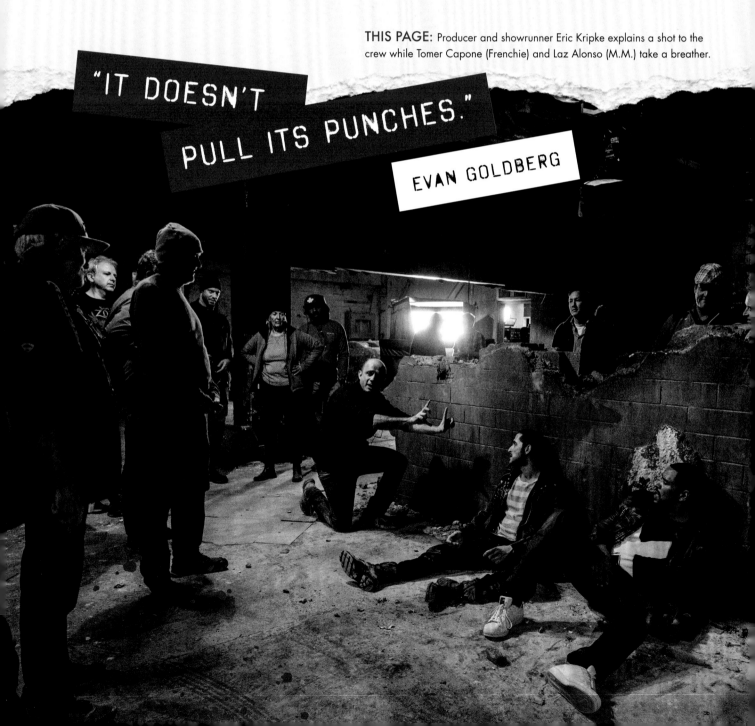

"IT DOESN'T PULL ITS PUNCHES."

EVAN GOLDBERG

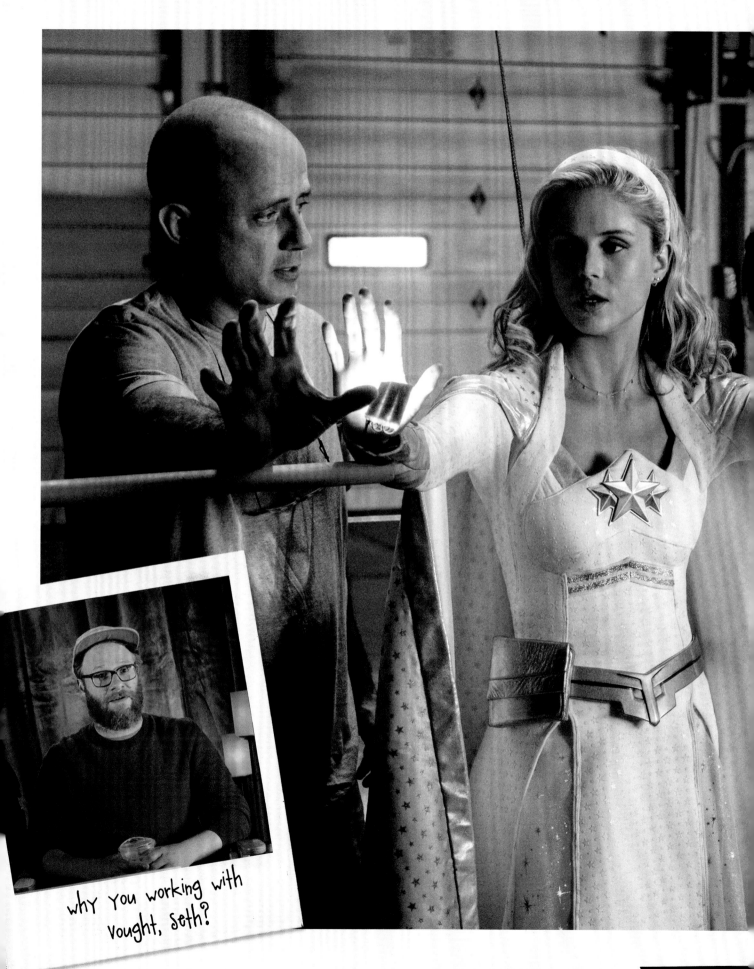

why you working with Vought, Seth?

ROAD TO STREAMING

THE PRODUCERS

Appropriately, *The Boys* took its first steps on that long journey with a "Fuck you!" from Eric Kripke, creator of *Supernatural* and many other shows, and another Ennis ultra-fan. "Garth Ennis is my favorite comic book writer of all time. I obsessively inhale every word the guy writes," says Kripke. "I'd read *The Boys* and loved it. I'd put *Preacher* up with *Sandman* and *Watchmen* as some of the best comics that will ever be made. I'd read that Seth Rogen and Evan

Goldberg and Original Film were making *Preacher*. I didn't know Seth and Evan at the time, but I knew a producer who worked for Neal Moritz, Ori Marmur. So, I set a meeting with him, we came in, exchanged pleasantries, and he says, 'What's up?' And I say, 'Oh, I just wanted to say fuck you for giving *Preacher* to somebody else, because I'm the world's biggest fan of *Preacher*!' And Ori said, 'Well, we have the rights to *The Boys*. Do you want *The Boys*?' And I was

like, 'Absolutely!' And that's how I got attached. It was kind of stupid how quickly it all happened," he says.

For Moritz, bringing on Kripke to run the show was a no-brainer. "It came down to the fact that he loved the source material. He knew how to take that source material, given his experience on all these other shows that he worked on, and translate it not only into a makeable show, but a commercial show. He just has the passion for it.

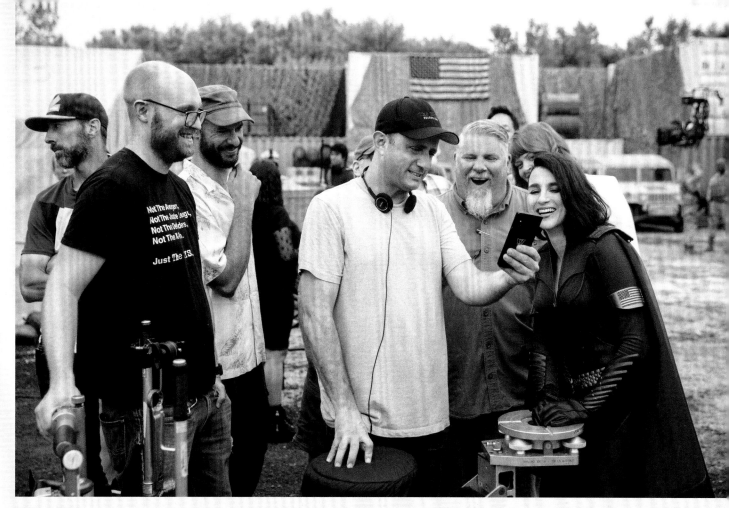

THIS PAGE: Kripke (black cap) shares something diabolical with (L to R) Marty Schluter, Stephan Fleet, Rian McNamara, Phil Sgriccia, Colby Minifie (Ashley Barrett), and Aya Cash (Stormfront).

He's great at knowing what these characters would do. There's more to being a showrunner than just being the creative mind behind something. He's a bigger figure than that, and takes on much greater responsibility," he says.

"Eric's pitch for the show was incredible," says executive producer Pavun Shetty. "We walked into every network's conference room and set up giant poster boards with pictures from the comics, and once all of the executives filed in he just launched into it. He's a masterful storyteller and the pitch was filled with the same energy you see in the show. He took them through the entire pilot story, hitting every gnarly

detail along the way. Almost every time, there was a pregnant pause after Eric was finished and then the first word we heard back was, 'wow.'"

But regardless of how quickly the deals initially came together or how perfect Kripke was for the job, the road to the small screen was not without its bumps. For example, a year spent crafting the pilot for Cinemax was lost when that streamer decided to focus on lower budget programming. That could've easily spelled doom for the project as it languished in limbo. "A real unsung hero of The Boys was an executive at Cinemax, Scott Nemes, who I'd gone to college with, thank God. Without

him, I think Cinemax would've just held onto the script," Kripke explains. "Scott, because he was a friend of mine and he was a really good dude, said, 'I like this script too much to have it go through this castration. I advocated to my bosses that they let go of it and give it back to you.' And they did! At that same time, Prime Video had just started a genre division, and they were looking for stuff exactly like The Boys—noisy, turnkey, developed, and in good shape. And they bought it." It would still be another six to seven months of development, meetings, concept art, and lots of notes before Amazon gave The Boys the coveted green light.

ADAPTING THE COMICS

FROM PAGE TO SCREEN

Despite Ennis and Robertson delivering a proof of concept before Kripke's first keystroke, he found adapting someone else's work to be agonizingly nerve-wracking. "I'd never adapted before this, and I don't think I'm ever going to do it again," he says. "When you're creating your own story or world, there's nothing but smooth, empty horizon. You can go wherever you want. But when you're adapting, there are all these pitfalls and minefields, because it's somebody else's world that is beloved by many, many people—and beloved by me! But it's a different medium, and so you can't do a one-to-one adaptation. With every choice I make, I run the risk that I'm going to ruin the thing that I love for the whole world... for Garth or the audience. So, the pressure is really intense. I liken it to an incredibly stressful game of Jenga—every piece you pull, you're wondering if that's going to make the whole thing topple over."

OPPOSITE: Butcher and The Boys from the original comic.

One thing that steadied Kripke's Jenga hand was a meeting with Ennis to talk about the inspiration behind the comics. "For him, it was really a lot of James Ellroy, which I thought was super interesting," says Kripke. "I took that to heart, and I'd even say the show owes a lot more to James Ellroy than the comics do... because we needed to come up with an eight-episode storyline. The comic itself is very episodic, like a cop show. But the Ellroy piece really opened a door for me: 'Oh, we could do a season-wide, *L.A. Confidential* mystery.' *Chinatown*, although not Ellroy, is another example. It's a good noir story—not Black Noir, but noir... We could open with something that seems very basic—which in Season One is Robin getting run through by A-Train—but it opens the door to a larger, and larger, and larger conspiracy that has world-changing consequences. In Season Two, Stormfront comes in as a femme

fatale. What's her story? And then she opens up into something larger and more nefarious."

Another example that informed Kripke's take on the superhero biz was 1976's *Network*, a masterful, satirical look under the hood of television news. "Now obviously, I wouldn't be able to hold Paddy Chayefsky's piss in a bucket," says Kripke, "but that's just one of my all-time favorite movies. It's just so smart and funny, and so 'inside baseball' about how the whole industry works... I saw through Vought an opportunity to make my version of the movie *Network*." Vought International, of course, is the mega-corporation behemoth behind Compound V, the glowing blue elixir that gives the Supes their powers. Vought also controls Supes' crime-fighting contracts, PR, marketing, appearances, movies, TV shows, and a full range of Supe-branded consumer products—from frozen peas to dildos.

WHAT'S IT ALL ABOUT?

SUPERHERO SATIRE

With those perspectives in place, it remained to narrow down what the show was really about—on the surface as well as underneath. Moritz sums it up very succinctly: "It's a look at if superheroes were real in our world, how they would be treated like celebrities. It's about how corporations are really, truly about the bottom line. And it's also about showing that you don't need powers to stand up for what's right." He adds that "a lot of material has been pulled up from what's going on in our political climate. I think there's a huge entertainment value to the show, but there's a timely political value to the show as well. The subtext of our show is what's currently going on in the world, without hitting people on the head with a news show.

"If superheroes were real they would probably be egomaniacal, sociopathic, godlike beings who were not constrained by the normal physical and moral things that keep humans acting remotely appropriately... Absolute power corrupts absolutely and all that," says Rogen, while reminding us that the Supes themselves are really metaphors. "Mostly, celebrity culture is what we ended up lampooning—is that a word anyone uses anymore? I just used it. Let's bring it back—That was more the conversation we would have when we were trying to sell the show, and I know this more than anyone: Celebrities are insane, and they have just slightly more power than

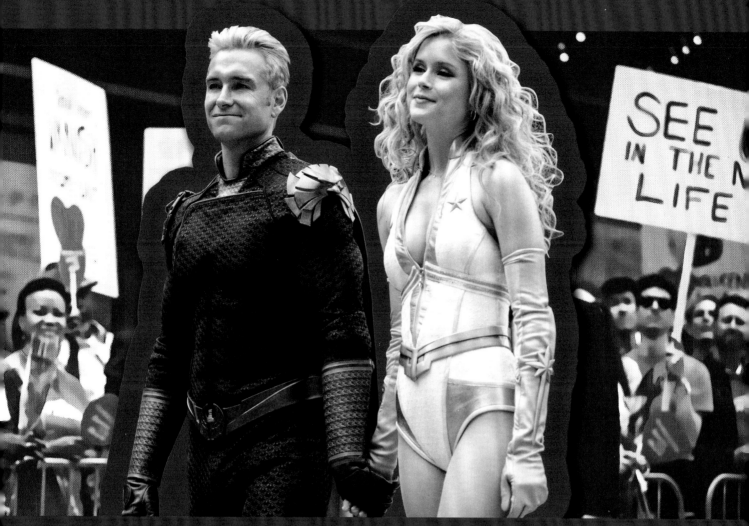

THIS SPREAD: (Left) In-universe comic book covers created for the TV series by Darick Robertson. (Above) Homelander (Antony Starr) and Starlight (Erin Moriarty) make nice for the cameras.

the average rich person does... Now, imagine they could fly. They would literally be the worst people ever to be born," he contends.

"Seth and Evan had a lot of input there," says Kripke. "They said from the very beginning, the way to make this work is just assume every superhero is a movie star and just write them like they're movie stars. And that turned out to be true. Just that idea of the ego, and the access, and the lack of concern about all the people around you making your life happen."

But Kripke is quick to add that there is another crucial facet of

movie star life that, when applied to Supes, simultaneously made them more complex and cranked up the tension: frustration. "There's this really interesting conflict in big movie stars, because they have all the power, and control, and access in the world, and at the exact same time they have none of it," he explains. "At the end of the day, you're handed a piece of paper and told where to report in the morning. They don't get to choose what they say. They don't get to choose where they go. They're not in charge of their own destiny. That conflict of, 'Hey wait, I'm supposed to be the most powerful person on

the planet, but there are all these people around me that are forcing me in one direction or another.'"

How each Supe deals with that reality is fodder for many story arcs. "Once you go down that road, everything springs from it. Realistic psychology and how would a person respond in a realistic situation—they might not behave heroically. The idea that the all-powerful, invincible character would become sociopathic. The "Fish Guy" would be hopelessly insecure, because his powers are really stupid. The speedster would be a really stressed-out professional athlete," explains Kripke.

MAKING IT REAL

THE WORLD OF THE BOYS

So, dealing with that reality—our reality, specifically—is the most important directive on *The Boys*. "Grounding it in reality was our number one priority," says Goldberg. On a daily basis, it informs every creative decision, from character to wardrobe, from production design to visual effects. Other superhero franchises may be epic and pretty, or in some cases even gritty, but they generally don't exist in a world we would recognize as our own. "It's supposed to feel incredibly like our world that we live in, except there are superheroes," says Rogen, and cites the example of laser eyes: "We've seen [a certain superhero] shoot people with laser beams our whole life, but I think not until I saw Homelander do it did I realize how truly grotesque an act that would be."

But pulling off the realest comic book show ever is a challenge. "We're making that choice to ground it in reality, but therefore the level of execution that is necessary to achieve these superhero-y things is just a lot harder. It's a higher bar that we've set for ourselves, tonally and visually, that the show needs to achieve," says Rogen. Goldberg adds that, among other things, it requires, "A lot of fake blood. Fake viscera. Limbs."

Besides the lovely gore, which we've all grown to enjoy, what does that realness get us? A couple of things, according to Kripke. "Part of it is my style. My writing is very pop-culture-reference heavy. I like

BELOW: Homelander (Antony Starr) kneels over the burned body of Stormfront (Aya Cash).

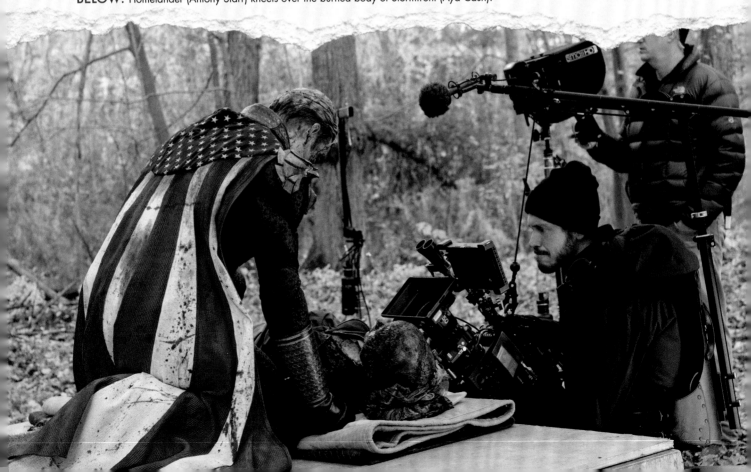

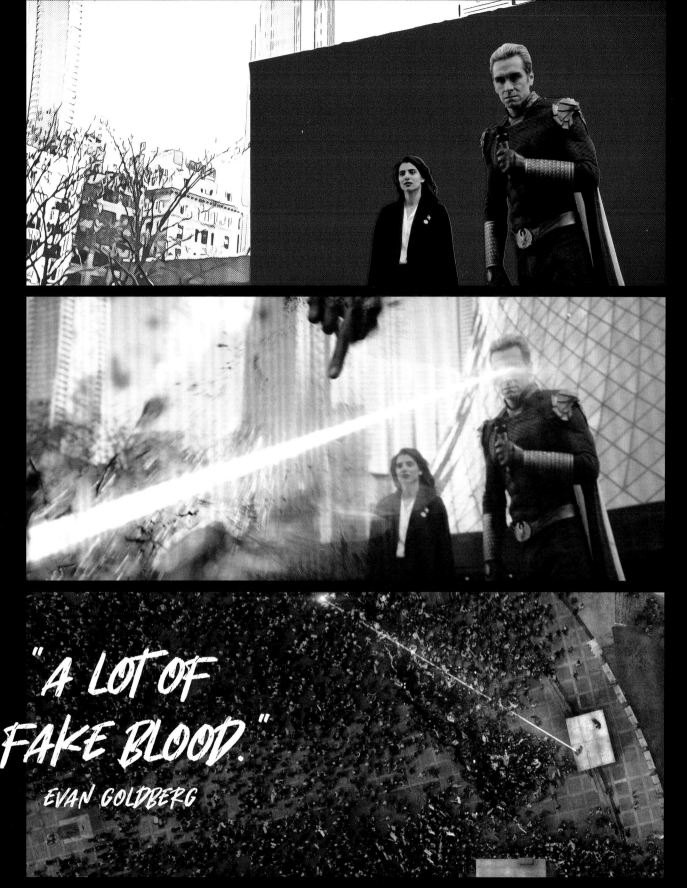

"A LOT OF FAKE BLOOD."
EVAN GOLDBERG

ABOVE: VFX help Homelander's murderous fantasy become 'reality'.

ABOVE: Alastair Adana (Goran Visnjic) loses his head.

characters that speak like I speak when I'm with my friends, the way everybody speaks. They're always making references. But in order to have that, you have to have a recognizable society. So, I like setting things in a world that's as close to ours as possible," he says. But the more important benefit is that the social commentary lands harder. "It's better for satire, because you're directly satirizing the world we're living in right now," says Kripke. "I like to bring the audience in with a warm embrace: 'This is your world. These are your emotions. These are your characters. Just some of them happen to fly around.'"

While in some other cinematic universes <cough, *Watchmen*, cough> the presence of superheroes can completely alter history and society, in *The Boys*, 80 years of superhuman shenanigans have left us just as we are today. How is that possible? Simple, really. "The superheroes on *The Boys* are completely ineffectual as heroes,"

explains Kripke. "They're there to make money for Vought, and make it seem like they're saving people. There's a really important difference between image and reality. And just as so many politicians and media figures are telling you that they're there to save you, they're not really there to change anything, except to line their own pockets... They're really good celebrities, but they're terrible at what it would take to be a hero, which is [to be] unsung and selfless."

The Boys of *The Boys*, on the other hand, are in the fight for all the right reasons. Supes and the Vought machine have wronged them all in some deeply personal way, and they'll use any means necessary to claw back some semblance of justice. "Ultimately, it's a show about blue-collar guys fighting superheroes, and I think that's something, in terms of wish fulfillment, that people can relate to. You're just a regular dude, and you're going to try to kick the shit out of someone who's a lot richer,

more powerful, and stronger than you, but you're going to figure it out because you're going to fucking fight dirty," says Kripke. Moritz echoes that sentiment, arguing that punching up is a license to be a bit more brutal than they might be otherwise. "A lot of people are feeling marginalized and hopeless right now, so it's okay to let them go farther, because you get to see people fight back for once and do some good in the world," he says.

Of course, all that obsession and dirty fighting has consequences. Can good guys fight bad guys and remain good? "One of the huge, multi-season themes of the show is that vengeance does as much damage to the person seeking it as it does to the person on the receiving end. Ultimately, the strength of the Boys is their humanity and their vulnerability. Generally, the more vulnerable you are on this show, the stronger you are, and the stronger you pretend to be <cough, Trump, cough> the weaker you really are." says Kripke.

THE LOOK

WORLDS COLLIDING

At this point, the creative team had cracked the multiple codes of what the show was about: the realistic tone, the external conflict between the groups, and the internal conflicts within those groups—and within the characters themselves. They then tackled how to portray those two groups visually; because, at least initially, the Supes and the Boys occupied separate worlds. Phil Sgriccia, executive producer and director of many episodes, credits pilot director Dan Trachtenberg with setting the series on a solid foundation. "Dan Trachtenberg did

"IT HAS ITS CHARMS."

HUGHIE CAMPBELL

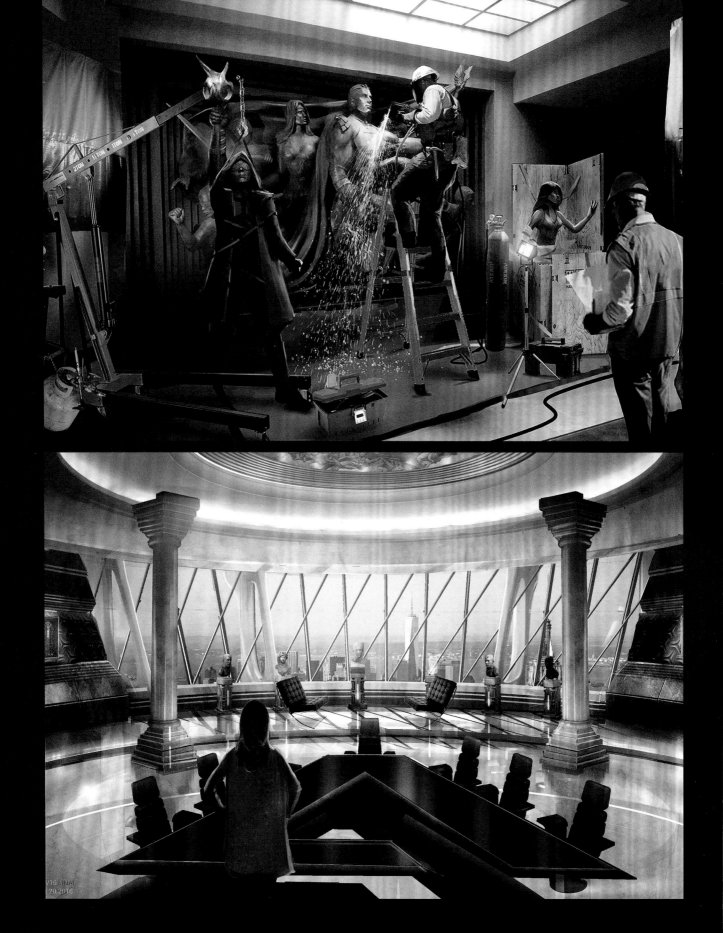

a magnificent job. In the beginning, there was a sense that the Vought/ Supes world was all very balanced, kind of a Kubrick framing. The camera was settled. Whereas, anytime we were with Butcher and the Boys it was punk rock. So, it was handheld and grittier, and the lighting was uglier," he explains.

That aesthetic began to change as their interactions became more frequent and more violent. "As we got moving with the stories, the Supe world started unraveling. We started going more handheld and less nice, beautiful frames. Almost everything is handheld now. If it's not, because we need to do some visual effect, we add a handheld feel to it. We like the frame to be kind of active. We try to play it like this is really happening, and we just happen to have a camera in the place. We don't mind showing a wart—as I call them—here and there. Add a smudge here, or if we're shooting over a shoulder, and part of the person we're shooting gets blocked by the person in the foreground, we don't try to fix every moment," says Sgriccia. He adds that this naturalistic approach extends to the way scenes are lit: "We tell the DPs [directors of photography], 'Don't let us catch you lighting!' We don't want that silver moon in the background that you always have in night scenes. We try and light it to reality, so it's more documentary."

THIS SPREAD: (Left) Concept art for the conference room of the Seven. (Below) Mural in the Haitian Kings' hideout.

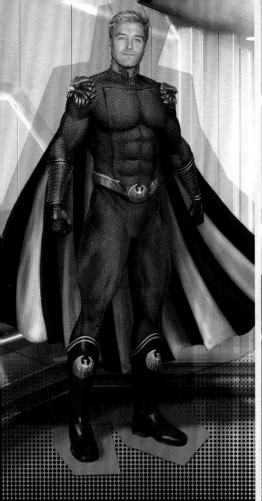
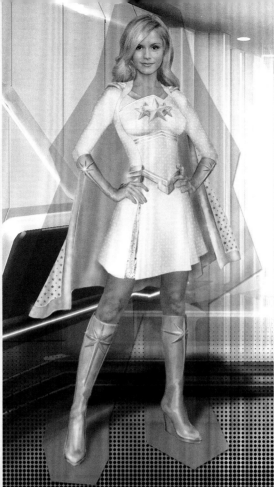
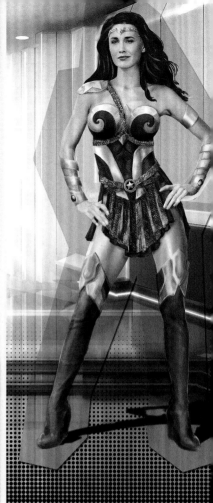

THE SUPERSUITS

DRESSED TO KILL

Another look they had to get right *waaaay* before any filming started (and even before the show was greenlit) was that of the supersuits. Unlike the campy spandex ensembles of yesteryear, these custom-made suits require incredible amounts of toil and time to develop—anywhere from twelve weeks to over a year, depending on the complexity. They can also cost hundreds of thousands of dollars. "Kripke called me super early, and we started talking about the main Seven characters. The edict was this was a legitimate superhero universe—not tongue-in-cheek," explains costume designer and supersuit virtuoso Laura Jean "LJ" Shannon. "The writing was going to dictate the actual comedic tone, not the design of the show, including the supersuits. We wanted to ground the audience in the Vought Cinematic Universe—to have it be visceral and impactful."

Shannon describes a lengthy and surprisingly high-tech process that takes a dedicated and talented team to accomplish:

"We start the journey studying the canon, studying the books, and extrapolating the elements that we feel would be good contenders to be a part of the world that we are having our live-action characters inhabit. The choices we make in designing our super suits are intentional and have a message behind them. We created renderings, and then we did some fabrication samples. We worked

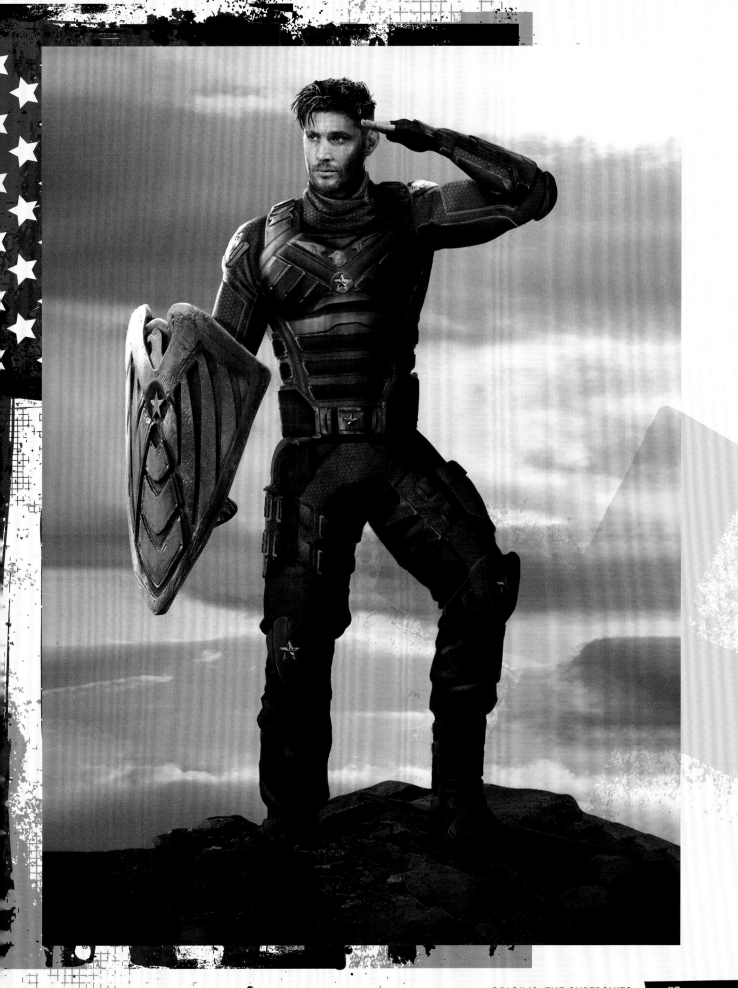

with Creative Character Engineering (CCE), my sub-contractor that does all the sculpted elements and unconventional material aspects of the suits, to put together some fabrication samples of what those armor bits would look and feel like. With feedback from Eric Kripke and our other executive producers, we go through an approvals process with Sony and Prime Video. Once everybody signs off on the designs, then the builds begin…

"We have the actor get scanned. Sometimes have a fitting before we even scan the actors, to build out their bodies. Whether it means they need a little more hip, or a little more ab, or a little more pec—because, as you can imagine, our guys are not as completely muscle-bound as they appear on TV… Sometimes we'll scan them just as they are, and sometimes once we build a muscle suit that goes under their supersuit, we'll scan them again. That scan provides us the ability to have a digital likeness of the actor, where we can digitally sculpt aspects that are specific to their physique;

we also build a physical body form (from the scan), so that in the workrooms (tailor shop, sculpting studio, molds shop) we actually have the likeness of the actor to fit the suits on. All of the sculpted aspects are developed digitally with our 3D modeling, and then created by pumping them out of a 3D printer. Those then get molded in multiples in the body shop over at CCE."

Depending on the complexity, the designers require four to eight in-person fittings with the actors in order to get the supersuits

to fit them like gloves. "Those fittings literally begin with Agnes Grzybowski, my manufacturing foreperson. She and her team will create a basic catsuit that we'll put on the actor, pinned to fit them perfectly. Then Gina DeDomenico Flanagan, my concept artist and I, with a bucketful of Sharpies, take the concept art and old-school translate the design by drawing lines on the actor's body in the suit. The reason we do this is, even though we study the actors and their bodies when they get cast, we also have to make those designs look really snazzy and up the coolness factor," Shannon says. After a couple of iterations, including a lo-fi, cosplay version, the real suit begins to emerge.

"Each one of the suits has at least one, but up to ten custom fabrics that we had to develop for the suit itself," she continues, noting that to get the looks that they need, vendors have to employ advanced methods such as, "...laser cutting and high-density screen printing—it's a dimensional screen print using several different screens to add a sculptural quality to the fabric itself, so it feels tactical. We push the limits of what they're capable of—giving each suit its own visual voice." Photo shoots, final notes, last touches, and the suits are camera ready.

Because of that extended lead-time, normal casting priorities get flipped. "It was interesting and a little challenging, because the supersuit process drives so much of what we do on the show. So, in general, we usually have to cast our superheroes first, because these suits are only built to their specifications. But the Supes in our show are the villains, and you almost never cast the villains before you cast the heroes—but we had to. So, everyone wearing a supersuit in *The Boys* were the first people cast," says Kripke.

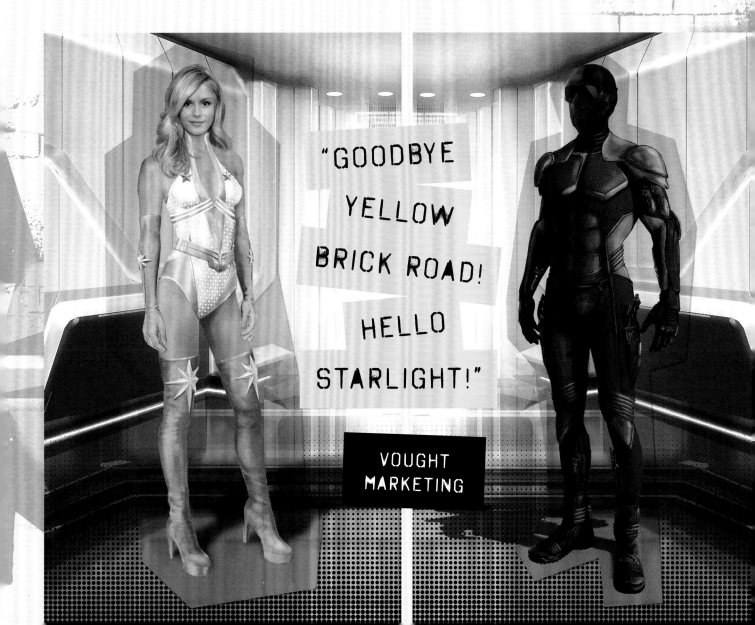

"GOODBYE YELLOW BRICK ROAD! HELLO STARLIGHT!"

VOUGHT MARKETING

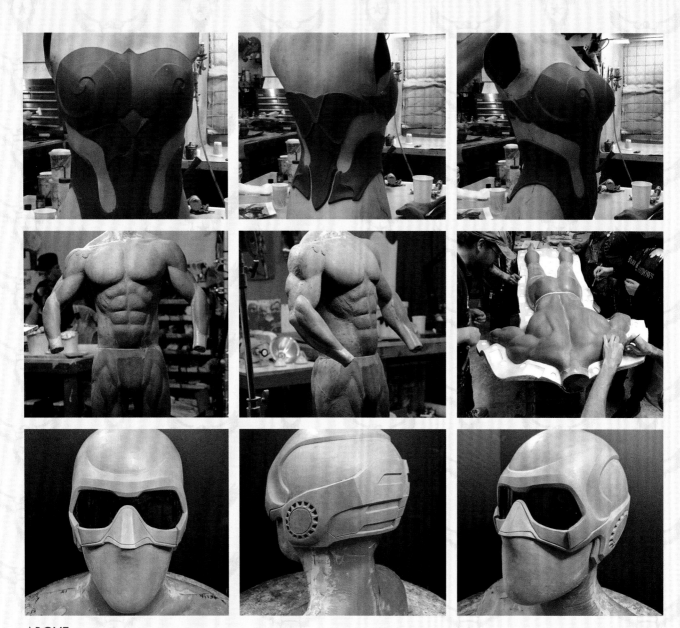

ABOVE: Artists create forms from body scans and sculpt supersuit elements directly on them.

Wardrobe fittings, in addition to ensuring the actors appear fabulous on screen, are also crucial for them to fully inhabit their roles. "They spend months with me prior to even showing up on set. Beyond the painstaking creative aspect of dialing in each element of the suit to perfection, it's also my job to really dive deep on a psychological level with the actors—talking about what choices these characters have made to get them here. Talking about how they move. And I'm in constant contact with Eric Kripke about this as well, because I have to represent what his vision is, while I'm going on this journey of discovery with the actors," says Shannon.

An interesting aspect of the fittings, one that stays with the actors long after they've gone off to set, is music. Shannon explains: "One of things we do with each of them is we create a soundtrack for them. I'll come up with what I think feels right for the character, and sometimes actors come up what they feel is right for the character. That's what we'll play literally every single time they come in for a fitting. It's Pavlovian, so they get right into character. When we deliver the suit and I'm there to direct the camera tests, we put on the soundtrack and they're immediately comfortable. Now they're on set with 50 people they haven't met, and they immediately feel that they're in the womb that we've created in the fitting room."

NOW AVAILABLE ON VOUGHTIFY

THE MUSIC

Music can be one of the last elements added to a show, and *The Boys* is no exception. It's the glue that can hold the whole story together, but in the case of the pilot, it just wasn't happening as quickly as the creators would've liked. "I'm a big fan of needle drops—the popular music that plays instead of score. The audience knows them, and they set the tone," says Kripke. "We had already shot the pilot. I was struggling a bit. We tried a lot of things that didn't work. Then director Dan Trachtenberg and I stopped scoring the show and started scoring the characters. We can't figure out the show, let's narrow it in. We were like, 'Okay, what does Butcher sound like? What would Butcher listen to?' And that's what clicked. Butcher was a kid growing up in East London in the '80s and '90s. He's listening to punk—and hard punk. In tiny clubs with 30 people. Once we understood that about Butcher, and the fact that Butcher is a force for anarchy—like dangerous, rip-it-all-down-and-kill-you-in-the-process anarchy—then it all was of a piece. Sid Vicious, Iggy Pop… I just listened to all the punk I had."

Composer Christopher Lennertz takes up the story: "Eric and I were developing a sound for the show and for Butcher. The Boys are just a really gritty, nasty, sloppy group—desperate, all visceral and energy—rather than Vought, which is so planned and produced. So, Eric wanted Butcher's sound to be very ragged, and messy, and aggressive. All sorts of punk that he was listening to reminded him of Butcher. Once we delved into that, I came up with our Butcher theme, which is definitely a punk riff on guitar, like the Sex Pistols meets The Clash. And often we use that when he's leading the charge for the Boys. Because that worked so well, and the end of Episode One was The Clash's 'London Calling' as well, at that point Eric was like, 'Wow, this is really working.' It works just so perfectly with *The Boys*. It's flying by the seat of their pants, messy, aggressive, visceral, violent."

Punk infused not just the sound, but also the entire aesthetic of the show. "Butcher's music ended up defining the anarchy of the show," says Kripke. "We would then bring that up when Prime Video marketing was designing the logo. What's punk rock? Graffiti, Banksy-style street art. The question we always ask everybody is, 'Well, what is the punk rock version? 'Cause that's what we do.' Subversion, anarchy, and ripping down the corporations."

WHY NOW?

"FUCK SUPERHEROES"

Anyone with a pulse in 2019 could tell you why that was an ideal time for *The Boys* to begin streaming, and why it continues to resonate with audiences today. But hey, let's do it anyway, and allow Seth Rogen to state the obvious: "*The Boys* is about superheroes, which could not be more popular, right now especially, so the timing of that was helpful. When the comic came out, [superhero] movies were not very popular, so it aged into relevancy in a mainstream way." Kripke seconds that emotion: "There wasn't the sheer avalanche of superhero shit out there that there is today... That wave is just starting to crest. There's getting to be too much of it. It's getting to be overwhelming. When I walked in on my very first pitch meeting, the very first words out of my mouth were, 'Fuck superheroes.' It was time to take the piss out of all that god-myth-making," he says.

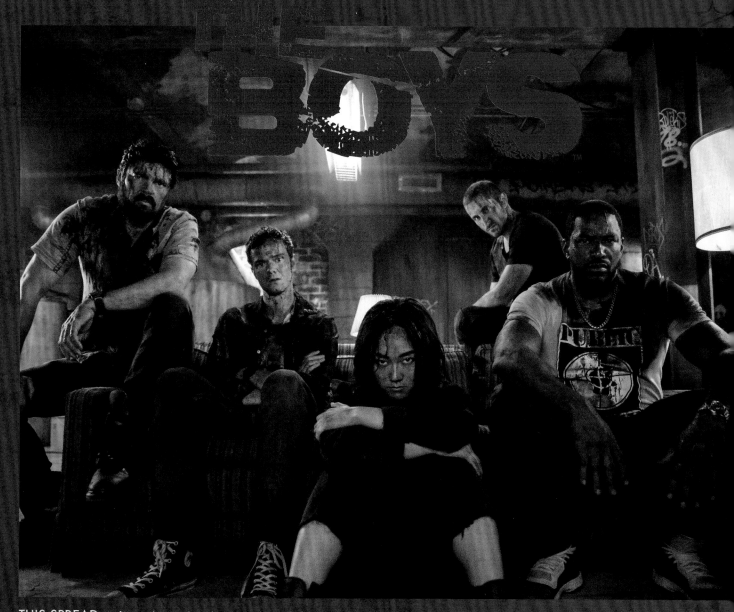

THIS SPREAD: (Left) Vought superhero hype invades real life. (Above) The Boys recuperate after a bloody tussle.

As mentioned, part of that was showcasing the insanity super-powered beings would wreak in the real world. But you'd be sorely mistaken if you thought that was the end goal. "The madness of the show is the spoonful of sugar. It's also the thing that can be noisy and gets asses in the seats. The crazy, gonzo moments are just what's on the front of the cereal box," says Kripke. "I'm interested in monsters, or science fiction, or superheroes, because they represent and symbolize something. Because they really work as metaphors. You should be extremely suspicious of anyone who stands in front of you and says: 'I am your hero, and I'm here to save you.' That person is selling you something." And there's no better time than the present to shout that warning from the rooftops.

"Garth Ennis was just incredibly prescient in terms of predicting this intersection of politics and celebrity. *The Boys* comic has been around for well over a decade, but this world happens to explain the exact second we're living in. He always had authoritarians posing as celebrities. That was the gimmick. We happen to live in a world where one of them was our president," says Kripke.

And that's where we find our heroes today: Not seeking praise, but getting the job done any way they know how. Wedged between a "fuck you" and a "fuck superheroes," standing tall, defiant middle fingers raised at the powers that be. They are the Boys.

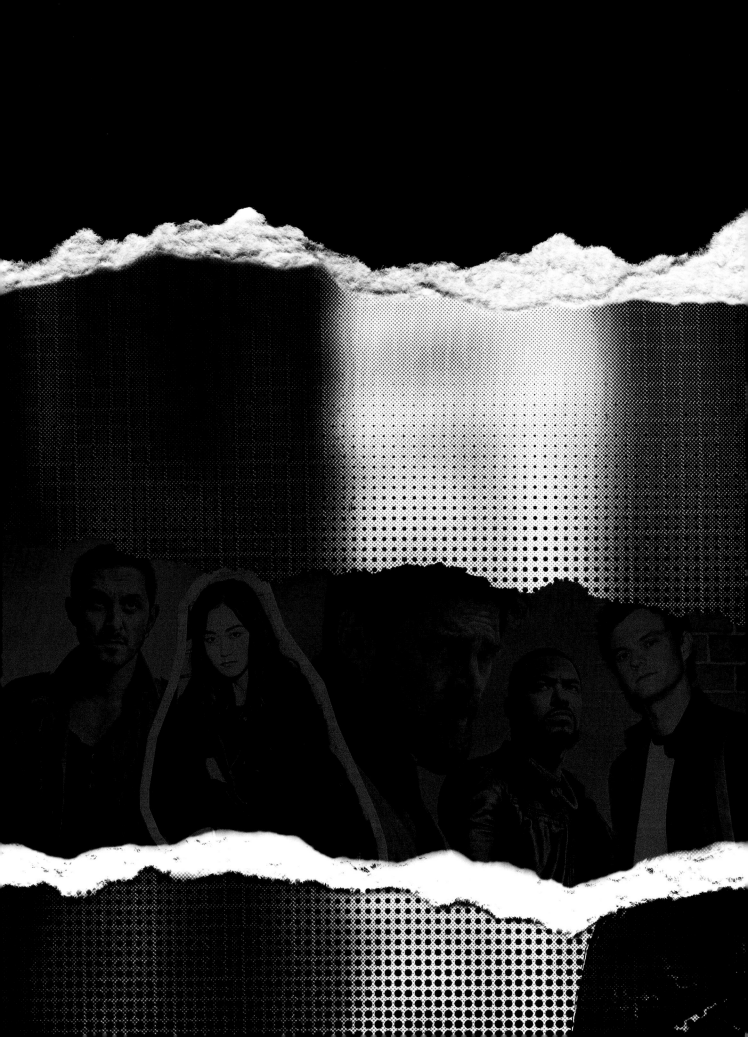

CHARACTERS

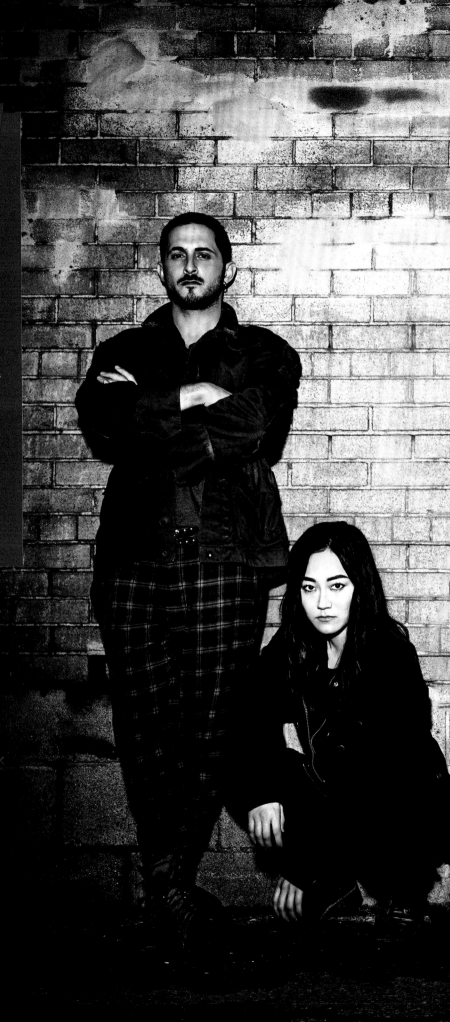

THE BOYS

"With love and respect for my other shows, this has been the most amazing cast I've worked with," says showrunner Eric Kripke. "It's a big cast. To have twelve regulars and have every single one of them be great is almost impossible odds. It's so hard to find one person who's great, so to find twelve of them is multiple lightning strikes in the same place." He gives a lot of credit to Robert Ulrich, the casting director. "I've worked with him since Season One of *Supernatural*—he's like family to me and a brilliant casting director," Kripke says.

"In my opinion, I think Mother's Milk is probably Posh Spice, because I would imagine her to be pretty fastidious and clean and meticulous. I think Jack is probably Baby Spice. I would go with Frenchie would be Ginger, and Butcher's Scary Spice."

KARL URBAN

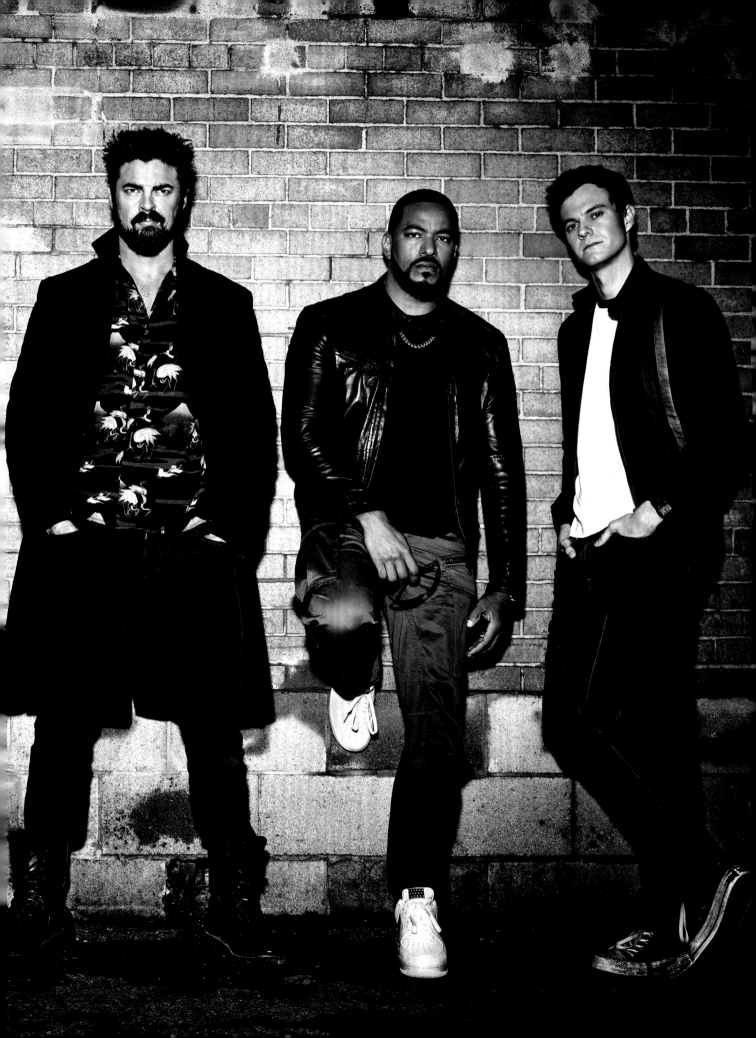

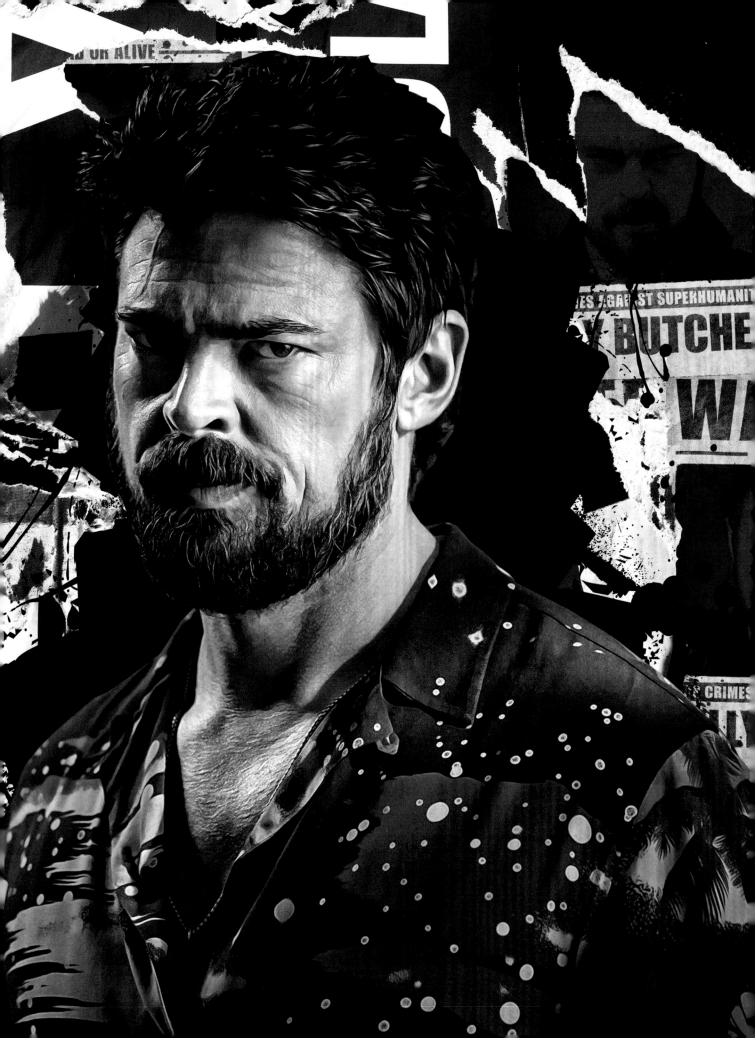

BILLY BUTCHER

"Don't you worry. Daddy's home."

"There's an internal struggle, a war that is waging within him—a fight for morality, a fight for Butcher himself to do the right things, to make the right choices," says Karl Urban, the veteran actor who plays the leader of the Boys. "Butcher, in many ways, is his own worst enemy. I think nine times out of ten he'll make the wrong choices for the right reasons."

But Urban points out that the obsessed vigilante is not without a human core; after all, his vengeance is fueled by his love for his wife, Becca. "This motherfucker's committed. He is unwavering. He's standing on

the edge of the cliff and he's not blinking... but I do think he does have a heart, despite his best efforts and intentions to be hard, and treat others around him with little regard or respect. At the end of the day, his heart does jump in at the eleventh hour, that morality bell rings, and there's a line that even he won't cross," he says.

"Garth Ennis loved *The Shield*, which is funny," says Kripke, "and he was really inspired by Vic Mackey in the writing of Butcher. Coincidentally, at the time I was running a show with Shawn Ryan, who created *The Shield*, and I got to sit down with Shawn and say,

THIS PAGE: Karl Urban brings a smoldering intensity to the role of Billy Butcher.

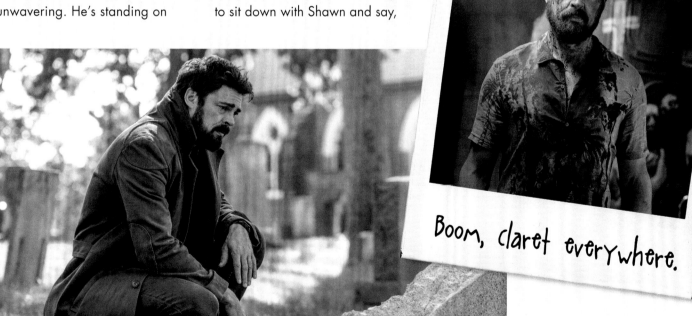

Boom, claret everywhere.

'Okay, what made *The Shield* work for you?' I love the research. It's one of my favorite parts of the job."

"We chased Karl. From the very beginning, Seth, Evan, and I said, 'It's Karl Urban.' He's perfect. He's a super-credible action star, he's incredibly charismatic, and *Thor: Ragnarok* had just come out, so we knew he could do comedy. This guy's got everything we need," says Kripke. "Sony and Amazon said, 'Maybe. But chase down and look at a billion other people.' He could've gone and taken another movie any day. We felt the pressure. Finally, through

Seth and Evan, they put enough heat on everybody that we got the approval to go after Karl. He came into that meeting with a beard, and Butcher does not have a beard [in the comics]. But Dan Trachtenberg was like, 'We should keep that beard. It gives a roughness to Butcher that I think would be useful.'"

One look from the comic that has stayed with Butcher is his signature black trench coat—but it came with a few twists. "The design lines were actually based on a jacket he wore to his first fitting," explains Carrie Grace, the costume

designer for the pilot episode. "He had this really great jacket with these shoulder details. We rebuilt it as a longer jacket, made out of an oilskin fabric—a cotton twill with a wax coating on it. We built about six jackets. We had them all aged equally. We slapped a piece of duct tape on the back shoulder as an easy repair that he had done; we made sure the elbows were scuffed up. Gave it a sense that he'd been wearing it for a long time and that he'd been in some scuffles. One of the notes we got was that they really wanted him to be greasy and sleazy, rumpled,

THIS PAGE: Don't get in Butcher's car if you can't pay the fare.

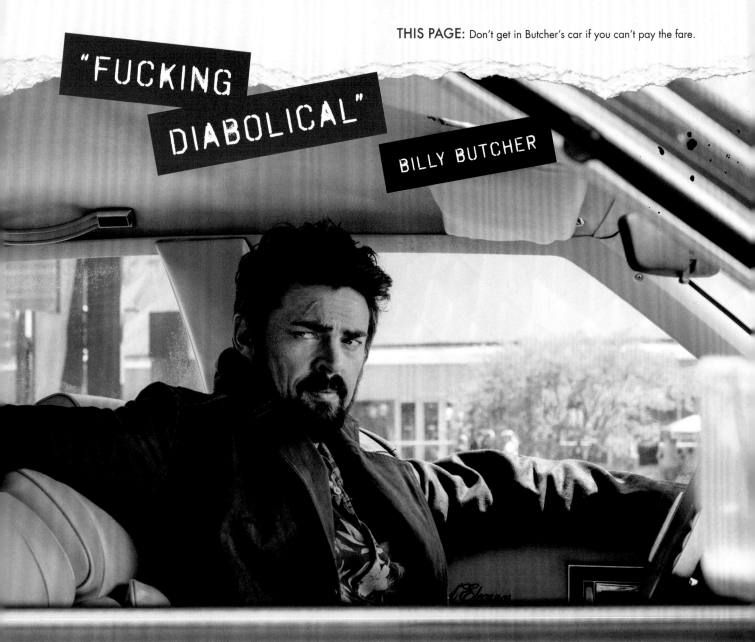

"FUCKING DIABOLICAL"

BILLY BUTCHER

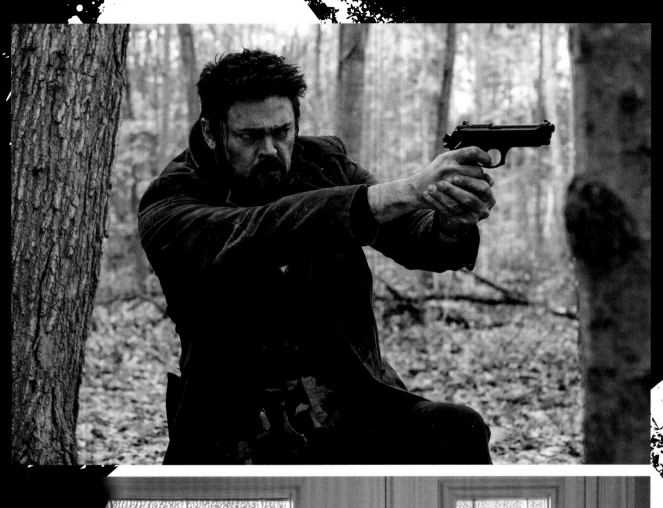
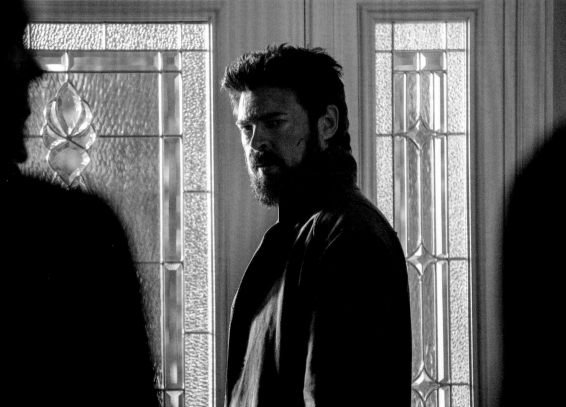

and not the kind of guy that you think is up to any good. So, we loaded even more wax onto the jacket. What's funny is that in the summertime in Toronto, he became sort of a walking crayon."

TV Butcher also sports an article of clothing that, at first glance, might seem contradictory to his character: brightly colored Hawaiian shirts. "That actually came from Dan Trachtenberg. He had this idea that Butcher had this dream of, when he finally gets his revenge, retiring to some tropical place, and then he can relax," says Grace. "Not only is that a great internal story, but also, when you pair tough black jeans and combat boots and this jacket with a Hawaiian shirt, it lends it this,

'Am I supposed to take this guy seriously? Is this guy messing with me, or is he for real?' It softens his look, but it also gives him a messed-up, quirky edge. Sometimes playing against type like that can really be effective."

Finally, it was felt that this man on a mission needed some sort of talisman. "We ended up going with a St. Christopher medal. It's one of those little details the audience probably never sees, but the idea behind that is just to protect him in his travels and his journey to get his revenge. I got a really gorgeous, vintage St. Christopher medal, probably from the 1910s; we had repros made so we had multiples," says Grace. The medal shows up in later episodes,

becoming a minor story point. "It's weird how ideas like that, laid down early, can carry through new people. It's synchronicity. The characters tell you who they are as you go through the fitting process. There's almost a magic that happens," she says.

For Urban, the chance to play Butcher the anti-hero has been a joy, not least the colorful vocabulary he gets to employ, as well as fan reaction to it. "It was certainly fun to be able to liberate certain words in the English language like 'cunt,' which you never see on television. It's funny the amount of people I bump into—the fans—who say, 'Hey, Karl. I love the show! Can you please call me a cunt?' It's bizarre," he says.

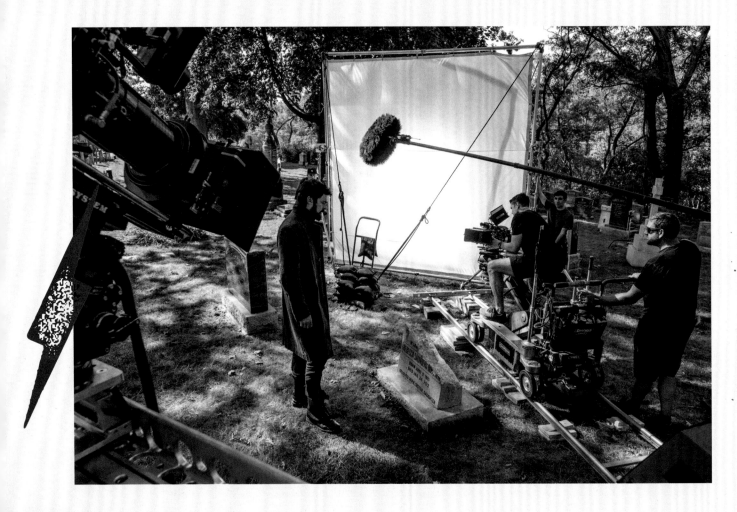

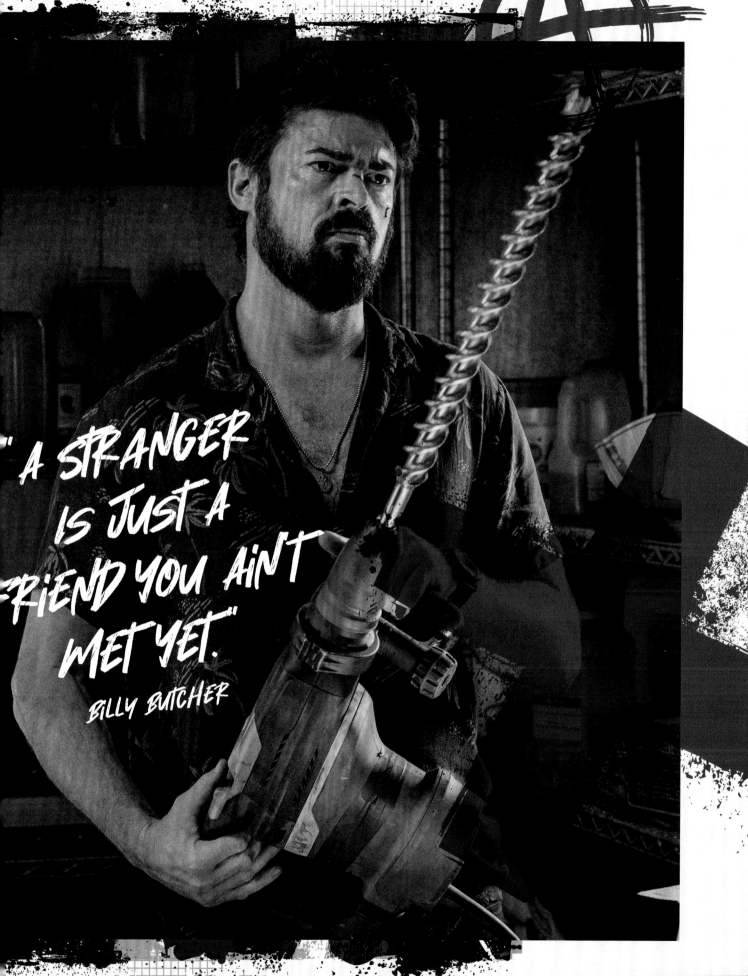

"A STRANGER
IS JUST A
FRIEND YOU AIN'T
MET YET."
BILLY BUTCHER

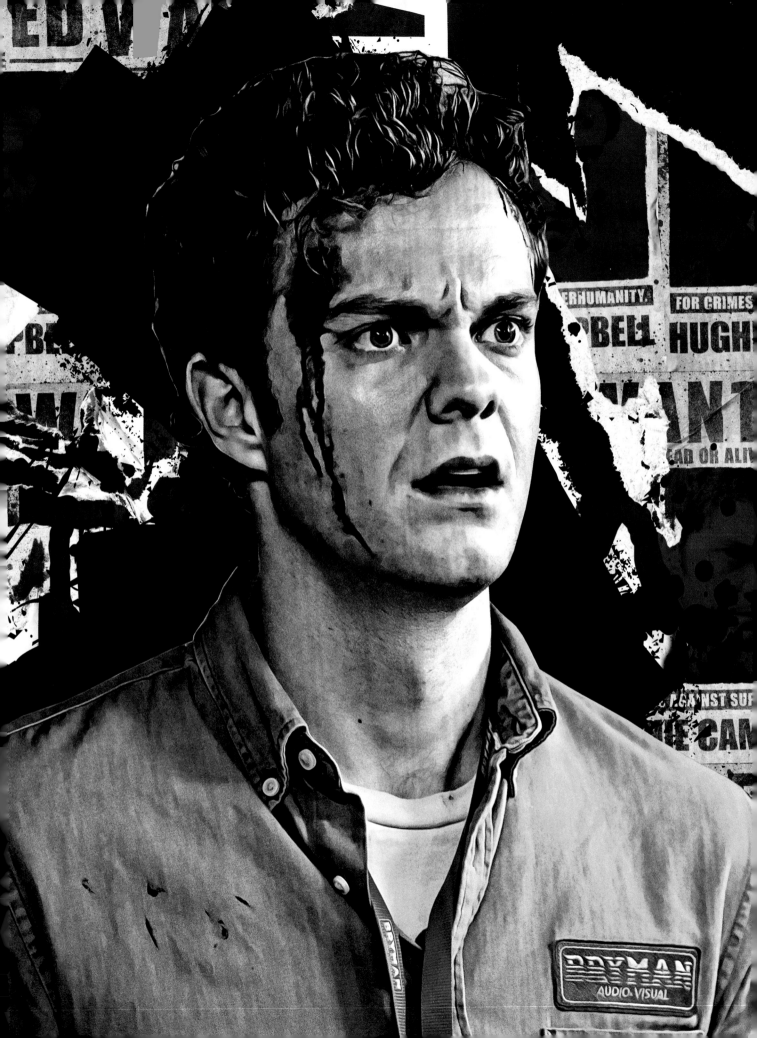

HUGHIE

"Okay, this is insane."

FUCK SUPES

"I was intimidated quite a bit when they first approached me with this," admits pilot director Dan Trachtenberg, "but the thing that got me the most excited to make it was the character of Hughie Campbell. I identify with that guy, and I tend to love movies and stories that are about sidekicks." Trachtenberg might've been the first, but he's definitely not the last person drawn into the series by relatable everyman Hughie.

"When we first meet Hughie, he's a little naïve. He's a little sheltered. He doesn't really stand up for himself," says Jack Quaid, the man tasked with embodying

Hughie Campbell, Jr. "He's got a girlfriend, he's got a job. He's really not trying to get much more out of life." And when A-Train evaporates Robin in the blink of an eye, Hughie has no idea what to do or if he should do anything. But then Butcher steps in and drags him into a swirling shitstorm of revenge and ultra-violence.

"There's lots of lines of morality he has to debate whether or not to cross. He has to do a lot of things he's not proud of," says Quaid, such as, "he's got to learn to lie. He has to learn how to manipulate people. He has to learn how to be not such a great guy to achieve

THIS PAGE: Hughie Campbell (Jack Quaid) goes from one bloody tragedy to the next.

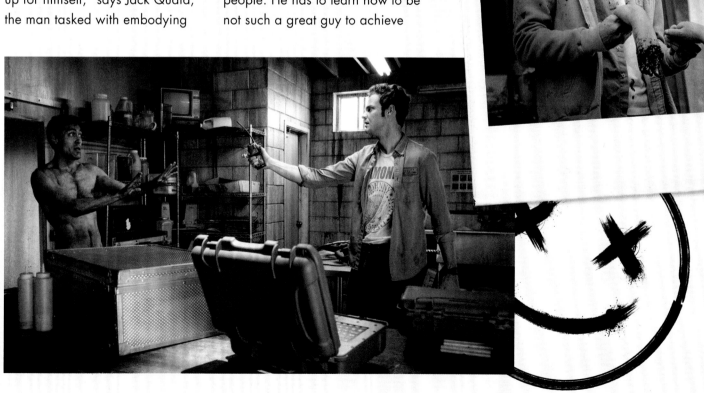

"YOU KNOW. I MANAGED TO GO MY WHOLE LIFE WITHOUT SEEING SOMEONE DIE HORRIBLY AND NOW I'M UP TO ABOUT A HALF DOZEN. SO I THINK I'M GOOD."

HUGHIE CAMPBELL

the goal he set out to do." Those newly acquired skills frequently put him at odds with Annie January (aka Starlight), his counterpart in this classic Romeo and Juliet tale of boy meets Supe, boy loses Supe, boy and Supe team up to try to take down a corrupt multinational corporation (and occasionally bang each other). "I feel like this show is very much about masks, and how we present ourselves to people. Annie and Hughie are the only two characters that don't have them, at least at the start," says Quaid.

"Jack Quaid was the very first person I saw for Hughie, and I was like, 'Oh, great. This is what we need,'" says Kripke. "We kept phrasing this person as, 'They have to be nerdy, but they can't be so nerdy that they're not credible as a romantic lead.' John Cusack in *Say Anything*, that's what our target was. There's very few guys who can do that, and Jack just walked that line so beautifully. He's gangly and awkward, but he has a smile, and he's so charming and likable. I think he could be Jack Lemmon. But the studio and network were like, 'Yeah, but he's the first guy you saw.' So, I kept looking at a billion people, and kept saying, 'It's gonna be Jack.' And of course it was."

If you were to ask Quaid what Hughie's superpower is, he'd say it's, "loyalty to the people that he cares about. We see him struggle with that in Season Two. He sees it as a weakness. He sees it as, 'My mom left me, and it's hard for me to lose people. I don't want to lose anybody.' But ultimately, that's his greatest strength, because he'll do just anything for those that he cares about."

"There's always a moment where you're like, 'Oh wait. This is gonna work.' For me that was when we were up in Toronto in pre-production and I brought Karl and Jack Quaid to meet each other for the first time," says Kripke. "Watching their energy bounce off each other, I liken it to a bulldog and a puppy. Karl was all about economy of movement—I learned a long time ago that 'cool' is defined by how little you move, not how much you move. And Karl was just, 'Yes,' and, 'No,' and, 'Sounds good.' And Jack is like waggling his arms everywhere, and saying these long, run-on sentences. It was just beautiful. These two are their characters."

"Hughie's look is very much influenced by his

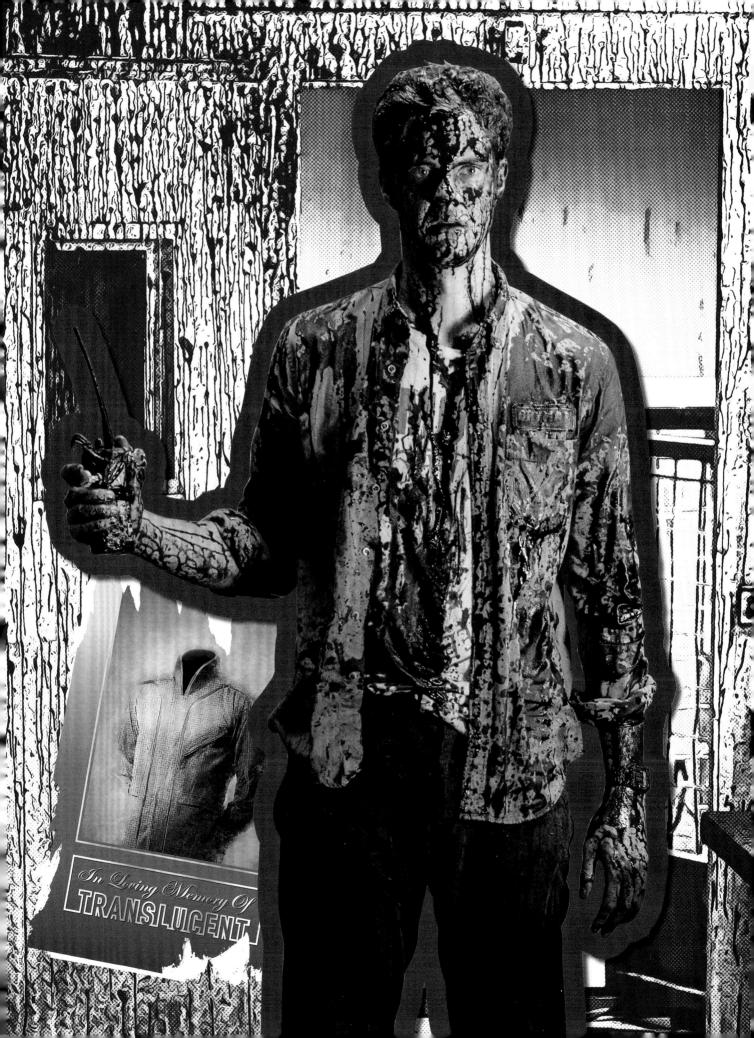

In Loving Memory Of
TRANSLUCENT

dad, who's very comfortable in his defeatedness, and he encourages Hughie to be defeated by events that are seemingly insurmountable," says costume designer Grace. "He starts out wearing vintage clothing. He wears corduroys—a soft fabric, fuzzy and approachable. His shoes are just Converse—classic, comfortable. He's wearing this '60s moto-racer style jacket. My thought is that he'd find it at a thrift store and bring home and show his dad, and dad would be like, 'Oh,

cool. I used to have one like that when I was your age.' A history of pleasing his dad, and he's starting to outgrow that. The jacket (a) tells you a lot about the character, and (b), since this is a superhero show, their iconic jackets became their anti-hero capes. You don't want to change a character so much that it's on the nose, but Joyce (Schure) did such a great job of carrying on where he came from and taking him to a place where visually he looked stronger. He wasn't the same man at the end of the season

as he was when we first met him in the pilot."

One part of his outfit sparked an evolution of the musical soundscape heading into Season Two. "Jack Quaid came to the first fitting with a playlist of all this music, and it really helps to flesh out the character. It had a lot of Billy Joel, some James Taylor, some Tom Petty, so we decided to give him these band t-shirts," says Grace. Kripke explains that, "In Season One we scored the music from Butcher's point of view;

BELOW: Hughie, unlike his dad (Simon Pegg), decides to take action.

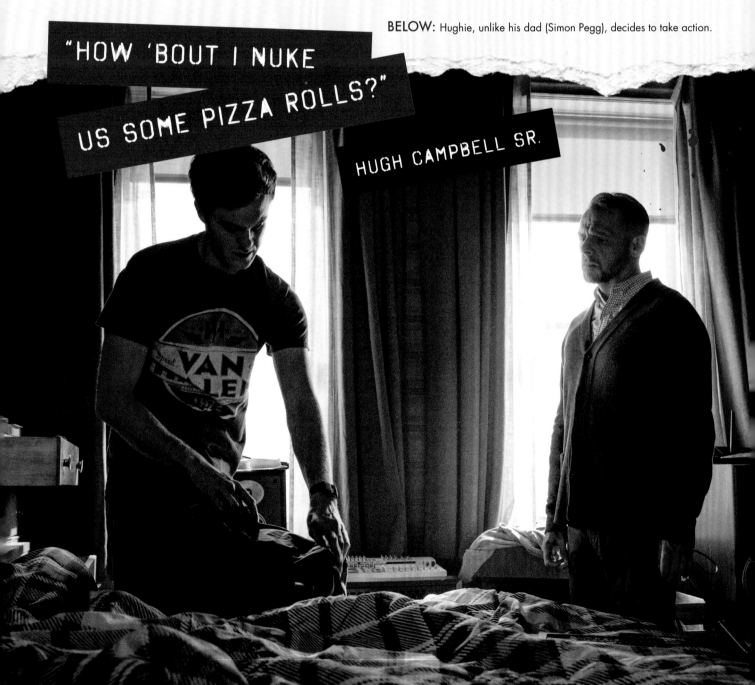

"HOW 'BOUT I NUKE US SOME PIZZA ROLLS?"

HUGH CAMPBELL SR.

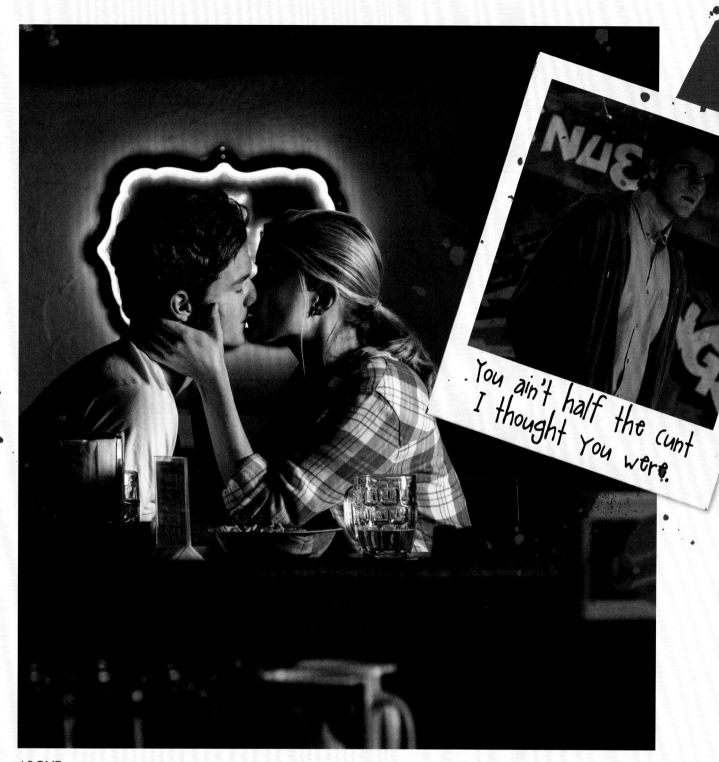

ABOVE: Hughie and Annie spend some time together, away from gory explosions.

for Season Two we scored from Hughie's point of view. We quickly realized that all the beats of Hughie's emotional journey could be defined by a Billy Joel song. Like the 'pressure' that he's under, and then, in the whale episode, he really needs a 'second wind.' We were really amusing ourselves in the writers' room with this Billy Joel rock opera that Hughie was going through. Even the video for 'You're Only Human (Second Wind)' is about a kid on the precipice, crying about a girl that might be unattainable, and then this guy in a black trench coat shows up, telling him the ways of the world. It was all too good to pass up.

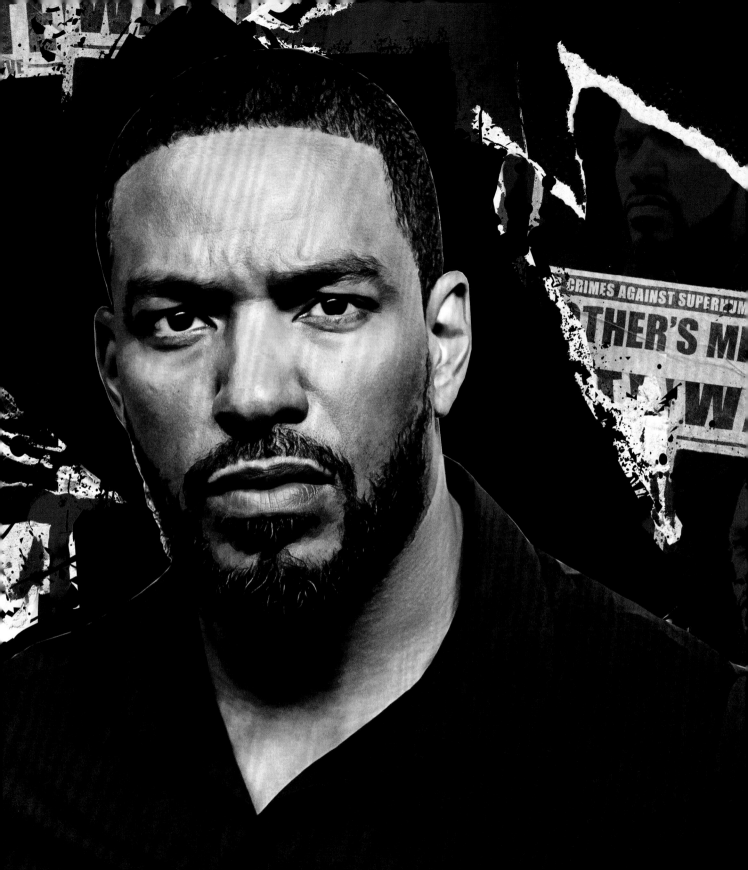

CRIMES AGAINST SUPER[...]M

[...]THER'S M[...]

[...]W[...]

AMSTERDAM JUVENILE
DETENTION CENTER

MOTHER'S MILK

"Two plus two equals nasty."

Laz Alonso plays the Boys' fastidious medic and muscle, Mother's Milk. He has a quiet strength and a rational mind—useful when those around him are losing theirs. Kripke says the casting was a slam dunk: "For Laz, it was how sharp he is, because Mother's Milk, in any given scene, is the smartest character in the room. So, you need someone who has that intelligence in their eyes," he says.

With a daughter and a rocky marriage to protect (spoiler: the marriage doesn't make it), M.M. is naturally the most reticent about returning to the craziness of the Boys when Butcher asks. "He's the one that has the most to lose, so his stakes are a lot higher," says Alonso. But because of the pain Vought has caused his family, and his own precise moral compass, he feels he really has no choice but to rejoin the crew and fight the good fight.

"Mother's Milk is the conscience of the Boys. And in many ways he doesn't get to have as much fun as the other Boys, because he still has to remind the audience that we're the good guys," says Alonso. "He has to remind the Boys, too. Are we doing evil things to get a good outcome, or are we slowly starting to mirror those that we

How'd ya like to come back for another go?

THIS PAGE: Mother's Milk (Laz Alonso) has to deal with a lot as the adult among the Boys.

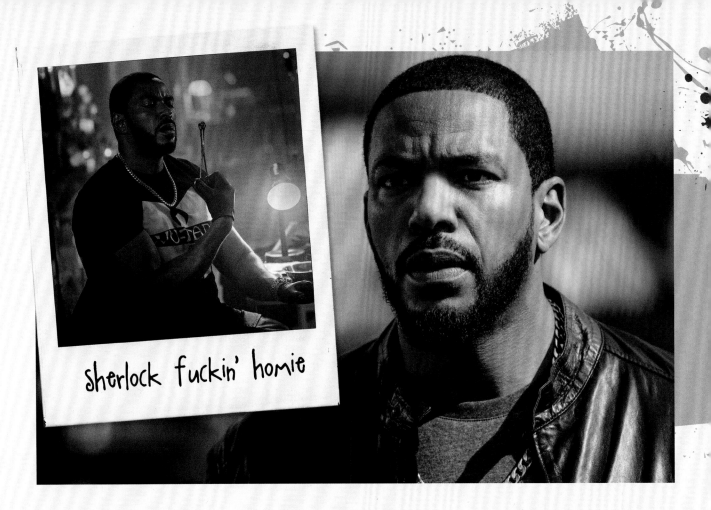

sherlock fuckin' homie

claim are the bad guys? I think Mother's Milk is trying to reel these motherfuckers in and keep them from just falling off the hinges in their quest for revenge. It's really about keeping the order. We can do this if we keep a plan and we keep the order."

Part of that need for order comes from M.M.'s Obsessive Compulsive Disorder, a condition that Alonso shares. "It has been the most gratifying work experience out of my career, to be honest: to be able to bring my OCD to work, and not have to, for twelve to fifteen hours, pretend that I don't have OCD," he says, adding, "I'm like the guy, on other shows, I've gone to co-stars' dressing rooms and cleaned them up for them."

Joyce Schure, costume designer

for Season 1 episodes 3 to 8, notes, "In the source material, Mother's Milk is this huge physical presence. In this show we wanted to emphasize the individuality and what each of them was bringing to the group known as the Boys, so we wanted to visually—with color and silhouette—block him in a way that made him extremely imposing, and he didn't have to say a word. We definitely wanted to create something that made Laz stand out, but not step on anybody else's toes. So, that pushed us in the direction of creating this custom, unique color for him and his iconic jacket." Also, it should be noted, his hip-hop t-shirt game is quite strong.

"Every season is full of surprises," says co-executive producer Michaela Starr (no relation!),

"but one of my favorite character choices the writers made at the top of Season Three was with Mother's Milk. At the end of [Season Two], M.M. takes Mallory's advice to get out of the Boys and go back to tilapia dinners with Monique and Janine. They were interested in approaching that story from Monique's POV. Just because M.M. went home, doesn't mean it was happily ever after. What if she didn't take him back? What if she moved on? What if there was a new father figure in Janine's life? So, we rooted his Season Three storyline in that struggle. A single father trying to earn his way back into his daughter's life, while being seduced by Butcher's call to return to the team. And Laz does an amazing job playing this conflict and emotion."

FRENCHIE

"You need to unclench your asshole."

Perhaps it's cliché that a character named Frenchie would be wracked by *ennui* and *terreur existentielle* (not to mention his need for a shower), but *c'est la vie, n'est-ce pas*? "You meet Frenchie at a point in his life when he's kind of a junkie. He's selling weapons, and lost in the world after the Boys split up. And then one day Butcher shows up with this guy, Hughie, at his doorstep," explains Tomer Capone, who plays the group's chemist and materials expert, adept at whipping up explosives, gas bombs, and specialty munitions. And yet, despite how aimless his life may seem at that point, "Frenchie... I don't think at the beginning he's quite happy about it. But you know what? Once you're in the Boys, you're always in the Boys," says Capone.

Perhaps it was pangs of conscience that brought him back into the fold: regret for the momentary lack of vigilance that led to the deaths of Colonel Mallory's grandchildren. "From Day One when we meet Frenchie, it's guilt all over. It's guilt mixed with revenge, mixed with so many different emotions—and cocaine," says Capone. "The masks come on. (He wants) people to see the truth behind the masks. Stupid masks of the stupid fucking superheroes."

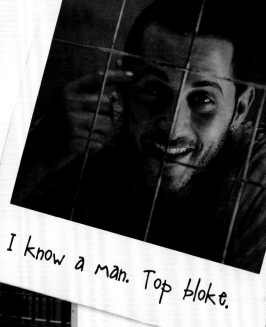

I know a man. Top bloke.

LEFT: Ari Magdar and Adam Tupper capture a serious moment with Frenchie on the street.

But if Frenchie embodies philosophical angst, deep down he also possesses his countrymen's fabled romantic nature. For it is he who insists on freeing the semi-feral mute girl they find chained up in a basement beneath a grocery store. "Frenchie and the Female have a strong connection, I think because they share similar histories," says Karen Fukuhara, who plays the Female (aka Kimiko). "They share a dark past, and they connect on that level. Frenchie is the one person that shows the Female kindness. That sparks her trusting other people."

Embodying this tortured and contradictory character takes a special actor. Kripke says, "Tomer, I think, was our very last person cast. We had a really hard time finding Frenchie, because he's gotta walk this line between absurd and really soulful. He's, in many ways, the 'Kramer' of the team, but we're not a comedy like *Seinfeld*, so you need to really understand that character and where they came from, and feel like they're real and grounded. We looked at a lot of people—we were already shooting, which is pretty nerve-wracking. Finally, this audition comes in. He walked the balance like nobody had been able to, of being funny and strange without being broad and cartoonish. He found a way to do a very human version."

Such an eclectic and mercurial guy as Frenchie needs an eclectic and mercurial wardrobe. "He's just such a weirdo. So quirky and out there. He selects his clothing in a mix of what amuses him, what's practical, what might irritate people, and what's on the floor next to him," says Grace. "We went with an intellectual gutter-punk kind of a look, based on a guy I knew in high school who went to punk and hardcore shows. Just that layering of beat-up clothing, some of it with massive holes—like thermal pants under camo shorts. That early

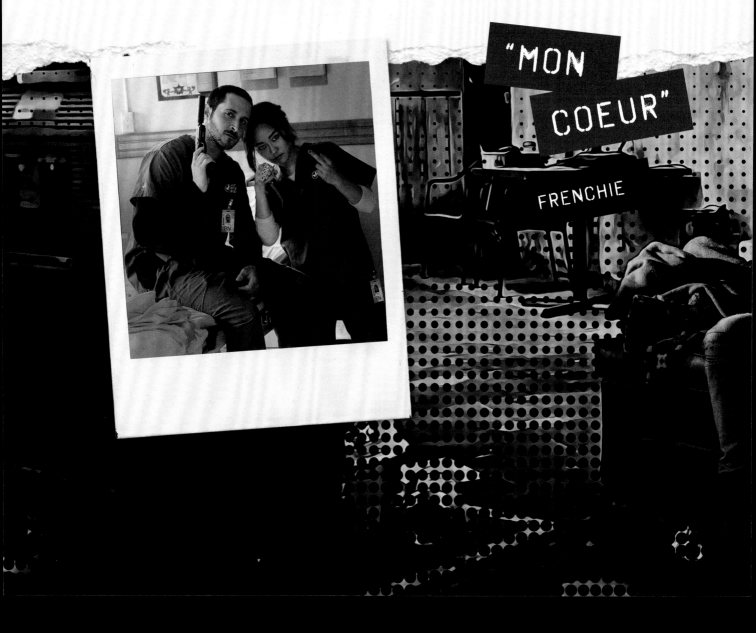

"MON COEUR"

FRENCHIE

Vice magazine guy kind of look. His anti-superhero cape was his military surplus field jacket. We aged the living hell out of it. I put patches and buttons in weird, awkward places, like on the edge of the pocket and the back hip pocket, randomly placed."

As with the other actors, Capone had a hand in his character's style. "He had a notebook that was filled with ink drawings in such a way that it was very claustrophobic and labyrinthine, and I love the idea of him drawing on his clothing, on his jacket. All the things to show that someone's lived in it for a while," says Grace. One prominent part of

Frenchie's outfit from the comic that got ditched for the show was his goggles. "I always loved the goggles look of the character in the comic book, but Eric Kripke was very much against that because it is very self-conscious looking. It wouldn't make sense with the realism. But we did get to pay homage to it in (Season One) Episode Two, when he's cooking up the carbon bullet when they're trying to kill Translucent, with beakers and Bunsen burners and stuff. We got to put him in goggles for that."

Although virtually unknown in America when he got the part of Frenchie, Capone is something of

a superstar in his native Israel. "I had dinner with him there once, and it was like having dinner with Tom Cruise," says Kripke. Still, that celebrity status didn't prevent a potentially dangerous run-in with the law while filming his audition. "He had a toy gun in his audition, and he was pointing it at his girlfriend, who was recording. But a neighbor saw that from a second-story window over the fence ... and the Israeli police do not take firearms being pointed at people lightly. His door got kicked down by SWAT, and had machine guns on him and his girlfriend. It could've gone very wrong," says Kripke.

THIS SPREAD: Frenchie and Kimiko (Karen Fukuhara) trying to figure it all out.

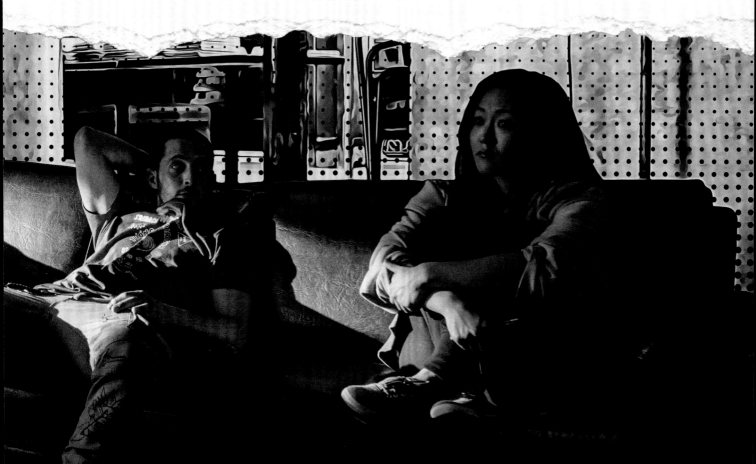

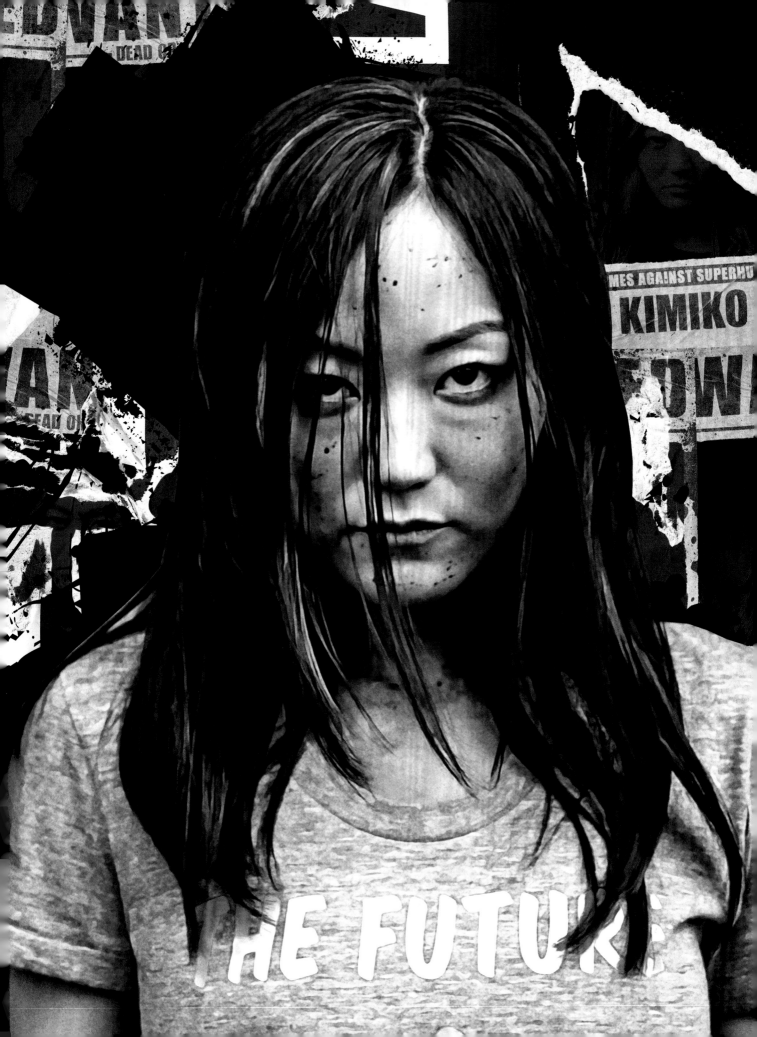

KIMIKO

"I'm not your fucking gun."

BOSSY

"The female of the species is more deadly than the male." So wrote Rudyard Kipling, somehow, without having met Kimiko. Karen Fukuhara describes her alter ego: "She's incredibly strong—strong as hell—and she's vicious." These are perhaps not surprising traits for someone kidnapped as a child and experimented on with Compound V. Coupled with being the only Supe member of the Boys, they initially complicate her ability to fit in.

"In Season One, she was just very much thinking about survival. She was more of a creature than a human being," says Fukuhara, but points out that Kimiko's resilience is extraordinary as well—and not just her ability to bounce back from seemingly mortal wounds. "She's time and time again put into situations that are not ideal. She really starts from the bottom, especially in Season One, but she keeps going. She's representative of someone who will keep standing up to the greater evil," she says.

When the Boys find her in a cell, she is certainly at a low point, and her wardrobe at the time reflects that. "We were able to do something that was really quite fun, and create this put-upon look, something her captors would've put her in. The concept came out

Feral pixie dreamgirl

LEFT: Kimiko may be quiet, but she's always listening.

of, 'What would a man think that a girl that age would like to wear?'" explains costume designer Schure. The result was a t-shirt emblazoned with a unicorn declaring "Nothing is impossible," along with a chipper-but-filthy pair of pajama bottoms. "It was a distillation on a distillation, but it ended up being a little bit humorous and a little bit sad, a very poignant kind of an outfit. It really gave you an insight into her psyche and the darkness and mystery about her," she says.

Part of that mystery also comes from the fact that she's mute, but Fukuhara doesn't think that should define Kimiko. "There is so much more to her than being a silent character," she says. "Even though she may not speak out loud, she is able to speak her words. I want to point out that signing is a language, even if it's not the mainstream mode of communication. So I did have lines and I did have things to say."

"That was a really fucking hard audition," recalls Kripke. "Her audition scene was the one where she's chained up, with Frenchie there, and she's trying to communicate that she wants him to let her loose. She had to deliver all that with zero dialogue. Her ability to nail that, right from the beginning—it was honestly one of the most exciting auditions that I'd ever seen. To have someone who isn't allowed to speak, and they come in and tell you everything they're feeling, is just a remarkable performance. I distinctly remember when she first came in, I was like, 'Oh my God! That's amazing!'"

The challenge of communicating through signs was something Fukuhara overcame with the help of sign language coach Amanda Richer, who had to develop a custom system just for Kimiko. "This was the first time I created a language. Before this, I was Sally Hawkins' ASL coach for *The Shape of Water*," says Richer. "To create some of the signs, I watched videos of different sign languages from around the world, and I also watched baseball hand signals... You will see some ASL signs, but it's never true to the word with Kimiko. What is the meaning behind that word? Is there a picture behind it? Like 'boy' was like throwing a baseball. Or, 'Japan' was opening up a passport and (mimes a stamping motion in the air) for the flag of Japan. We have a total of 227 words right now. That's insane!"

Richer can attest that, "Karen is a fast learner. I'll show her each sign, and she draws how her hands should be in her script. She learns through repetition, and we have a lot of rehearsals. After a couple of days we're in the flow. Karen really loves the sign for 'asshole' (mimes flipping the bird and flicking a lighter on underneath)." Although Capone is nowhere near an expert in Kimiko Sign Language (KSL), Frenchie did learn the sign for "*mon coeur.*"

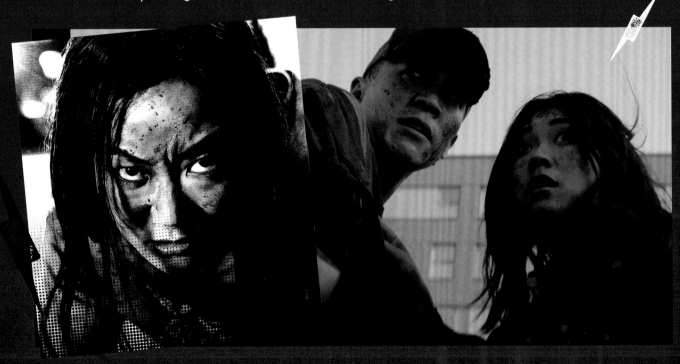

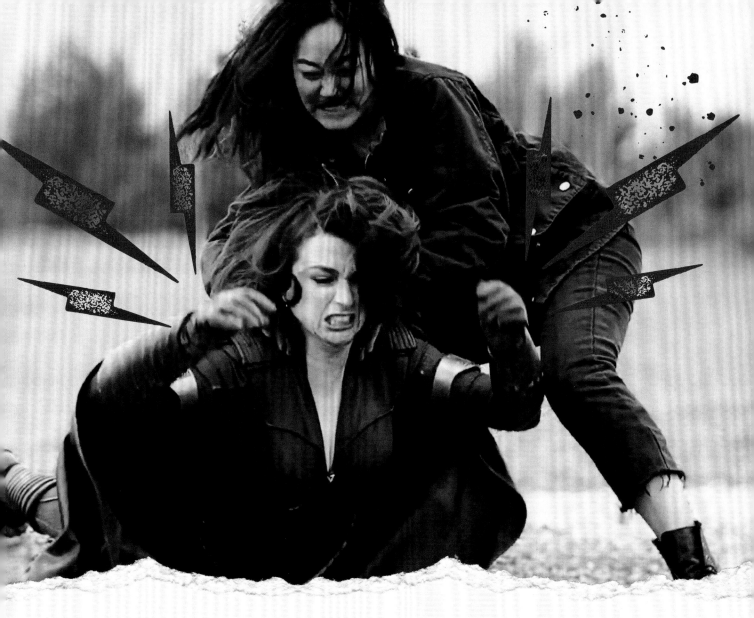

ABOVE: Kimiko getting some payback on Stormfront for Kenji's death.

Fukuhara describes Kimiko's relationship with Frenchie as powerful but hard to define. "We're excited to see where their journey goes, but since we don't know for sure right now, let's just call it 'Twin Flame'. And that means two souls that were divided into two bodies, two people, and so there's almost this stronger than soul-mate connection," she says. "To be honest, I'm not sure if love and romanticism is at the forefront of her mind right now, but she's headed in a positive direction with Frenchie. Personally, as Karen,

I love Frenchie. So I hope something happens, but we'll see."

It's Kimiko's tight bond with Frenchie that helps her find her feet in the group, but her brief, bittersweet reunion with her brother, Kenji, sets her on a path of revenge and redemption. "Her arc in Season Two is to become more humanized, and a huge part of that was reuniting with her younger brother. In her formative years growing up, they only had each other to experience this camp with. Reuniting was a remarkable

moment for her, but losing him was an even bigger moment, because she feels guilty for leaving him. She feels like she caused his death, in a way," Fukuhara explains.

"I don't think anyone would be able to replace Kenji, but I think the Boys—through Frenchie and Hughie, and even Mother's Milk, who says, 'Kimiko is a part of the team,'—that allows her feel that she does have a home within this group. She has a place. At the end of Season Two, we really see that click together," she says.

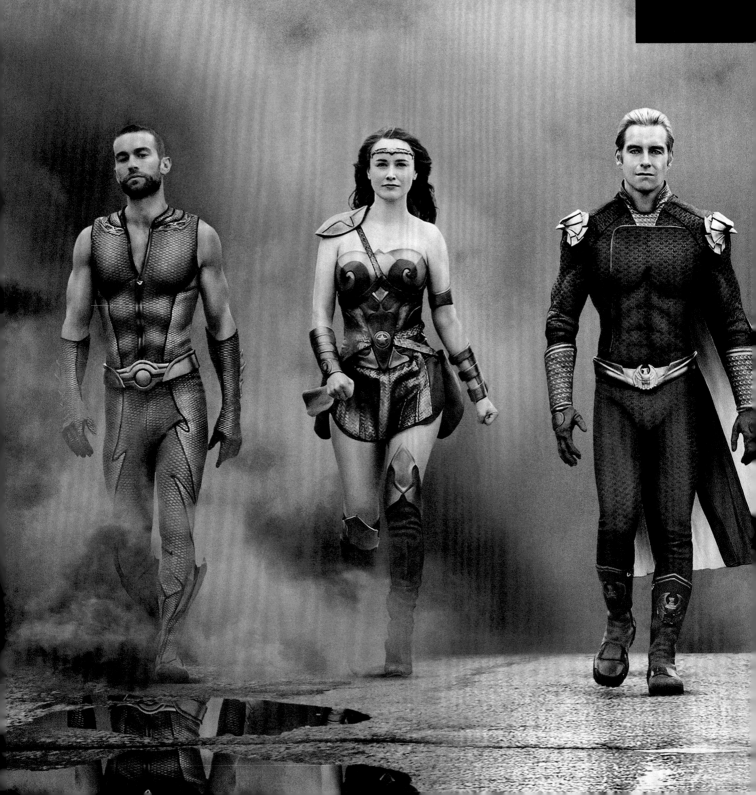

THE
SUPES

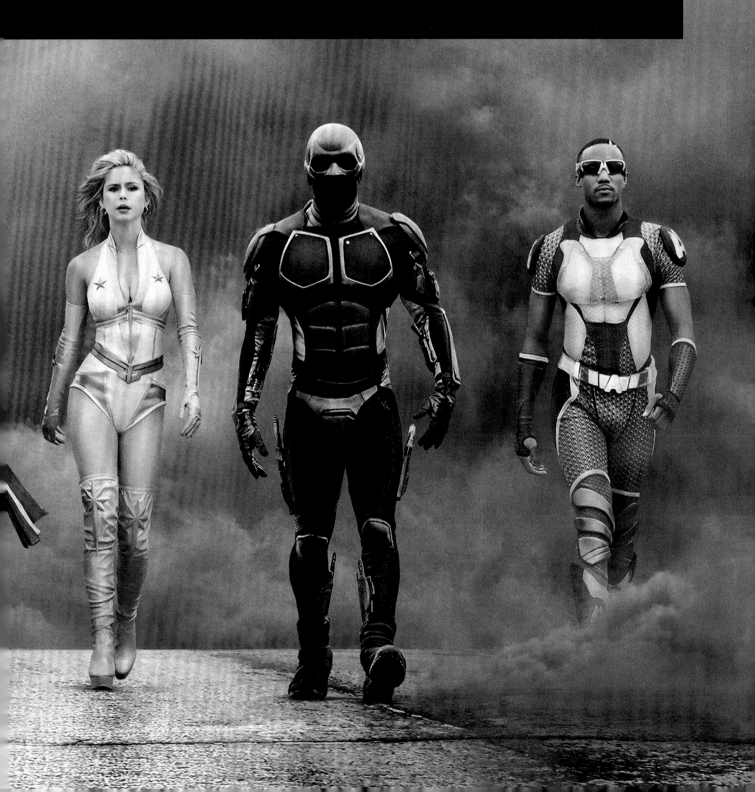

"As a comic book nerd, the Seven is the funniest thing in the world, 'cause they took archetypal characters, kinda mushed a few of them together—every comic nerd knows who they're supposed to represent—and they just fuck with them so hard, and make them do terrible, terrible things."

EVAN GOLDBERG

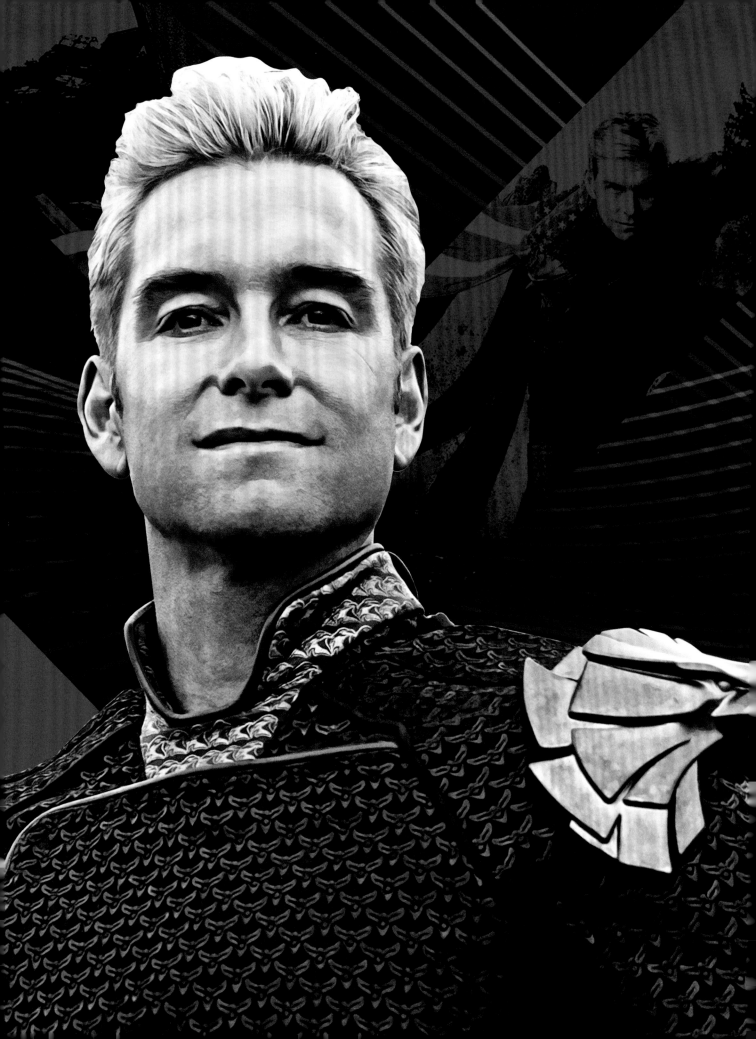

HOMELANDER

"I will laser every fucking one of you!"

The leader of the Seven—the *crème de la crème* of the Vought superhero teams—is Homelander. "I'm the apex of the pyramid, and I see them as my little babies, where if they step out of line, they get brought back into line," says Antony Starr, the man in the red, white, and blue suit. "Every time I say 'I,' by the way, I mean Homelander. I'm not crazy," he clarifies.

Slipping back into third person, Starr describes his character as, "America's hero. He's Captain Good Guy. It's all promoting a very wholesome, all-American, apple-pie sort of image, but underneath it is this severely corrupted soul—a guy

that has psychopathic tendencies. It's the mask of fake bullshit, but underneath is this seething mass of turmoil and emotional extremes that are always out of balance and struggling for control—mixed with a bit of a God complex." Kripke likens the character to a constantly thwarted diva: "He's an actor that really wants to direct, and no one's taking him seriously, and he's increasingly frustrated by it." All that, combined with his ability to level a city within minutes, is a truly terrifying concept.

Naturally, that level of dysfunction makes forming healthy relationships a non-starter. Starr says, "Ultimately,

THIS PAGE:
Homelander making sure the cameras get his good side.

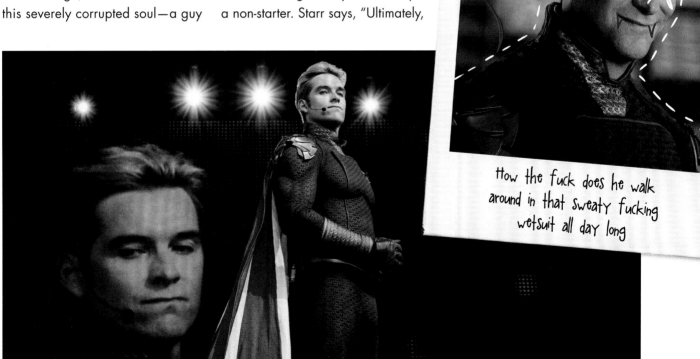

How the fuck does he walk around in that sweaty fucking wetsuit all day long

the guy is an emotional wreck. He's got a healthy disdain for humanity and people that are less than him, which is kind of everyone. I think he's forever going to be a lonely dude, who wants connection but he's not going to be able to achieve it. I think he does know how to build relationships, I just think the relationships he builds are completely one-sided. Anyone who comes into his orbit has to serve him in some way, or they become superfluous... I got to say, this is one of most fun things I've ever done."

Starr chalks Homelander's various neuroses up to his poor upbringing (in a Vought laboratory). "It's a bit like when you raise a dog," he says. "You raise it badly, and the dog's going to be a little nippy and a little bitey. But if you raise it well, it's going to be a lovely family pet. I am not a lovely family pet." Homelander, he means.

"We live in a very strange time. It's an interesting time to be alive. What's going on in America with Trump... From a character perspective, I think that's relevant with my guy, Homelander, very much," says Starr. He freely admits that he did look to POTUS #45 for some character inspiration. "He's good for some elements, but the problem with him—ironically, because he is in some way, shape, form, flesh and blood—he's so one-, maybe one-and-a-half dimensional, that he's only usable for certain things," he says.

And creating and inhabiting a more complex character is always the goal. "He's the strongest physical guy on the show, obviously, and thinks he's a god, and has got lots of issues, but also... I always took it like his kryptonite is his humanity. You need the light and the shade

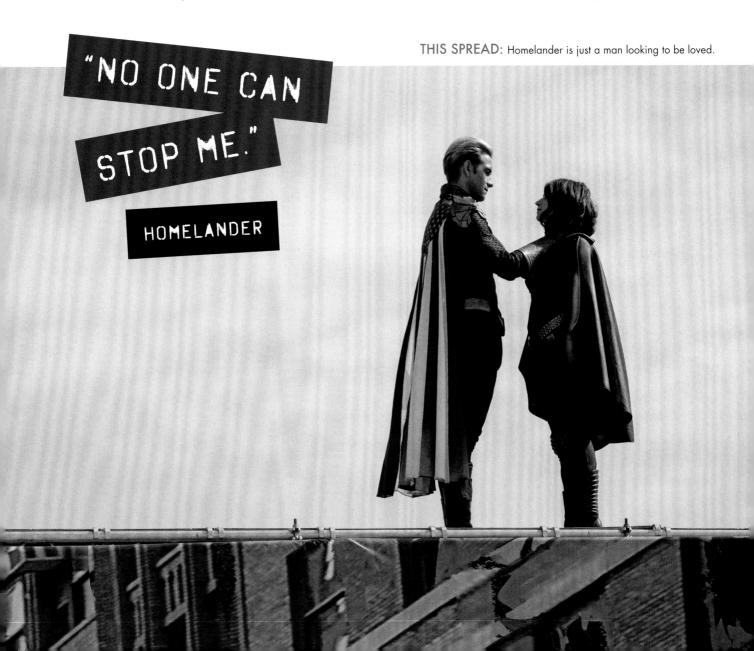

"NO ONE CAN STOP ME."

HOMELANDER

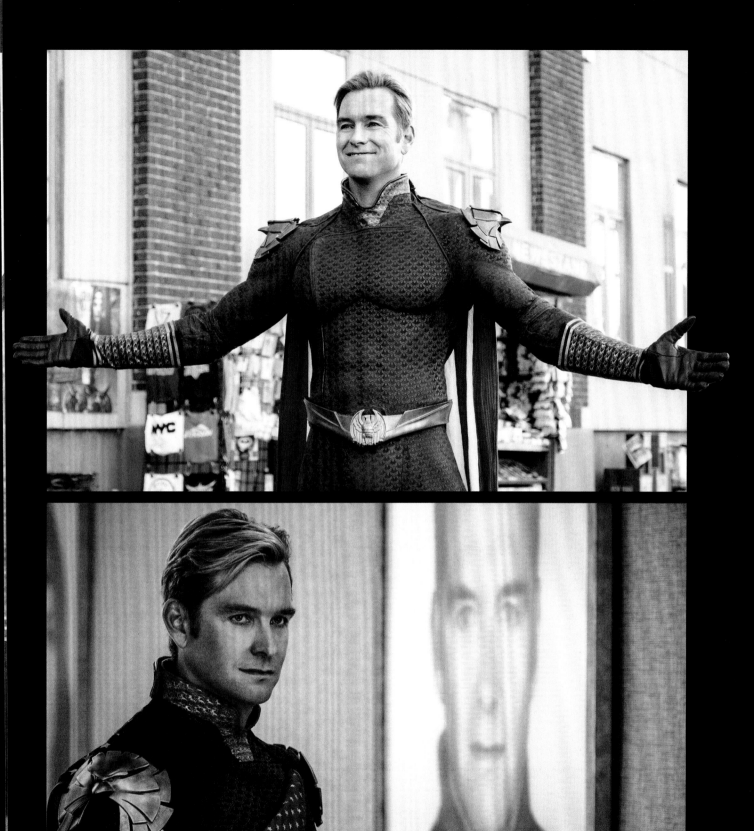

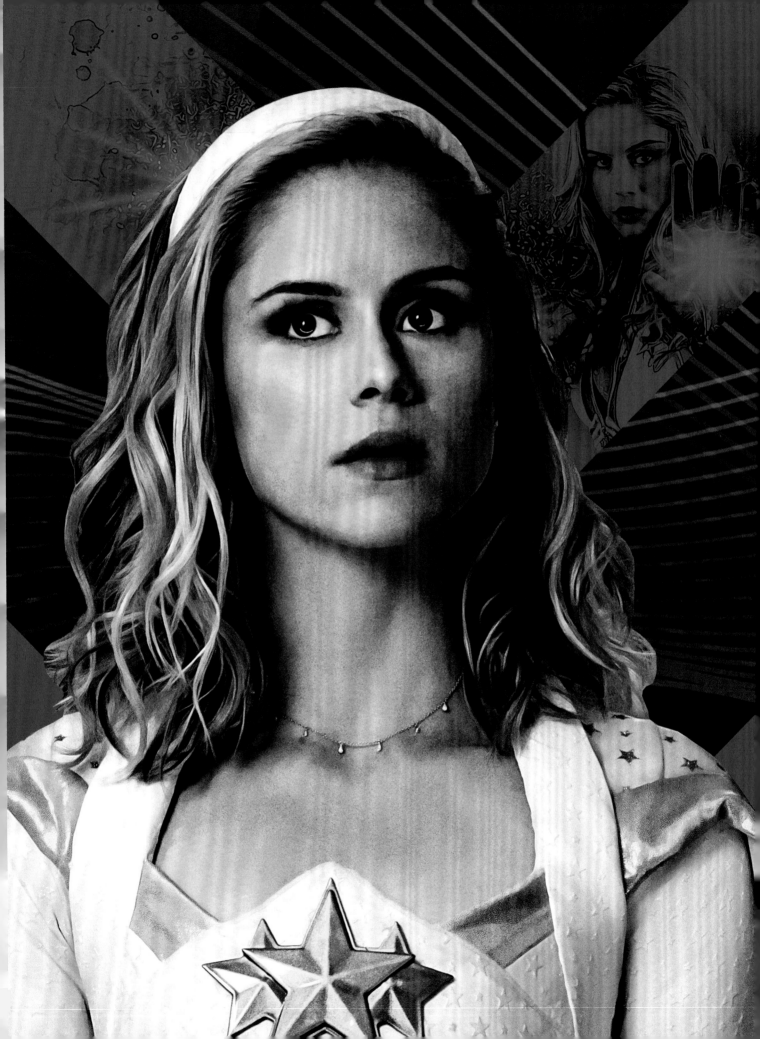

STARLIGHT/ANNIE

"I'm a fighter, I'm going to fight..."

"Starlight had a real risk of becoming a naïve, small-town, *Kimmy Schmidt* character—and I love *Kimmy Schmidt*, but it would've been wrong for this," says Kripke. "Erin (Moriarty) makes you believe that she can be earnest, but still a really formidable intelligence, which I thought was really important."

Moriarty describes her Supe self: "She comes from a very, very religious upbringing, and that manifests in a very pure earnestness. I think more than anything, she's just a good soul; well-motivated. She just wants to save the world." That breezy

outlook is challenged once she joins the Seven, however. "When she realizes that none of her heroes are who she thought they were, she has to decide whether she's going to be defeated by how corrupt this world is, or whether she's going to let it light a fire behind her ass and show up to the task," she says.

Of course, Annie is a true hero, so that fire leads her to expose the injustices she's suffered and continue to fight against Vought from the inside. "We know she's unambiguously good, but she's adapting to the world that she's in," says Moriarty. "She's developing an edge. It's nice

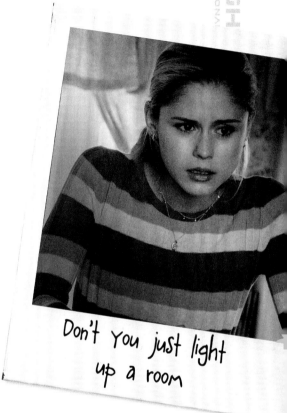

Don't you just light up a room

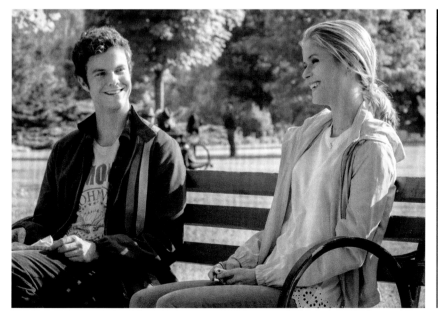

THIS PAGE: The reality of Annie vs. the image of Starlight.

to play a character that defies stereotypes, in terms of her strength and her ability to face these adversities. I'm just excited that the writers are writing moments for her where I feel real satisfied for her. We play up the human side of her, she's super flawed. She's got rough edges that are getting increasingly rougher, but I love that."

One place where she can reveal her softer side is with Hughie—when the supe/normal human power dynamic doesn't get in the way. "I love Annie's romance with Hughie, because [they] are kind of the anchors of the show in

terms of being grounded," says Moriarty. "They are honest, good human beings in a world that is really dark. That, to me, is the one thing that they connect the most about. Given the complicated circumstances of both of their lives, it's this weird, contradictory thing where they're exactly what they need for each other."

No place is the dichotomy of the naïve and rough Annie clearer than in Starlight's two supersuits. "We wanted to create a costume—what we refer to as Starlight 1.0—that really spoke to her roots," explains Shannon. "She only had a certain

amount of elements that were sculpted, only one of the fabrics to be super elevated. We spent all of our budget on this one fabric, then we went to Joann for others. We went to a dressmaker that makes prom dresses to help us build it, so there's a bit of an innocence to that suit that is by design, specifically. It's important that you really believe that she's this small-town hero and her heart is in the right place."

That innocence is definitely lost when she puts on the suit Vought dreams up for her. "Starlight 2.0 is basically an elevated bathing suit," says Shannon. "Probably of

BELOW: Fighting the system from the inside.

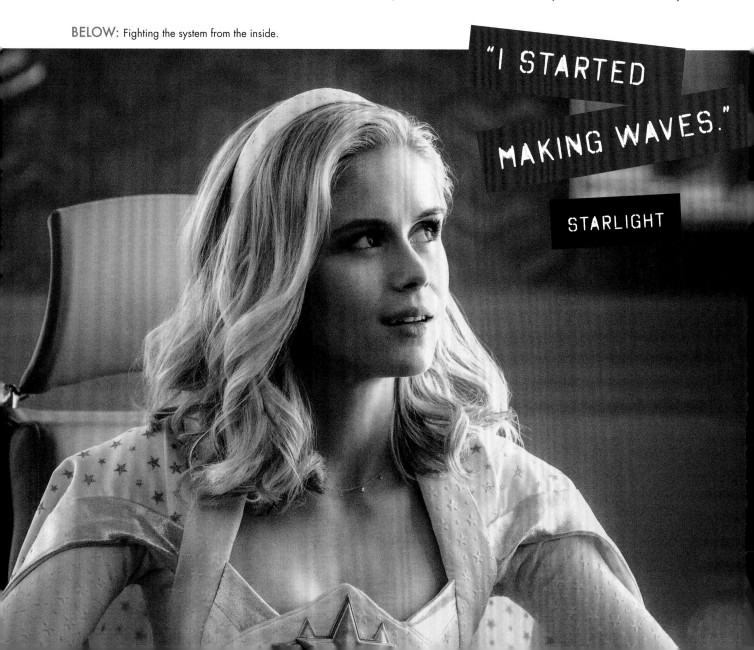

"I STARTED MAKING WAVES."

STARLIGHT

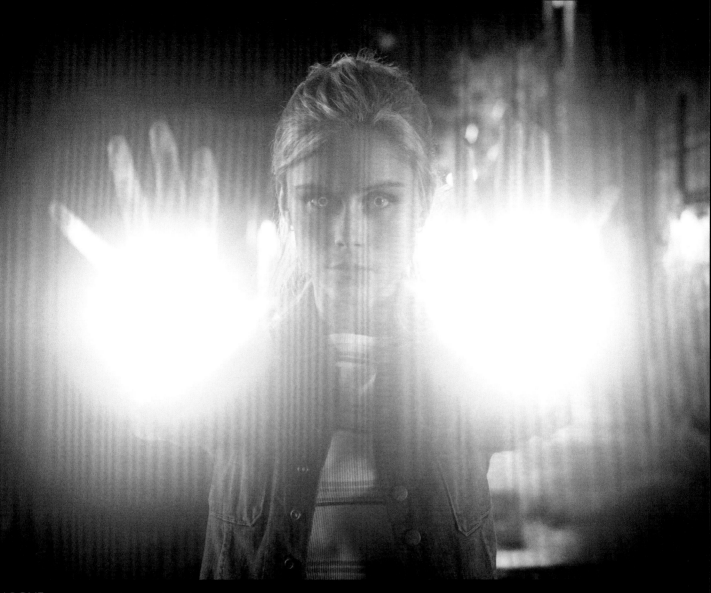

ABOVE: In or out of uniform, Starlight shines.

all of the suits that we've designed for *The Boys*, that might have been the most challenging, because we had the least amount of material to work with. It's hard to take a bathing suit and elevate it enough that it feels like it could be a supersuit. It's this great, classic moment where Starlight is forced to don this suit. But then she's smart enough to harness the power of wearing that suit to effect positive change. Interestingly, Erin Moriarty, when she first started this journey, she was a little trepidatious about having to don 2.0. But she ended up being like, 'I love this! It's so comfortable! I get to wear a bathing suit to work every day.'"

Speaking of comfort, Annie is one of the only Supes who regularly gets to wear street clothes. "I love that, because there's a component to Annie and Hughie that's very grounded, and the ability to throw on a pair of jeans and a t-shirt every now and then and return back to Annie has kept me feeling human throughout all of this," says Moriarty. "It's kind of like a childhood dream to be able to play a superhero half the time, but then there's part of me that also very much wants to make sure that she's seen as a human being." Given the overwhelmingly positive fan reaction, her humanity is shining through. "I'm lucky, because I'm one of the few people on the show who gets to play a character who's not a cunt, so people have responded very warmly to me," she says.

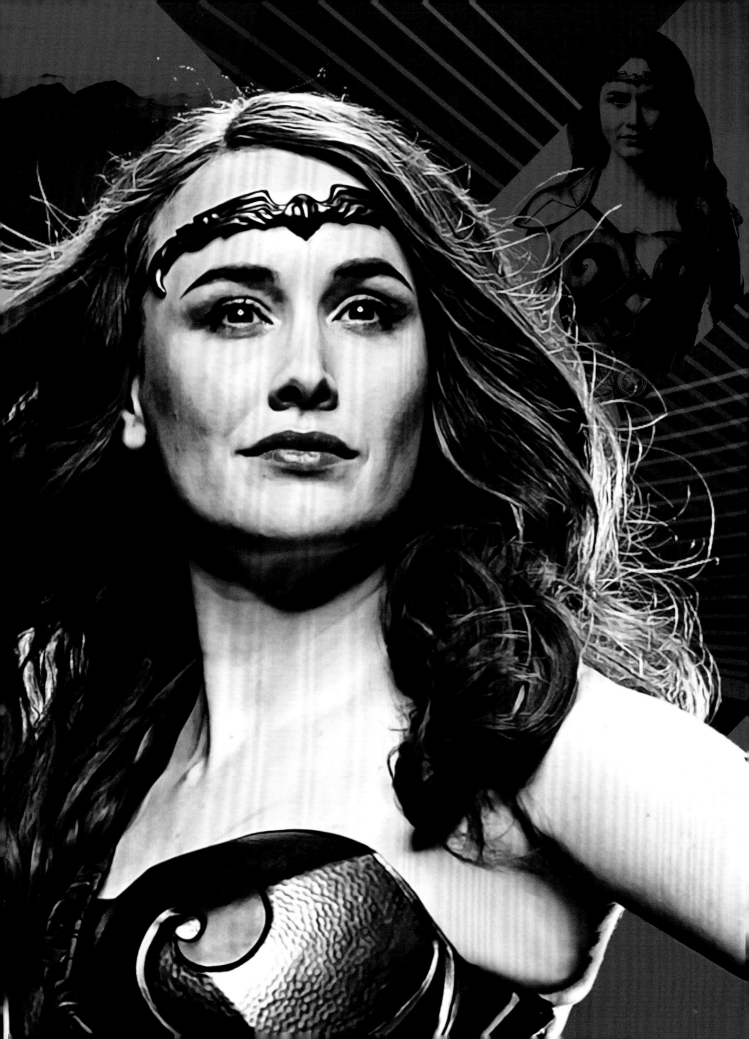

QUEEN MAEVE

"I started giving pieces of myself away... I gave away everything."

When we first encounter Queen Maeve, she stops a stolen armored car dead in its tracks and makes short work of the hijackers inside: heroic. When Annie meets her soon after in the ladies' room in Vought Tower, a better description would be: jaded. But Dominique McElligott reminds us that Maeve wasn't always that way. "When she comes into the Seven, she's idealistic and quite passionate, and really committed to helping people," she says. "But eventually her spirit gets broken and she becomes an alcoholic. She becomes very traumatized by the events and the behaviors of the other superheroes,

their amoral ways and behaviors towards civilians. There's a persona there that idolizes superheroes and the organization, but the underbelly is a very different, dark reality. Nothing is as it seems."

But having Starlight on the team reminds Maeve why she got into the superhero biz in the first place. "That's the common thread between Starlight and Maeve's characters, because they really are the only superheroes that have a conscience. You can start to see, especially in Maeve towards the end of Season One, that she has a soul," says McElligott. Moriarty notes that, "Maeve steps forward

THIS PAGE: Queen Maeve (Dominique McElligott) puts on a brave face.

NEXT SPREAD: Maeve ponders the choices she's made over the years.

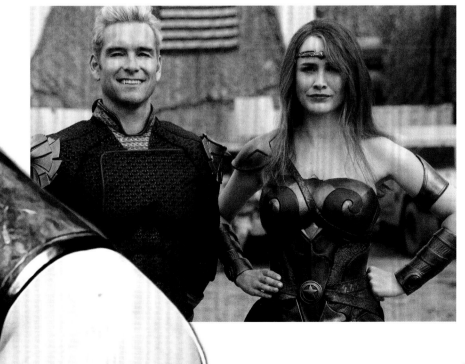

and warns Starlight about the path that she could be pursuing, and the choices she has. At the end of the day, they are the females of the Seven, and they are allies. You have a lot of sympathy for Maeve, because clearly she has a lot of self-awareness to realize that perhaps she didn't take the road that in an ideal world she would have." That alliance leads directly to Maeve openly helping the Boys at the end of Season Two and into Season Three.

"She was on *House of Cards* at the time, and *The Last Tycoon*, so there was a lot of film on her," says Kripke about casting McElligott as the warrior queen. "She just had

the elegance and the strength I needed that character to have." Good traits to have when your sociopathic, superhuman ex outs you on national TV.

"Queen Maeve was meant to be evocative of a strong, female superhero that we've all grown up being inspired by, especially all of us gals," says Shannon, "so immediately it felt right for her to be in an armored bodice. The bodice was done by an amazing sculptor—Seiko is her name, at CCE—following the concept art that Gina Flanagan and I worked up. For her armor, instead of sculpting it in something that

was super-pliable and light like foam latex, we molded it out of a semi-flexible urethane. It appears to be metallic, however she can still move in it and do all of her ass-kickery. She was a little less armored and battle-ready in the books, but it's always important to me that I infuse enough DNA from the source materials that the fans feel like an homage has been paid. We draw in little influences like the diadem or some jewels that we turned into gauntlets. We laid in some leather, a material I don't work with often, actually. But the vibe of who she is as a character really lent itself to that."

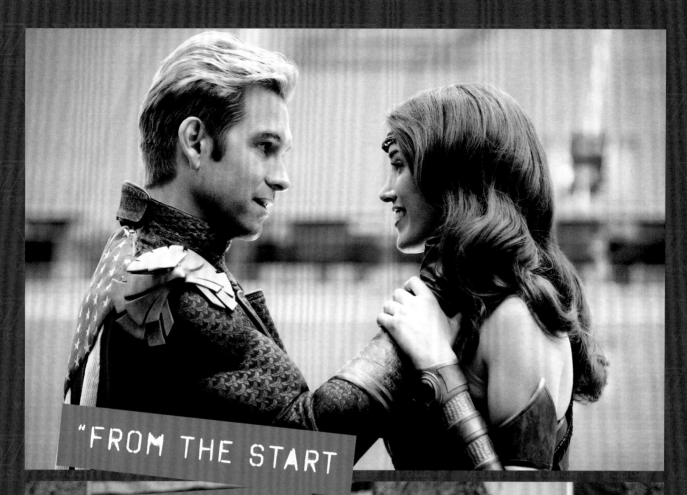

"FROM THE START

I HATED YOU."

QUEEN MAEVE

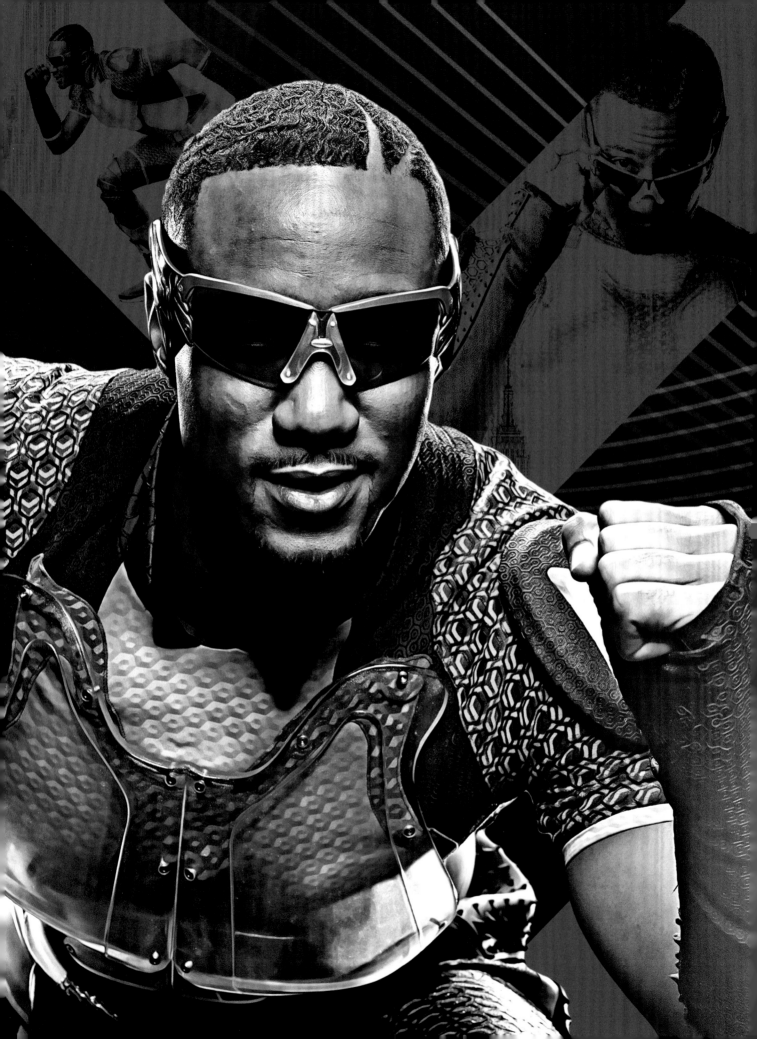

A-TRAIN

"Nobody wants the second fastest man."

The problem with being the Fastest Man in the World™ is that there's always someone on your heels, racing to rip that title out of your hands and end your career. That could lead you to abuse certain performance-enhancing drugs, like Compound V. "That amps his abilities quite a bit and is a large part of the reason why he's on top," says Jessie T. Usher, who portrays the cyan speedster. "It causes him to be addicted. It messes with his mind. It makes him think he's less than who he was before. It obscures his judgment quite a bit." Obscures, like running through a girl at the speed of sound obscures?

That job insecurity and impaired judgment are only two of the reasons A-Train joins Homelander's hare-brained scheme to use Compound V to create super terrorists, er, 'villains' around the world for the heroes to battle. "I think there's a lot of layers to that, one of them being his dependency on his lifestyle that he has within the Seven. It's also a matter of the fear he has of Homelander, the fear he has of losing his position—it's compromising his moral standards, compromising his state of mind. He's willing to do whatever it takes to stay where he is, and if that means creating super villains, then

THIS PAGE: A-Train (Jessie T. Usher) is always racing to stay on top...

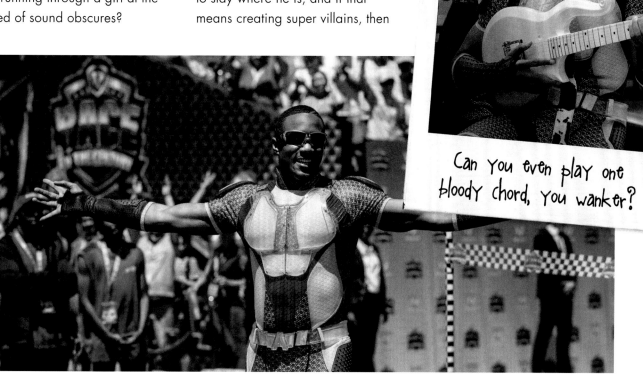

Can you even play one bloody chord, you wanker?

THIS PAGE: ...but he also takes time to chill at the club.

he'll just shrug it off and hopes everything works out well," says Usher. Homelander's hold on him even extends to A-Train having to murder his own girlfriend, Popclaw, when she messes up and exposes their operation.

"Him being a superhero of color is something that absolutely would be in the back of his mind," Usher adds. "If he's not the fastest, if he's not polite, if he's not respectable, it could just be taken from him. And what you'll learn, as you dig deeper into his past, is that he started from nothing and he always feels that he's this close to being

back there. It's kind of sad, but at the same time you just wish that he could open his eyes and see that there's another way." Still, Usher is blunt in acknowledging that his character won't make any progress until he stops blaming others for his actions. "He's a tattletale, finger-pointing pussy. Like, why can't you take some responsibility, man! He's like, 'I did it, but you forced my arm!' He sucks," says Usher.

"Jessie actually read for The Deep," says Kripke. "Then we brought him back to read for A-Train. He's an excellent actor. He's naturally very good at the

cockiness, which is what A-Train is on the outside, but vulnerable and complicated on the inside, addicted to steroids and white-knuckling his place on the perch. He nailed that cocky professional athlete in his read. He was pretty undeniable in that part."

"Jessie T. Usher exudes so much charisma that I could dress him in a sack and people would be like, 'That's fabulous!'" says Shannon. "A-Train for me was so important in terms of the science behind him. I don't want to make arbitrary design choices just because they look cool—they also have to function.

So, anything in his suit design needed to be able to withstand the friction and heat from being a speedster, but also aid him in creating less drag and being more aerodynamic. Carrie (Grace) came across some really great research on golf balls. Golf balls have their divots, because it actually makes them become more aerodynamic. It breaks up the air and makes it flow around it. So, all of the custom fabrics that we developed for A-Train's suit have this aerodynamic design in mind. We also added blades to cut friction in sculpted areas of the suit. Vought was able

to throw all their scientists at and create that transparent armor to withstand the speed with which A-Train travels. We also wanted to make sure he looked sporty: popping, bright, vibrant colors that spoke to that athletic vibe, something that could be harnessed and capitalized by Vought in terms of branding and marketing. We did take some influence from the books. We didn't want to put him in shorts, but you'll notice he has the lines of shorts."

When Stormfront begins to show her true colors, A-Train steps up to expose her, albeit for selfish

reasons. Could he be on a rocky path to redemption? Usher says, "Who better to put through the wringer than A-Train? He's put himself first in every scenario, but now he has to take a step back and be a better person. With a bad ticker up against a Neo-Nazi, he has to find some real strength. Not what he's been gravitating towards since he's been in the Seven. Now he has to finally re-ground himself and find out who he is and how he can navigate." That includes a ham-handed attempt at re-branding himself in Season Three. Stay tuned!

BELOW: It takes some heavy "training" to recover from an injury.

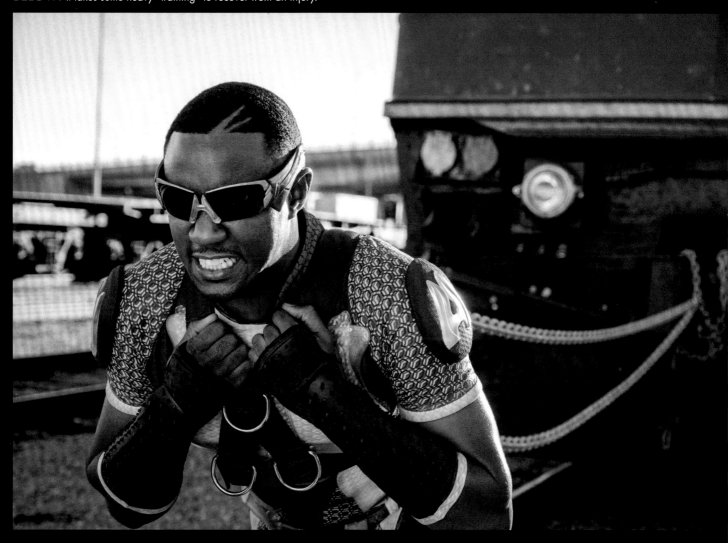

THE DEEP

"Oh, wow, what a surprise. A water crime."

Chace Crawford describes his character's superpowers thusly: "Well, he can breathe underwater. He can swim. He can swim very deep. He can talk to marine life, and flex his guns. That's about it." Compared to folks who can fly, shoot lasers, throw cars, and turn invisible, having this suite of powers would naturally feed into his inferiority complex, going all the way back to childhood. "He had these gills and he felt like a freak, and he was teased for that when he was in school. He's never quite felt really secure in who he is," says Crawford.

The way he dealt with that, and continues to deal with it, is with bravado and indignation—something his position in the Seven helps him exploit. "He puts on this ego to cover up for a deep insecurity," explains Crawford, "asserting his dominance by force over someone he can take advantage of or manipulate." Like with the sexual assault on Starlight. "He's never been told no. He almost doesn't see anything wrong with what he did in the first episode. He also feels like a victim, still," he says.

"We talked a lot about these superheroes. What is literally and figuratively the mask they wear?" says Kripke. "The Deep is

THIS PAGE: The Deep (Chace Crawford) vows revenge for Lucy the whale.

NEXT SPREAD: The Deep: 1) discussing philosophy with Eagle the Archer; 2) returning Translucent's remains; 3) shaving his head during his exile from the Seven; and 4) relaxing in his tighty greenies in a sunscreen ad.

GO DEEP OR GO HOME

RISING TIDE

a competent dude-bro who really hates himself and how ashamed he is of himself, that he compensates by coming up with this toxic shell. Chace is a really smart and aware guy, and he comes in and he captures the arrogant idiocy of a frat boy. Just the, 'I'm a white, entitled frat boy, and the world is gonna be mine, and I assume so.' He just nailed that in a way that's so funny and oblivious." And that's what makes watching him repeatedly getting his comeuppance such a joy, whether it's another sea creature dying horrifically because of his actions, or him getting a taste of his own medicine with a handsy date.

"Of all of the characters, The Deep is probably the largest departure from the books, because in the books he's this huge guy in a huge, old-school metal diving helmet," says Shannon. "We kept his color scheme, for the most part, and then I did incorporate those chains [from the book] as well, a loose interpretation. That's what you see around the collar of his suit in high-density screen print. What we wanted to do is have him be a bit of a sex symbol. He's the perfect character for us to put in a form-fitting wetsuit that could actually function in the water, which it does. I couldn't give him any muscles on his arms, so he had his work to do, and he did it. There's some augmentation under that suit, just to give him that classic superhero 'V' and hyper-accentuated musculature. We did some work with transparent elements, laying various fabrics into those to create his fins on his opera gloves, and you'll notice that he has webbed fingers on his gloves. There was one note I got; I actually had to dial back on 'Little Deep'. Hey, if we can pad the boobs on the girls, why not?" (FYI, she's talking about his sea cucumber, folks!)

Again, with form following function, the costume greatly aided his portrayal. "He's one of those guys that once he puts the suit on, he totally becomes the character, and adopts that vacant stare,"

says Shannon. Crawford can't help but agree. "It's comfortable and it definitely does help you get into character when you put it on. Like a mask, almost. You do have an air of that false confidence that The Deep needs to have," he says.

Shannon also notes that Crawford was game to try whatever costume designs they might come up with. "There's this wonderful moment that we had in our fitting with Chace," recounts Shannon. "We put Chace in his little zip-up top, which was connected to these sort of 'tighty greenies.' And he was like, 'Okay, cool. This is great.' And we were like, 'Oh no, this isn't your suit! You get pants. Don't worry.' It was so cute of him that he was just ready to roll with the undies. Which we did later use in some advertisements."

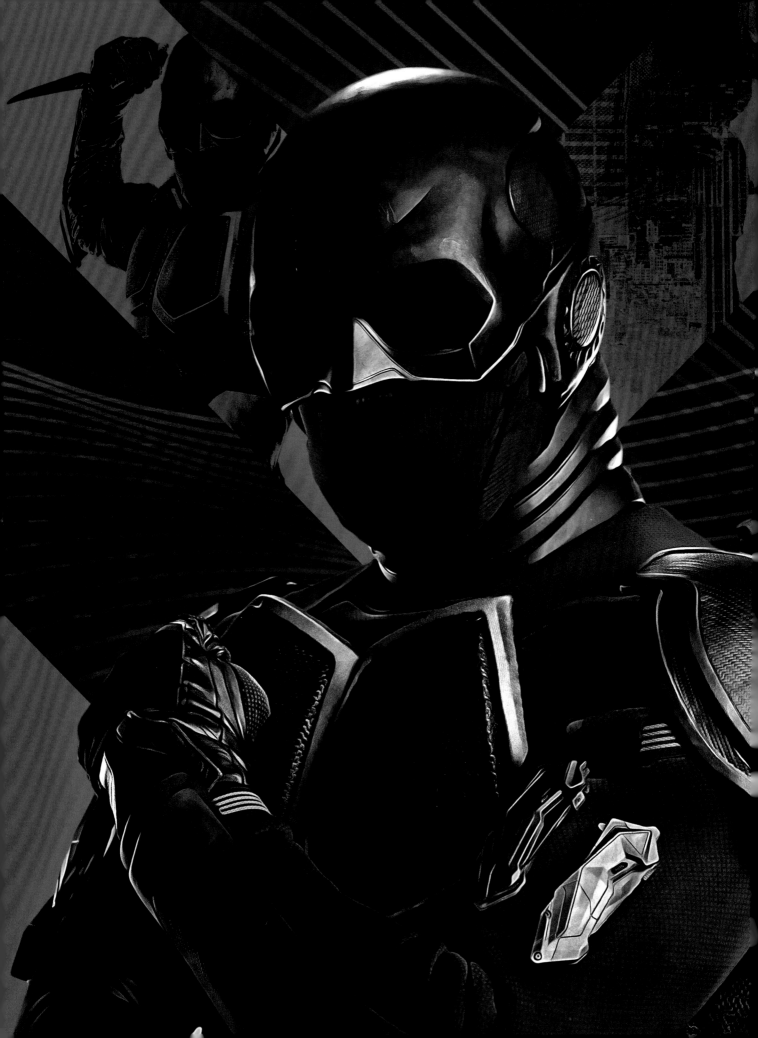

BLACK NOIR

" ... "

"One of the most interesting things to me about Black Noir is his duality," says Nathan Mitchell, who portrays the silent assassin. "You see this menacing, badass, terrifying figure who could cut you up in a second, but there's also this human dimension to him, you know? Like, he's fighting on the battlefield, he's cutting people up, but then he's at a party and he can't get an hors d'oeuvre or he's sipping from a straw, not knowing how to talk to people. He's so smooth and efficient when he's fighting, but then he's kind of like this lovable, funny, adorable, awkward figure in everyday life." "Lovable" and "adorable" might be pushing it, but we see where Mitchell's coming from. (Unlike Black Noir. Because he's quiet and stealthy, get it?)

Not being able to speak brings its own challenges, even more than Kimiko, who at least has a face to emote through. But Mitchell points out that having to be silent brings opportunities as well. "One of my favorite quotes is: 'The funny thing about a mask is, no matter how hard you try, it's always a self-portrait.' And it's really fun to focus in on that, where a turn of the head, or a glance, or a jolt can be read in so many different ways. It's this kind of blank canvas

THIS PAGE:
Silent and deadly, Black Noir (Nathan Mitchell) is most at home in combat.

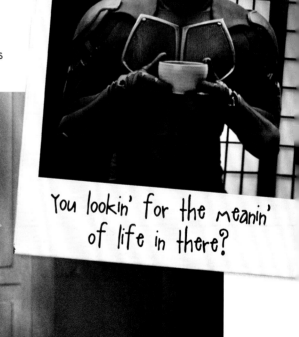

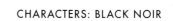

You lookin' for the meanin' of life in there?

that people can project on. So, it narrows your focus as an artist, but also offers a lot of creative freedom when you can just open up to that and play with it," Mitchell says.

"We knew we needed to put him in black, and black is really tricky. When you shoot black, the camera just kind of disappears into it and you don't see any distinction," explains Shannon. "Our first order of business was to create this cool, sleek silhouette; the second was making sure we incorporated plenty of textural changes, as well as tonal changes. His suit is comprised of several different custom fabrics that either have a texture to them or some kind of UV printing, painting. We also utilized a shiny, gun-metal gray that we did a sculptural paint effect on in areas of understructure to his suit. His muscle plates—like his abs and pecs—are actually created out of that gun-metal gray fabric with a mesh over the top of it so you can see that fabric coming through from underneath."

Finally, a deadly ninja needs his blades. "Basically, I tasked my team with figuring out the maximum number of knives that we could apply to Black Noir. It's been a while since I counted, but I know there are at least 26 knives on his body," says Shannon. And if he runs out of those, Black Noir always has a spare handy: "You have a knife at the back of the helmet, which I use to poke people's eyes out. It's very intimate and very deadly," Mitchell says.

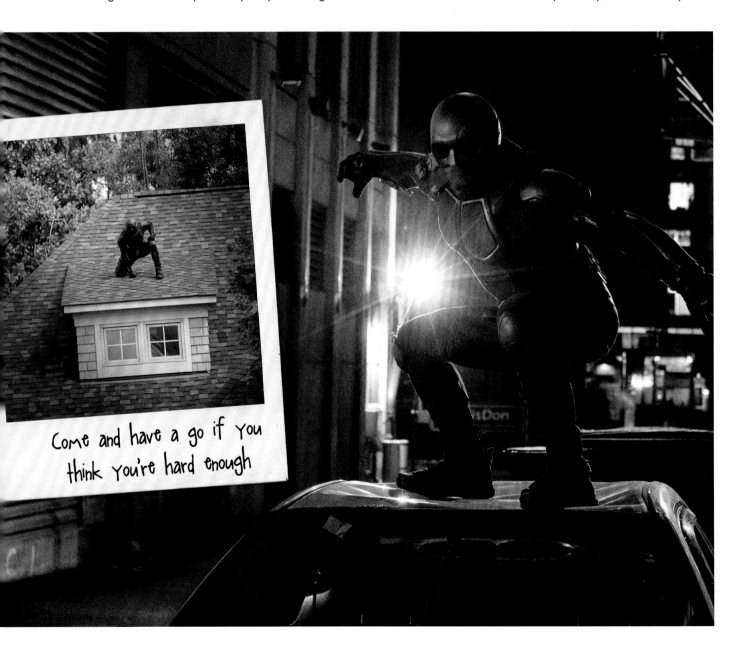

Come and have a go if you think you're hard enough

*"F***ING MORON. TRANSLUCENT DOESN'T EVEN MEAN 'INVISIBLE'. IT MEANS 'SEMI-TRANSPARENT'." BILLY BUTCHER*

TRANSLUCENT

"I see people for who they really are."

Jessie T. Usher muses on the wasted talent of his departed teammate, Translucent (played by Alex Hassell): "He abuses his powers. Naturally, somebody who can become invisible becomes a Peeping Tom. That's just what happens in his world. I guess his immediate thought was, 'Nobody can see me, I'm going to hide out in the women's bathroom.' That's just where he went with it."

Knowing that no doubt made Hughie's decision to splat him that much easier, but it was still a shock to the lad, popping his Supe-killing cherry like that. "I think if there's any regret, it's the fact that this guy has a son and a family, and people who maybe didn't know quite how creepy he actually is. If there's any regret in terms of murdering Translucent, I think it's that," says Quaid.

Well well well. If it ain't the invisible cunt.

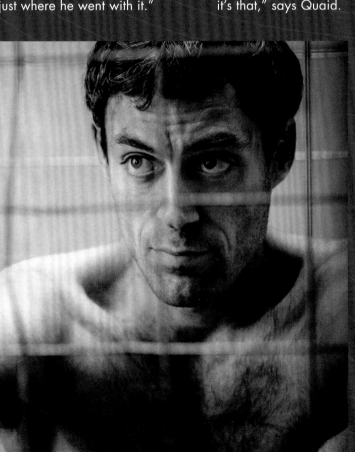

YOU CAN'T KILL
WHAT YOU CAN'T SEE

TRANSLUCENT:
INVISIBLE FORCE 2

THIS PAGE: Translucent (Alex Hassell) no doubt thinking about better days when he was a big draw in the VCU.

STORMFRONT

"Fuck this world for confusing nice with good."

Aya Cash plays the white supremacist social-media maven with the scary electrical powers, Stormfront. "I had a moment of, 'They'll never let me do this.' And then, 'How cool would it be if I got to do this?' simply because I was raised Jewish, and to play a Nazi feels like something out of my wheelhouse, and it feels exciting to take on new challenges. I also knew there would probably be some backlash. First of all, Stormfront in the comics is a man, a very large man. So people will have a reaction to that. People will probably have a reaction to the fact that I'm Jewish. But it's not my job to monitor people's reactions; it's my job to do the best I can to bring a character to life. And it's Eric Kripke's job to punish her deeply."

Does Kripke have any thoughts on negative feedback from bigots? "They would tweet at me like, 'You guys are just a bunch of SJWs, and you're so fucking woke, and fuck you, I'm out!' And I'm like, 'Byeeee! Eat a bag of dicks and fuck off to the sun!'" Geez, Eric. Open up and tell us how you really feel, okay?

Of course, when she sweeps into the Seven, Stormfront just seems like a fresh, spunky ball of badass girl power. "She's a lot of fun.

THIS PAGE: Stormfront (Aya Cash) sees Homelander as the Aryan super— uh, *übermensch* she's been looking for.

NEXT SPREAD: A battered Stormfront confronts Becca and it doesn't go well.

Can I get a side order of sauerkraut with that?

She's not afraid of anybody, and willing to stand up for herself. She talks about the greatest superhero of all time is Pippi Longstocking. I think that says a lot about her. I think it's refreshing to see someone who's not going to take any shit from anyone. Until she turns," says Cash.

"I feel the Seven are like old-school movie stars," she says, "and Stormfront is the new TikTok star with millions of fans that everyone else doesn't quite understand the value of yet. She's able to use social media in a way that none of the others of the Seven understand or know how to. She brings kind of a tech-savvy and a new generation. She understands the power of harnessing a smaller but passionate group of people in a way that a lot of people are doing now. She thinks that's the way of the future for the Supes."

Because of the time needed to build her supersuit, Stormfront had to be cast long before they had a full grasp on her character or story. "So, Rebecca Sonnenshine wrote these scenes that were just these raw stabs at what we thought Stormfront might be," says Kripke. "Aya showed up in our very first session, and nailed it. Her vibe is ironic and sardonic, but so smart. And you got the sense that Stormfront wasn't just a rabble rouser. She's like a straight-up genius. That was what won me over. I'm a fan of hers from *You're the Worst*, and I knew that she could handle comedy and drama. She just walked out, and I'm like, 'It should be her. Just give it to her.' At that point, maybe because we already had a successful season under our belt, Sony and Prime Video did not say, 'Okay, but you still have to see every other human being on the planet.' I think they were fans of Aya, too. It got done shockingly easy."

Shannon delves into the thought

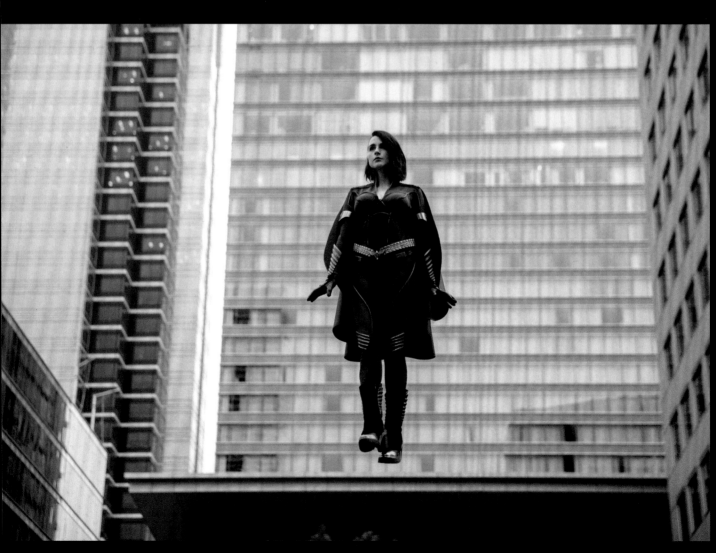

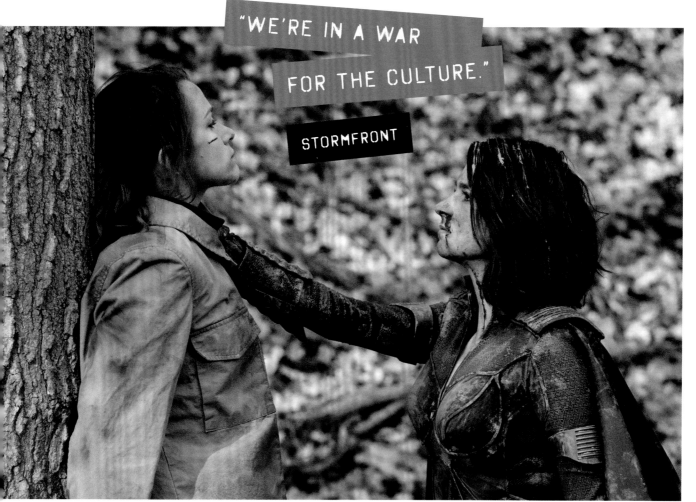

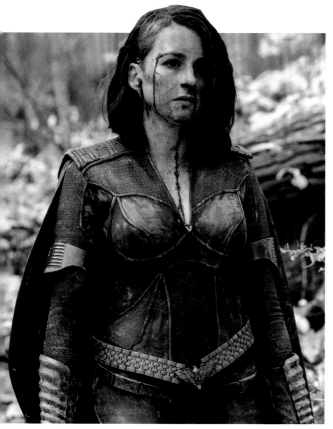

process behind Stormfront's supersuit: "What we wanted to harness was that iconic vision of a superhero that we're all familiar with. What we landed on was a catsuit, which is something you see on a lot of female superhero characters in other comic book universes, but done our way. Like Homelander, we laid into iconography like eagles that were specific to fascist regimes, because there are nuances and subtle differences. We created a custom fabric for her suit, which was gray, not black, and then we painted into it with black after doing our high-density screen printing in burgundy. If you look at it, it's kind of deconstructed, iconic fascist... If you look at her fabric and look at her belt buckle—that eagle is not a very friendly one. It was important to Kripke that we show a history and an age. We intrinsically added in some weathering, battle scarring, and then we enhanced that as well with our paint techniques. And the American flag in the way that we presented it has a hint of distress, as in, 'I'm not a good guy, folks.'"

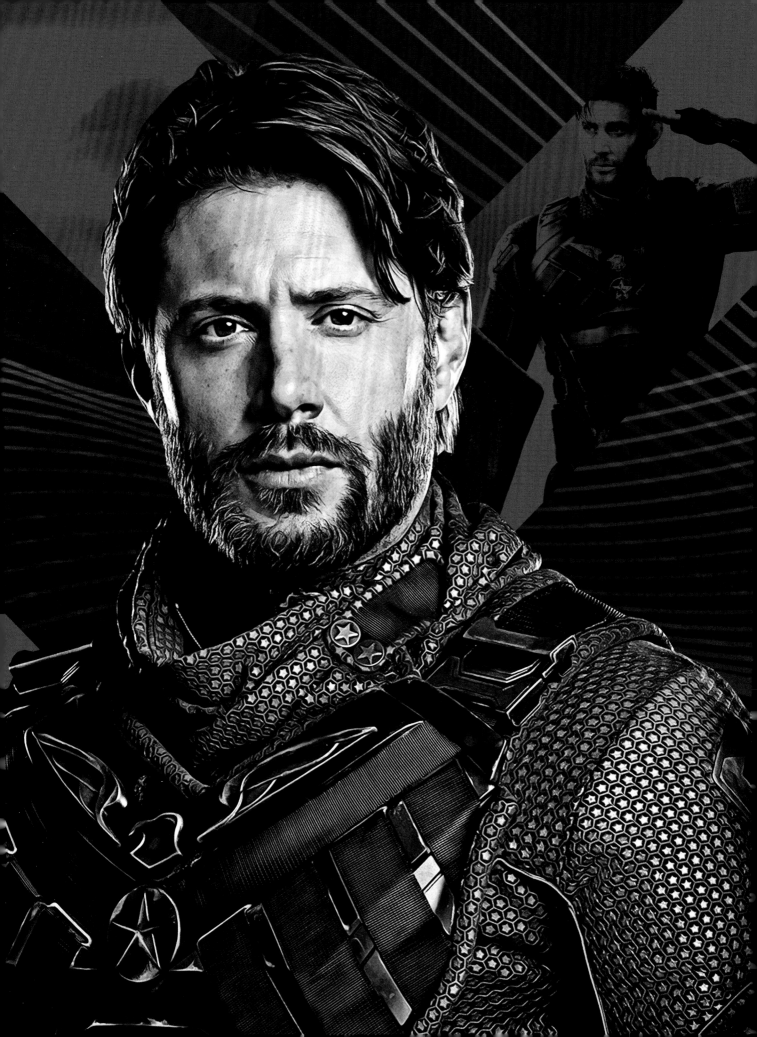

SOLDIER BOY

"No one's the new me, pal."

"In politics today, there's a lot of talk of taking America and making it great, one more time," says Kripke. "My point was always, 'This notion that there was this idyllic earlier time is mythology. Make America great again for who, exactly?' Because, unless you're part of a very specific demo of white Christian, it's not as idyllic as people made it out to be."

Enter Soldier Boy, leader of the now-defunct Vought super group Payback... "Okay, there's this guy who's a World War II hero, and the epitome of what a soldier would be, and that's his public-facing persona. But this guy is a real product of his era, in that he's very racist and misogynist and entitled, and basically failed his way upwards. This very American brand of toxic masculinity that poisoned a couple of generations of men, like how they have to act and be tough. And I think a lot of the reason we are where we are is because of that notion of needing to be manly, and not being able to talk about your feelings. It's a lot of old shit that needs to be looked at for the country to really be able to move forward. We wanted a character that represented all of that. That's what Soldier Boy is for us," says Kripke.

THIS PAGE:
Soldier Boy (Jensen Ackles) has spent decades locked away in a Russian lab.

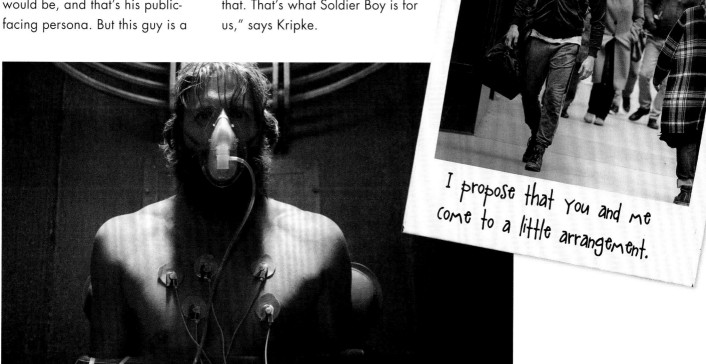

I propose that you and me come to a little arrangement.

Shannon wanted the contrast between old-school Soldier Boy and the shiny, new Seven to be undeniable in his costume. "He pre-dates the whole Vought branding and yank-fest on who's rating and Insta accounts. He's looking at these Supes now, and he's like, 'What's with these pussies?' While the others might be feigning patriotism, this motherfucker's a patriot! His classic iconography is like star repeat. He's got eagles emblazoned across his chest and on his shield," she points out.

"With this character I worked with Greg Hopwood for the concept art," says Shannon. "We immediately started a deep dive on research on old-school grit with a military vibe. We developed 1940s Soldier Boy, and also his 'classic' suit from the '80s. We created custom fabrics, but kept it believable that they could've been created from whence this suit came. Soldier Boy's not going to be a guy that's wearing tights. His pants are

a little looser, and based on a BDU pant—but obviously custom made and super tailored. Even his top is structured like a jacket, where he can zip and unzip the neckline. Every detail that we created for him is tied into that utilitarian approach to a badass super-soldier."

"Casting Jensen (Ackles) was a funny story, because he was one of the leads of my show *Supernatural*, so I've known him for a million years," recalls Kripke. "Originally, we were looking at actors that were older, more like guys in their 50s, because he was a World War II hero. The archetype was somewhere in the John Wayne world. But we weren't really finding them. Randomly, Jensen called me to discuss something else entirely. And I don't chat on the phone with Jensen that much, maybe a couple of times a year. I was telling him what I was up to, and how we were having a really hard time casting this part. And I went, 'Hey, wait a minute. Would you be

interested in this part?' And he's like, 'Send me the pages.' I sent him the pages, and five minutes later, 'I'd be super interested in this part!' Because he's younger than what we were looking for, I don't know that it would've occurred to me if he hadn't randomly picked up the phone to call that day. Definitely fate at work."

Kripke adds, "I'm always blown away at what a fine actor he is. There's really nothing he can't do: he's an incredible action hero. He's an incredible comedian. He's incredible at drama. He's the total package."

Still, joining an already established show can be daunting, according to Ackles. "It's always interesting coming into somebody else's house, and being a guest in that house, which is exactly what I am. I was a fan of the show prior to ever even thinking I'd be a part of the show. But the great thing about coming on to *The Boys* and it being Kripke, is he gave me

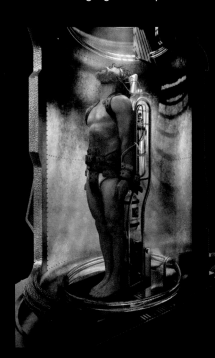

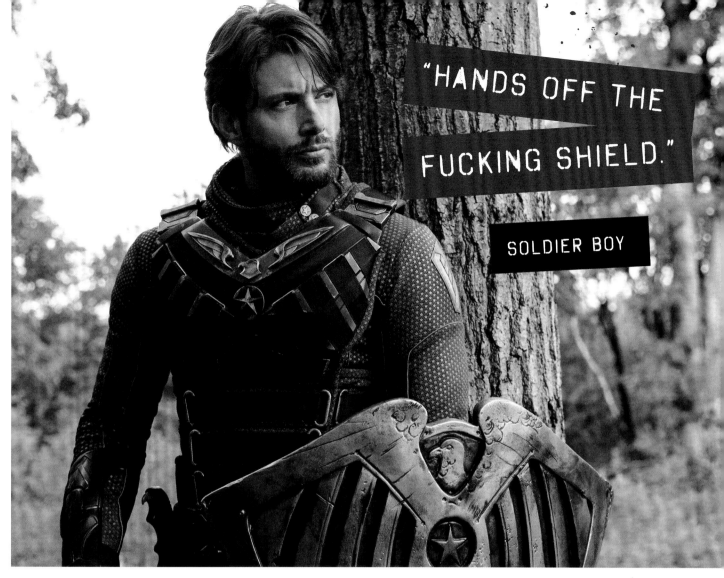

"HANDS OFF THE FUCKING SHIELD."

SOLDIER BOY

OPPOSITE: Concept art for the lab setup, along with Soldier Boy ads through the years.

kind of the vote of approval. So I knew I at least had that coming in. Everybody here was like, "Oh, well, Kripke's vouching for him so you know he comes from that world. He's probably as messed up in the head as we are. And they're right," he says.

Right from the audition, Ackles knew Soldier Boy would be a major departure from Dean Winchester, the character he'd played for fifteen seasons on *Supernatural*, but he was ready. "I was like, 'Oh yeah, this is wildly messed up—and right up my alley,'" he says. "He's the

OG, who fought in World War II, didn't really age so he became like a movie star in the 60's and 70's. And hung out with Hugh Hefner and was spending his weekends at the Playboy Mansion, and, you know, he's just a real asshole, basically. I think it was his, to use a big boy word, his cantankerousness that I kind of twinkled at. I'm like, 'Oh, that's going to be fun, just being this kind of bigoted asshole.' I thought I had a story to tell through Soldier Boy. And I think that he's going to illuminate some of those extreme human emotions that we've

certainly seen come to surface over the past 18 to 24 months, with all of the politics and the pandemic."

The role was also appealing to Ackles for the amount of action he got to perform. "I'm a sucker for stunts," he says. "Steve (Gagne), my poor stunt double. He got dressed up in that suit many days and just sat there and watched me do everything, which I felt bad for..." He adds, "I don't have any fight training outside of film fight training. I often say that if and when I do get into a bar fight, I'm going to miss the guy by like six inches. It's going to be embarrassing."

MADELYN STILLWELL

"Why have average when you can have extraordinary."

Elisabeth Shue recounts that her character's fortunes, both good and bad, were always tied to Homelander. "I'm a part of this myth-making machine that is Vought International. I did start out when I was very young, and my first superhero that I managed was Homelander," she says, "and I was very lucky. He was my ticket to the top. I take care of all of the Seven, and that's why I'm so powerful. They don't have real lives; I've helped create their lives through storytelling, through publicists, through wardrobe... I'm kind of like their mom, but Homelander and I have a little bit more of an interesting, sexual, mother, strange, Oedipal thing going on."

That complicated relationship with Homelander ultimately proves to be her undoing, but Shue couldn't have found a better partner to play it out with than Antony Starr. "He's everything you would want to work off of: he's scary, he's intense, and he's also very loving and can be very vulnerable. He has every color inside him, and it's wonderful, wonderful to play opposite him," she says, adding, "And he can kill you at any moment, and we're just having a long conversation as if it's no big deal."

"There were a number of deviations made from the original source material, but one of my favorites was the choice to make the James Stillwell character a woman," says vice president of television for Point Grey, Loreli Alanís. "And while the Madelyn Stillwell the writers' room conceived of is just as ruthless and manipulative as the male character in the comics, Eric and the writers took great care to make her leadership style and business strategy uniquely female, so it didn't feel like a gender flip just for the sake of a gender flip."

Shue sees ruthless Stillwell not as a villain, but as an ambitious believer in superheroes' ability to get things done and improve the company's bottom line. But don't look at her as a stereotype of the cold career woman. "I was really excited that Eric Kripke didn't see her as one-dimensional in any way," she says. "He loved the idea of her using her sex appeal when she needed to, that she could have a playful side, that she could be persuasive in many different ways, and that her warmth could also be a way to get what she wants."

STAN EDGAR

"You're under a misconception that we are a superhero company."

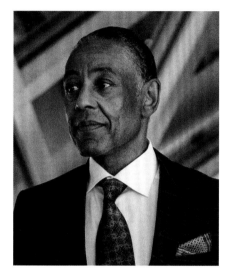

"Homelander might be the savior for humanity," says Giancarlo Esposito, "but behind him is Vought CEO Stan Edgar, manipulating what he thinks and also directing him to do certain things that he may not even realize he's doing for the company. Vought is a company that has its hand in every pie, more than you will ever begin to realize."

But what kind of person is Stan Edgar? "Stan is a very particular and tricky guy," says Esposito. "He's a businessman, and he knows what he wants.

He is fearless, and he can be terrifying. The guy doesn't get rocked by anything. He's efficient in his thinking, he's efficient in his planning, and he's efficient in the way he delivers his message. To say less sometimes is more," he says.

ASHLEY BARRETT

"Tindered my way through Barcelona."

Ashley is very much a company gal, always protecting the brand, without worrying too much about exploitation. "She's very much looking at optics all the time," says Colby Minifie, who plays Ashley. "She has that line in the Blindspot scene where she's like, 'We have a differently abled member of the Seven. We're going to poll very well with Millennials.' She's constantly thinking about that kind of thing."

"Ashley was originally only intended to be in the pilot episode," says co-executive producer Michaela Starr. "We needed someone to guide Starlight into this new world of celebrity/overnight-Supe-sensation. Eric came up with the idea to present Starlight at the annual Vought shareholders meeting (a send-up of the annual network 'upfronts', where TV shows are pitched to advertisers). "She'd have a publicist meet her on the red carpet, right? That was originally Ashely's only scene. But Colby Minifie was so great in the role, we had to keep writing for her. And the next thing you know, Ashley's a series regular. I love her ruthless, yet vulnerable approach to the character. She has morals, but is not above compromising them, if the pros outweigh the cons."

Although recently fired, she was soon rehired and promoted to Senior Vice President of Hero Management following the death of Madelyn Stillwell. It has not been all she hoped. Instead of newfound power, she is now Homelander's whipping girl, and stress has aggravated her compulsive hair pulling. "As soon as she has a little idea with Homelander, he shuts her down. Now she's afraid for her life. I think she's going through a lot. She was excited, and now she's absolutely crushed," says Minifie. And at this rate, she'll soon be absolutely bald.

VICTORIA NEUMAN

"Oh, come on. You're not the first person to call me a cunt."

The popular young congresswoman from New York is not what she seems. Is she out to get Vought, or just to create mass panic with heads exploding all over the place? Whatever her ultimate goal, she's laser-focused on getting it done. "At the core of Neuman, she sees an imbalance of power, basically," says Claudia Doumit. "She sees something that's wrong, and, in a nutshell, she wants to correct that and make it right. It's not me at all, but I'm glad that I get to play this character. I'm a genius!"

And if that means working with the Boys, so be it. "She operates on a cost/benefit analysis. So, if the benefit outweighs the cost, then why are we still talking about it? If it gets the job done, it gets the job done. She sees that it's hard to win a fight like that completely clean," Doumit says.

In Season Three, "...it was exciting to evolve Victoria Neuman's role from an anti-Supe-stumping congresswoman, to the super-villain head of the Federal Bureau of Superhuman Affairs. Talk about absolute power!" says Michaela Starr. "It's an interesting lens through which to explore the interconnectedness between business, politics, and entertainment. Claudia Doumit is perfect in the role. FUN FACT: She's one of several *Timeless* (one of Kripke's previous series) alumni on *The Boys*. She played time travel expert Jiya Marri."

BECCA BUTCHER

"You have to promise me you'll keep him safe."

Having to disappear and raise a son in secret, without telling her husband or the man who raped her, would be a living nightmare. But that's what Becca needed to do in order to protect Butcher. That was her hope, anyway. She really can't be blamed that he launched himself down a blood-soaked path of revenge against Supes in spite of her best efforts.

It's torture playing the love of his life, let's be honest," says Shantel VanSanten (aka Becca). "The position that Becca is in is definitely not ideal. I think that she would much rather be with the love of her life, but at the end of the day she had a Sophie's Choice, and none of the options were really great. I don't think that Becca could've lived with the idea that something that happened to her took Billy's life, or that he would've defended her and taken his own life. So, it's not really that great, but my goodness does she love him."

She loves her son, too, but fears what he might become. "Becca's main concern is that he would turn out anything like Homelander. At the end of the day, they are still flawed human beings, while they have superpowers. She feels a responsibility to raise him having different morals and principles. Hopefully having mothering that changes him from his dad's ways," she says. We shall see.

"Keeping Becca alive might be my favorite departure from the comics," says Michaela Starr. "Love the idea of discovering a new truth, that turns another character on his head. All this time, Butcher had been fighting to avenge Becca's death... but Becca's still alive? With a kid?? How does that impact his loyalty and agenda? And the chemistry between Karl Urban and Shantel VanSanten is undeniable. FUN FACT: Shantel VanSanten is also a *Timeless* alum. She played newspaper journalist, Kate Drummond, in the pilot episode."

HUGH SR.

"You don't have the fight. You never have."

The Boys is unique for a TV show in that it has a walking, talking Easter egg in the person of Simon Pegg, whose visage was shamelessly used as an inspiration for Wee Hughie in the comics back when he was less well known. Pegg never had a problem with it. "I was just immediately well chuffed, you know? It was good to be part of a very cool series. I'm one of the original Boys," says Pegg. As for calls for him to play Hughie, Jr. when news of the show got out, he admits that ship had already sailed even before the comic was published. "Hughie was in his early 20s and I was already about 30 then. With each passing year, I became more too old, and older and older, as you do," he says. But all was not lost. "Someone in the show reached out and said, 'Would you like to do a cameo?' I think I said, 'Oh yeah, I could play Hughie's dad or something.' And they ran with that."

You've got a helluva lad there.

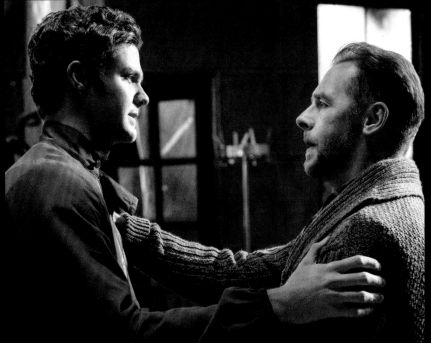

THIS PAGE: Hughie Sr., Hughie Jr., and Wee Hughie.

OPPOSITE: Becca relishes a couple of happy moments.

WITH GREAT POWER COMES...

It's time to unleash your superpowers in the bedroom, with the official The Seven range of adult toys from Vought.

- 💧 **Waterproof**
- 🏋 **Powerful**
- ⚡ **Multifunction**
- **6** **Collect the set**

Starlight's
Star-Brator

Deep's
FlounderPounder

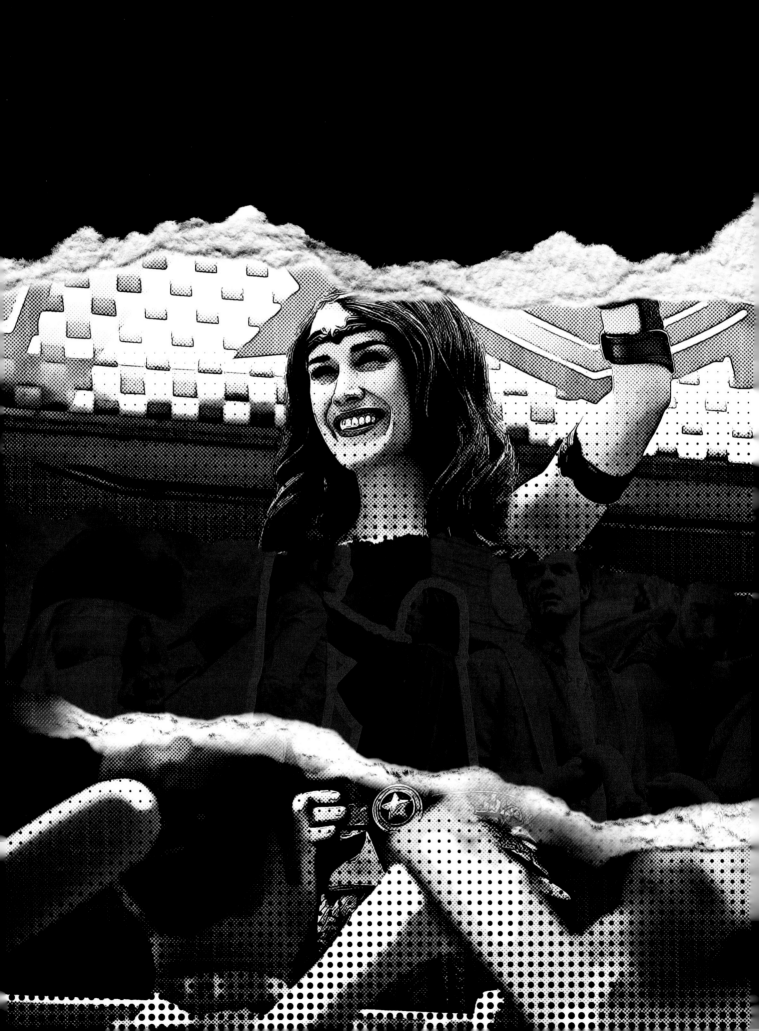

THEMES

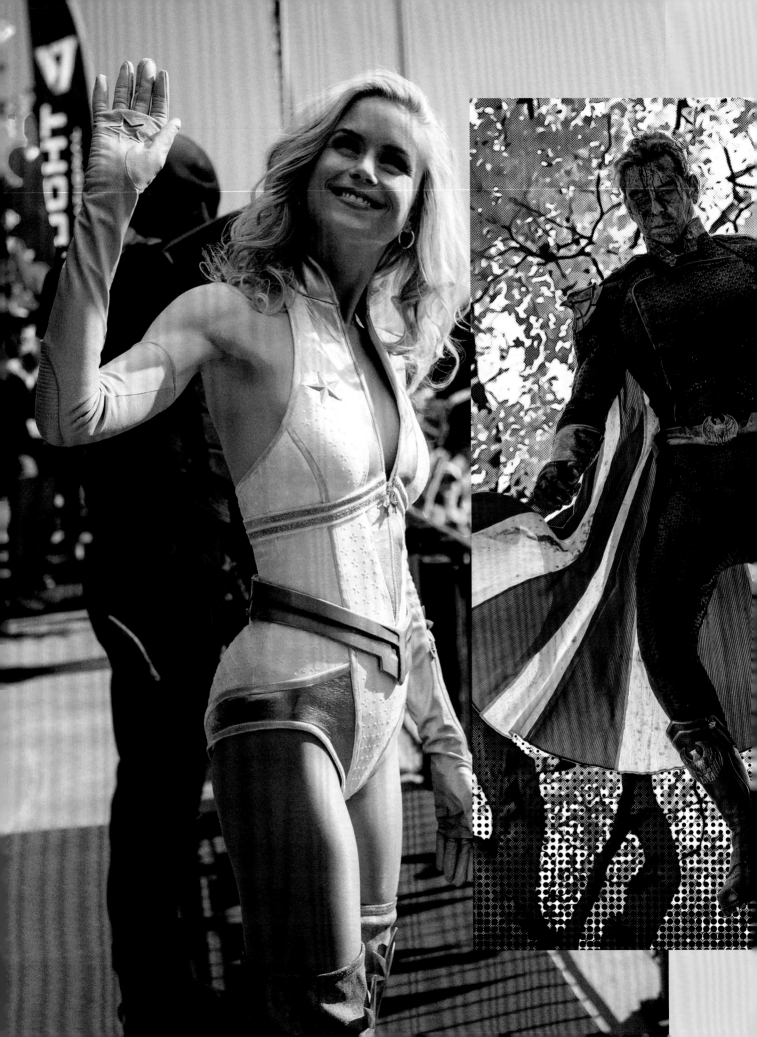

Never try to negotiate with Vought.

STARLIGHT

THEMES

INTRODUCTION

Eric Kripke has a few words on tackling serious themes with a *Boys* kind of attitude: "Rod Serling—my idol—felt very, very strongly that genre is only good if it's a metaphor for something else. If you have a superhero in that scene, what is that metaphor? What are you saying? Are you talking about professional athletes? Are you talking about celebrities? Are you talking about racists? Are you talking about politicians? Are you talking about authoritarianism? What is the suit a metaphor for? Thankfully, people are getting that and appreciating that part of the show.

"I think it's a primary importance that the show comments on what's going on in the world for a couple reasons. One, there are so many issues that are such four-alarm fires that I feel like people who have an ability and have a platform to talk about it to a lot of people, now almost have a responsibility to talk about it. Two, I think *The Boys* turned out to be a really excellent vehicle for discussing those things—probably better than I thought it was going to be when I first started. Because it's at the nexus of celebrity and authoritarianism, and who would've guessed that it would've been the exact reality that we would've been living in.

"One of the reasons the show seems to have more depth than it probably should is the time we take breaking a story. It takes about three, three and a half weeks to break a story from when you have an idea to when you have an outline. I'd say seventy-five percent of that time is just talking about the characters. Where are they, psychologically, from what happened before? Where do we need them to get to? Are there any parallels between multiple characters having similar psychological journeys? That's one of the best ways to find a theme. And only when you've come up with a really solid psychological foundation can you start saying,

'Okay, what would be a good scene that would shockingly make this character reach this revelation?'

"When that's done—and only then—do we say, 'Okay, now we need some crazy, gonzo, *Boys* moments.' Like Love Sausage at Sage Grove. Or the dolphin, or the whale. All those things are very late in the process. I knew everyone was going to tune in knowing this show was shocking and violent, so in a way I felt the most subversive thing I could do would be to make them really emotionally care about these characters, and cry during an episode. That's something that no one was expecting *The Boys* to deliver."

But deliver it did. Besides winning widespread critical and public acclaim, as of 2021 the series has received a total of six Emmy Award nominations—including the first-ever Outstanding Drama Series for a comic book adaptation. President Barack Obama even told Entertainment Weekly in 2020 that he counted *The Boys* among his favorite shows, "for how they turn superhero conventions on their heads to lay bare issues of race, capitalism, and the distorting effects of corporate power and mass media."

So, let's take a look at some of those societal issues and psychological traumas the Boys have come up against in three seasons—as well as some of the insane ways they've been presented to you, the viewing audience...

THIS PAGE: Queen Maeve and Homelander working the crowd.

"YOU FUCKING COCKSUCKERS."

HOMELANDER

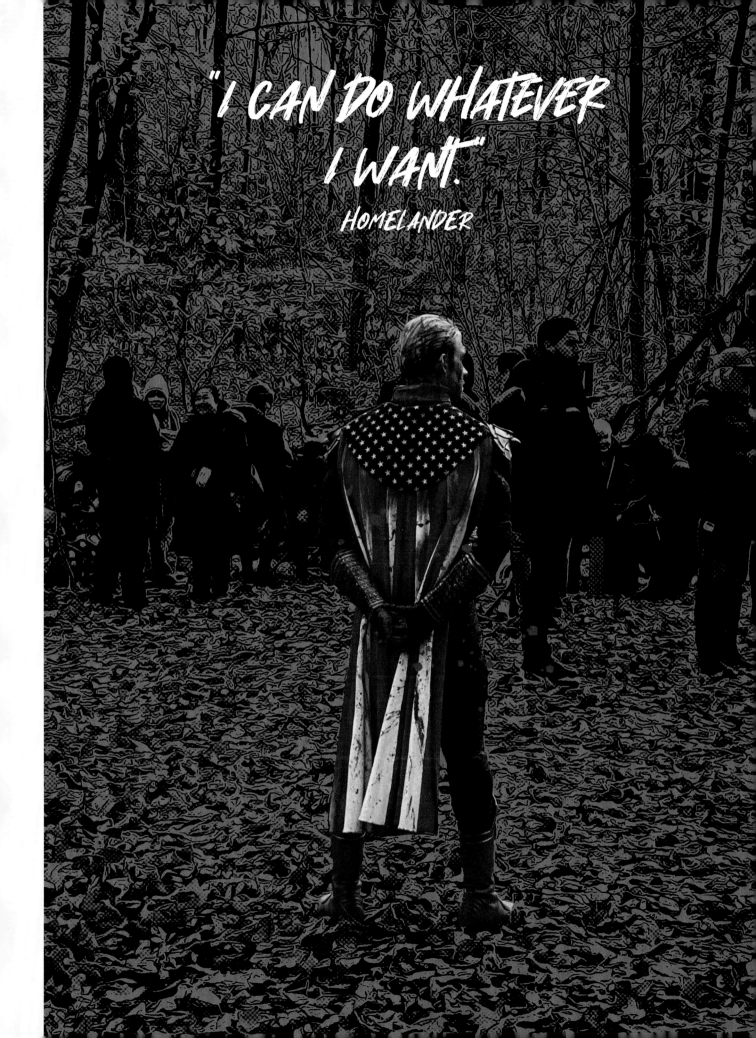

COMPOUND V

SECRET ORIGINS

The core of corruption at Vought goes back to its founding (in the Third Reich, of course). It is its most highly guarded secret: Supes are made, not born. As CEO Stan Edgar famously tells Homelander, "...You're under the misconception that we are a superhero company. We are not. What we are, really, is a pharmaceutical company. You are not our most profitable asset. That would be our confidential formula for Compound V."

Its clandestine program of injecting infants with Compound V has catapulted Vought to stratospheric heights. With the additional revenue sure to come from the as-yet-experimental Temp V, the company's profit outlook has never been brighter. An attempt to expose that secret to the world led to Butcher and Mother's Milk infiltrating a nursery where babies are hooked up to blue juice IVs. Mayhem and hilarity ensued, thanks to Laser Baby.

"We always knew we were going to find them dosing babies with V," says Kripke. "That was a real baby Butcher was swinging around. Obviously, you never know

That's a fuckin' baby supe!

BELOW: Starlight blackmails her old Capes for Christ chum, Gecko (David Thompson), in order to get a sample of Compound V.

"HOLY FUCK...
THAT WAS
DIABOLICAL."
— BILLY BUTCHER

what you're going to get when a baby shows up; it could just be screaming the whole time. I remember that baby was a remarkably good sport, and was just swinging around with these big, wide eyes. In a weird way, I think the baby is the unsung hero of that scene. I don't think that scene would've been quite as funny if that baby didn't have that wide-eyed, 'What the hell's going on?' expression. It really stuck the landing."

Supervising Stunt Coordinator for Seasons 1 and 2 Tig Fong describes how they captured the action: "It was a different take on a basic movie shootout. We did use gas guns instead of blank fire—that is the more popular way of doing things now, especially inside. We add the muzzle flash in VFX after the fact, and only used squib hits on the walls and the columns M.M. and Butcher are hiding behind to sell the realism of it all. Grabbing a baby with laser eyes and cutting their assailants in half, which is purely VFX, but seamlessly tied into everything else, it's quite a fun scene to watch."

COLLATERAL DAMAGE

THE DEATH OF ROBIN

"The thing that happens in almost every family-friendly superhero film is cars and buildings fall on top of cars, cars get thrown—and there would be people inside those cars," says pilot director Dan Trachtenberg. "In our show, we put a camera in the car and we follow the loved ones of those that would've been destroyed by that 'heroic' act. We're focusing on that collateral damage and putting a heart and soul around it."

Which is why he insisted that witnessing the gore in excruciating detail when A-Train obliterates Robin was the way to go. "Dan Trachtenberg deserves huge props," says Kripke. "The whole idea of going super slow-mo for Robin blowing up was his notion entirely. To be honest, I fought him on it a little bit because it was scripted as really, really sudden, but he was just really passionate that he wanted it as poetic, in a weird way, as possible."

In a departure from *The Boys'* desire to use as many practical effects as possible, Robin's explosion was entirely computer generated (CG). "It was certainly the most complicated shot in that episode," says Kripke. "Stephan Fleet, who was our VFX genius who was in control of the whole thing, had VFX houses exploding meat in front of green screens and filming it, and dropping it into the shot so we could understand what the shape of the blood needs to look like, how many organs should be flying around, etc. It probably took six months from start to finish to make that shot."

Costume designer Carrie Grace says that wardrobe choices, down to the t-shirt level, helped punch up the moment: "I chose the Tom Petty and the Heartbreakers as my own little tongue-in-cheek joke about the fact that he's going to be wearing this when Robin is killed. Also, it's a white t-shirt, so the red blood would look good on it. We always look out for things like that when we plan a costume, if there's going to be some bloodshed," she says.

THIS SPREAD: Hughie loses Robin in a carefully orchestrated ballet of VFX gore.

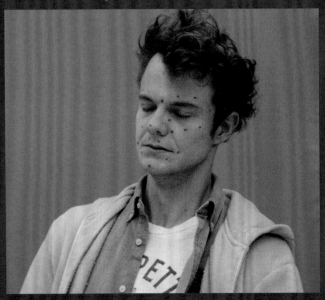 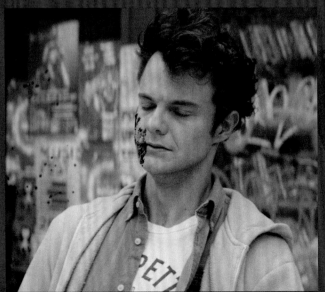

"THIS SHIT MUST BE PRETTY GOOD IF IT'S WORTH RUNNING THROUGH A HUMAN BEING FOR."

HUGHIE CAMPBELL

ASSASSINATION OF THE MAYOR OF BALTIMORE

Okay, we really can't pin this act on Vought, but they definitely covered it up. Homelander goes a bit rogue and thinks he's helping out to keep the secret of Compound V safe. Can you really fault him for that?

"I broke that episode with a really brilliant writer named Anne Saunders, and we made the choice to withhold the card that Homelander was the worst out of all of them until the very end of the pilot," says Kripke. "Play up that outside appearance that he's such a Boy Scout, and then reveal at the end that he's willing to kill a kid if it means furthering his aim. There are a couple of shots in there that are reminiscent of panels from *The Boys* comic itself. There's this image of Homelander flying up to a plane, and there's a little boy inside looking out at Homelander in wonder—and then Homelander proceeds to kill the kid pretty quickly. That idea told the story of how dangerous he was."

THIS SPREAD: With help from the VFX and stunt crew, Homelander shows his true colors.

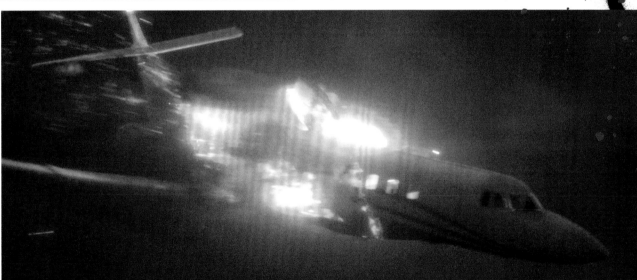

THE TRAGEDY OF TRANSOCEANIC FLIGHT 37

Superheroes need to obey the laws of physics. Who knew? So, when Homelander destroys the airliner's controls while killing a hijacker, there's not much that can be done. Sure, he could save a few passengers... But those would be witnesses to his screw up and powerlessness. The event proved to be a two-edged sword:

it accelerated the drive to get Vought Supes a lucrative military contract, but a video that survived became a weapon of blackmail that Maeve would eventually use on Homelander.

Apart from Homelander's laser eyes and the shot of the plane going down at the end of the scene, that entire horrific sequence was

THIS SPREAD: Over Queen Maeve's objections, Homelander insists they abandon the doomed passengers to their fate.

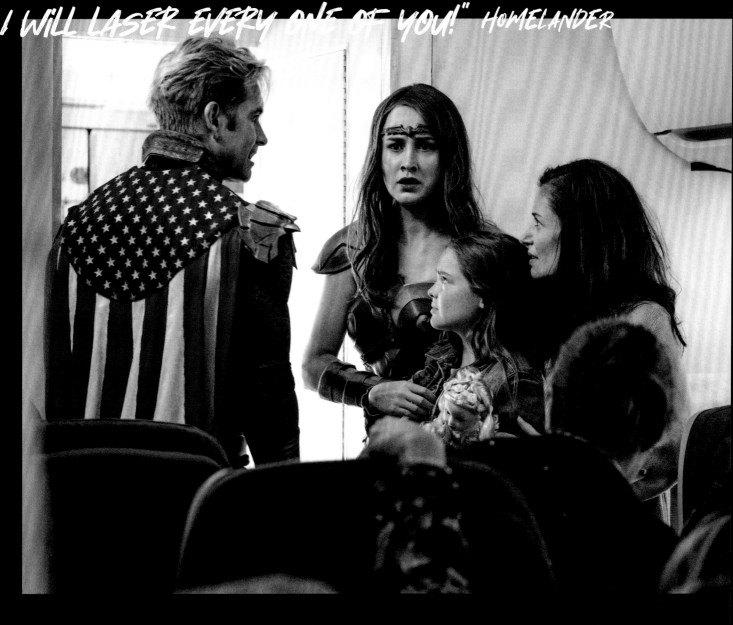

accomplished essentially practically. Lighting, camera work, stunts, and some great acting pulled it off. "The plane was a real fuselage, shipped here from California. They had this lighting rig on the outside of the plane, and instead of moving the plane around in the clouds, they had the lighting rig move," says Phil Sgriccia. "We had what's called an 'image shaker,' which was used on the beach landing in *Saving Private Ryan*, where the camera gets all jittery. It's actually a motor on the lens that shakes the glass—up, down, and sideways— and you can time it. So, as the plane started losing altitude after Homelander zaps the cockpit, they turned that up so the camera's never stable. That creates tension in the viewer. It's all shaking, and it's everybody's nightmare."

Stunt Coordinator Tig Fong adds that, "To make it work you had wind machines, and that first terrorist that was sucked out of the open door on a wire ratchet. Another was dragged down the floor until he comes to Maeve... and that *Star Trek* sort of thing where you've got the passengers leaning one way and the camera leaning the same way. The horror is really sold by Antony Starr. We see into his pathological nature, and Maeve gets to see it, too."

Sgriccia gives full props to director Fred Toye and cinematographer Evans Brown, as well as the cast. "The extras, and the little girl, all did great. When they put it all together, it was 'Wow! This is super tense and super scary,'" he says.

HEADS A-POPPIN' AT THE CONGRESSIONAL HEARING

Acquire sample of Compound V—check. Release information to the media—check. "Persuade" Dr. Jonah Vogelbaum to testify before Congress—check. Finally bring Vought down—oh, not exactly... The proceedings come to an abrupt halt as several key witnesses and officials suddenly find themselves with no place to hang their hats. Congresswoman Victoria Neuman is soon revealed to us as the head-popper-in-chief behind the attack; however, her endgame remains unclear until Season Three, when she heads up the Federal Bureau of Superhuman Affairs and is shown to have a chummy relationship with Stan Edgar. Could this be a case of an industry policing itself? Color us shocked!

Creating a bloodbath that outdoes *Game of Thrones*' Red Wedding required a tight partnership between SFX and VFX (or, the practical and the digital). SFX coordinator Tony Kenny says, "A lot of it is testing. Starting at zero and working our way up, showing the video to Eric [Kripke] and Stephan [Fleet, VFX Supervisor]. They both are always putting input in, which is awesome.

Makes my job so much easier. They're pushing us in the right direction. Then we'll do an element shot for Stephan. We'll get to the set and do air cannons and blood rigs to augment it. It's a constant learning process to get it exactly right." And what's in those exploding blood bags that makes them look so real? Sorry, Kenny is tighter-lipped than a Vought chemist. "If I told you, then everyone would be doing it," he says.

Then it's up to Fleet to take those elements and weave them together with CG goodness. "We did heavily look at brains and veins and bone.

THIS PAGE: Practical and CG elements combine to create an unforgettable congressional hearing.

We knew people would freeze-frame on it, actually. We know that going into it. So, not a frame can suck when we do this work. We go over every shot 30-60 times, at least. A lot of attention to detail," he says.

The results were certainly effective in creating the desired level of ickiness on set. "I love that for the first four hours of the day you were like, 'This is a regular scene.' And then you came back from lunch and it was like 'the floor is lava,' but it's blood. It's like blood, blood, blood. It was blood everywhere," says Claudia Doumit, who we later discover

was responsible for the carnage as secret-Supe Congresswoman Victoria Neuman. Similar thoughts are echoed by Laila Robbins, who plays the Boys' mentor, CIA Colonel Grace Mallory. "I came back and literally all of the background supernumeraries were covered in blood and brain matter. And they're just kind of chatting with each other at the craft table, completely drenched in human remains. Horrifying, horrifying. My thoughts and prayers go out to the custodians who had to clean up that bloodbath of a courtroom after we shot that day," she says.

Oi! Heads Up!

"ANGER SELLS." STORMFRONT

XENOPHOBIA

HOMELANDER AND A-TRAIN CREATE SUPER TERRORISTS—ER, VILLAINS

For a lot of people, Homelander is America. He wears the flag as a cape, for fuck's sake! So, why did he hatch a plan to supply Compound V to terrorist organizations around the world? Some might see him as an arsonist/firefighter, who starts blazes so he can be seen putting them out. Others see him as a pragmatist, creating a believable enemy that would prompt the government to accept Supes into the military. Or maybe, he just realizes a universal truth: Fear sells—and fear of the other sells best of all.

THIS PAGE: Newly created super terrorist Naqib (Samer Salem) gets cut down to size by Black Noir.

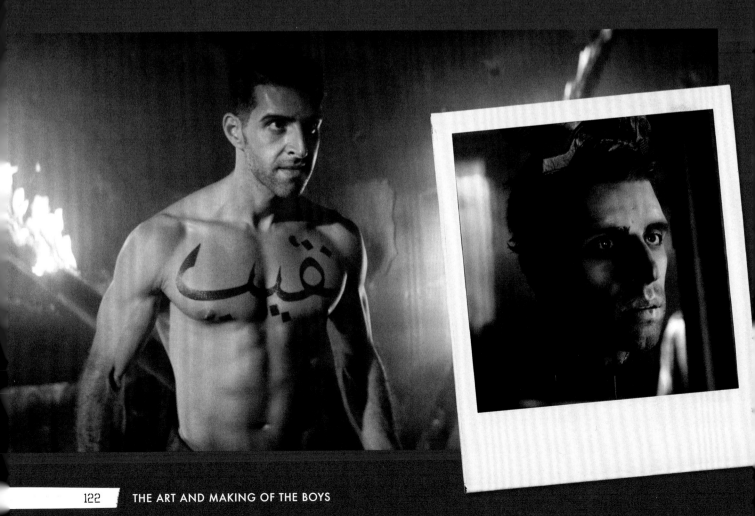

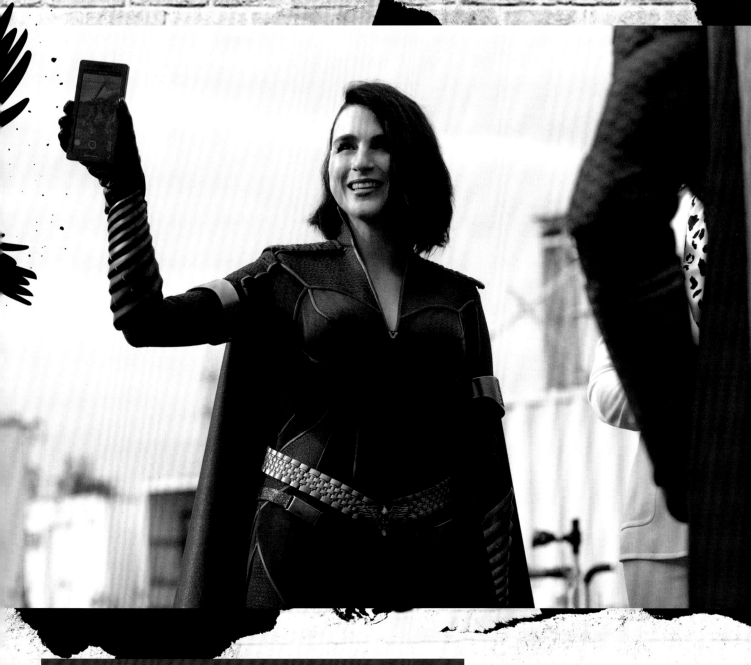

SAVING AMERICA

With anxieties rising that super-powered foreigners were about to swarm our shores, it was a great time to introduce Vought's Saving America Campaign (not Saving the World). Stan Edgar also felt it was a great time to bring Stormfront into the Seven, along with her social media army. It was very timely in our America as well. "The idea of a wolf in sheep's clothing is a trope for a reason," says Aya Cash. "She comes in, in an Instagram-friendly package—and unfortunately that's the way the world is working these days. Even Nazis don't want to be called Nazis anymore. Evil is packaged in all new ways these days. When she is using her 'Meme Queens' to change public opinion, that comes from real life. That's not fantasy. That's what's happening in the world right now—which is fucking terrifying! There are dangerous people spreading lies and trying to manipulate you to create hatred."

THIS PAGE: Stormfront, She-Wolf of Social Media.

Things reach a fever pitch just as the Boys try to hand Kimiko's brother, Kenji (aka the feared "super villain"), over to the CIA. The Seven swoop in to stop them, and the result is an action sequence that would've been more than enough for an entire movie, let alone a single episode of television. We go from a police helicopter crash, to a stampede of sharks, to a speedboat impaling a whale, to a raucous sewer battle, to the destruction of an apartment building, to a final melee and murder on a rooftop—all in the space of a few minutes.

"I was nervous heading into all of that," says Kripke, "for the reason that most of our episodes would have one or maybe two of those sequences, and here we had an incredible amount of action in short order. Could we get it all done? Could we get it all done well? The best piece of luck was

THIS SPREAD: Stormfront relentlessly pursues Kimiko and Kenji through the tenement, racking up the collateral damage.

NEXT SPREAD: Hughie in the belly of the beast.

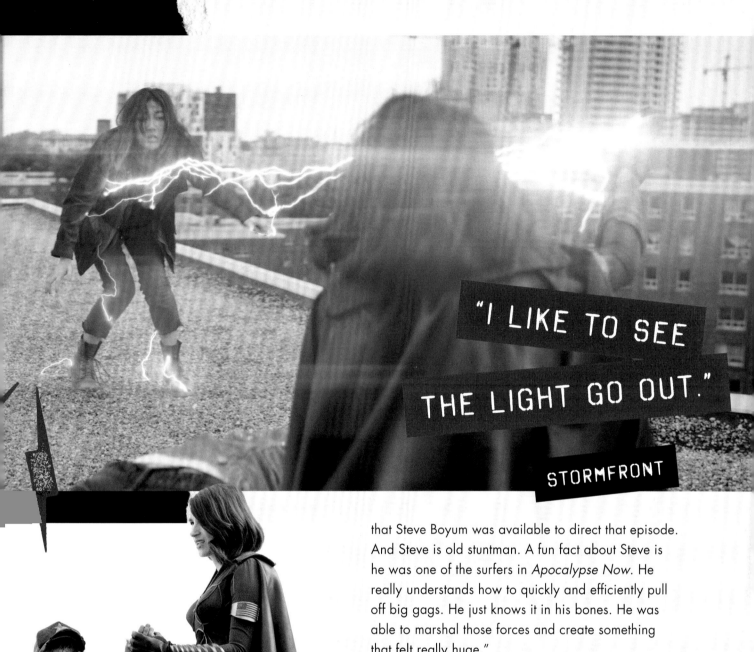

"I LIKE TO SEE THE LIGHT GO OUT."

STORMFRONT

that Steve Boyum was available to direct that episode. And Steve is old stuntman. A fun fact about Steve is he was one of the surfers in *Apocalypse Now*. He really understands how to quickly and efficiently pull off big gags. He just knows it in his bones. He was able to marshal those forces and create something that felt really huge."

And making the whole sequence huge was important because, "...it was a real unveiling of your villain for a season," says Kripke. "Stormfront had been the cheery, likable, new-media chick up to that point, and now she was suddenly revealing herself to be the monster that she was. We wanted the audience to feel that, 'Oh shit!' sense of dread of how formidable she was going to be—even to the point where she was able to show up Homelander."

Why a whale? "[Writer and Executive Producer] Craig Rosenberg really has it out for sea mammals, obviously," says Kripke, "because he pitched and wrote the dolphin going through the windshield. He said, 'I really want to top that. I want to bring out

a whole whale.' I actually was really resistant to that pitch for a long time. He kept pitching it and pitching. But once it became about the lowest point in Hughie's journey—when he's in the belly of the beast, he's really in the belly of the beast. Mother's Milk had to literally pull him out of it—he comes out as a different person. Once Craig figured that out, I was like, 'Okay, I got it now.'" And Rosenberg got to cross something off his bucket list: "It's very rare in your life as a writer that you get to do a logline that says, 'INT. WHALE'," he says.

Naturally, some shots of the whale are pure CG. "We couldn't get a real whale and have The Deep riding it. If we could've, we would've," says VFX supervisor Stephan Fleet. "We got one of the best visual effects companies in the world, ILM—Industrial Light and Magic—to do the sequence. It just worked perfectly in so many ways. So much comedy and sadness mixed into it." But based on how much the cast would be interacting with the doomed cetacean, it soon became obvious to those in charge that they would have to build a practical, 50-foot long, 11-foot high sperm whale.

"I found out about the whale early in prep, so that we could have a fighting chance of building this thing," said the late, and much-missed, Season Two production designer Arvinder "Arv" Greywal. "I worked with the storyboard artist and he and I sketched out, very roughly, what we thought the action for the whale would be. Then we contacted Ron Stefaniuk, who is a genius at this sort of thing. He did the dolphin last season. I said, 'Ron, I need to see a whale out of you in about three months.'"

Practical wizard Stefaniuk made sure it was, "...built so it could be taken apart, it could be moved, and it wouldn't weigh an

What are You smilin' about?

unfortunate amount. It became clearer, and clearer, and clearer that the boat was actually going to impact into that. And The Deep's going to be on the whale," says Stefaniuk. "We really wanted to reinforce it, so we retroactively put inside ribs like the ribs of a ship. By the time we foamed them in, they also looked like the ribcage of the whale. We wanted the surface layer to have some give, like blubber. So, we put a one-inch layer of foam over the entire whale that we could tool and shape like the final thing. We found out that whales had sucker marks all over them from eating squid. We

pre-painted all of the foam with the mottled whale coloring; one day it was this white whale-esque sculpture, and in three days all of the foam moved on—all of a sudden it just came to life."

"One of the things that was challenging for Ron," said Greywal, "was actually finding a space where he could build this whale, and also with a big enough door that we could get the whale out. We had about an inch of clearance. We barely got it onto a flatbed, and then we had to truck it out to another town about an hour from downtown Toronto where we were doing this."

Actually driving that speedboat (pre-crash) was experienced boat pilot Karl Urban. As Jack Quaid relates, "I was on the front of that boat. I'm going six feet up, six feet down, just slamming. And Karl was like, 'Listen. The safe word, if anyone feels unsafe, is 'Karl, Karl, Karl.' There's a helicopter overhead, and wind sounds, and as soon as we hit that first wave, I'm like, 'Karl! Karl! Karl! Karl!' He couldn't hear me." Karen Fukuhara was likewise rattled: "We thought it was just going to be special effects to get all the dynamic bits. No, we were going full speed. I thought I was going to fall off, and I still

"HE'S YOUR CANARY."

MOTHERS MILK

had to look badass. 'You gotta be Kimiko, you gotta be The Female,' so I got through it."

The violent impact involved every department on the show. "We crashed the speedboat with all the occupants on it, dragging that boat up on a rail into the whale, and real stuntpeople riding that boat, flying into a 50-foot sperm whale, complete with animatronic jaw and tail. We had blood cannons to spray into the camera to complete that scene," says stunt coordinator Tig Fong. Emmy-nominated sound supervisor Wade Barnett describes how sound effects added to the spectacle: "So much of that was coming up with groans, before and after the wreck, to make it a little bit sadder, along with the ripping of flesh and getting the blood spurts just right. Also a lot of work on the sounds of air releasing from the cavity of the body, getting the sound of feet just right with our foley department, of them slipping around in the guts. Just getting all the squishiness just right was cool."

"As you can imagine, there has to be quite a few discussions ahead of time to know where the handoff is, who's responsible for

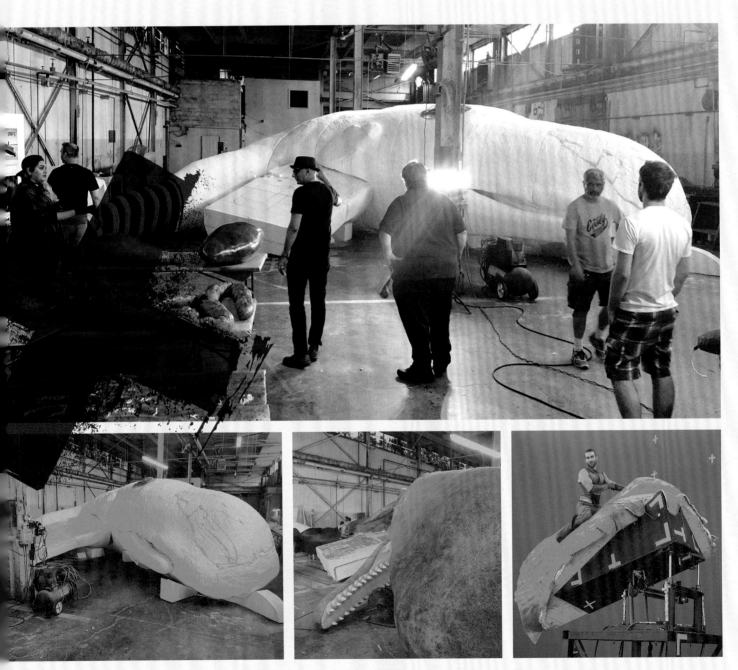

THIS PAGE: Lucy coming to life (briefly) in Ron Stefaniuk's workshop; The Deep atop a faux Lucy for the CG shot.

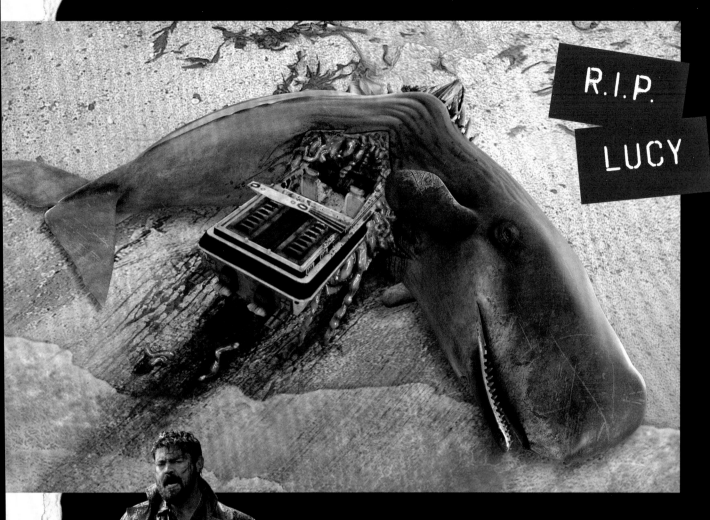

R.I.P. LUCY

what, and how do we seamlessly tie these elements together to bring you the visual experience that you had," says Fong.

After the Herculean task of destroying a life-sized whale, blowing up a tenement building during a Supe fight should be a piece of cake, right? As always, keeping it real was the name of the game. "Eric, Seth, and Evan said from the very beginning that they wanted this to be a grounded show. That was the word, 'grounded,'" says Fleet. "A great example of that is Stormfront's powers—how they interact with the cameras, especially with light effects. So much time researching Tesla, plasma, lightning, etc., etc. When the lightning turns off right away, you get this rolling stutter sort of glare error in the camera. We actually included that intentionally as a camera error. And it's really funny, 'cause I've gotten a couple people on social media, like, 'Why did you keep that camera error in there?' No, no, no, no, we put in that camera error. We embrace those mistakes."

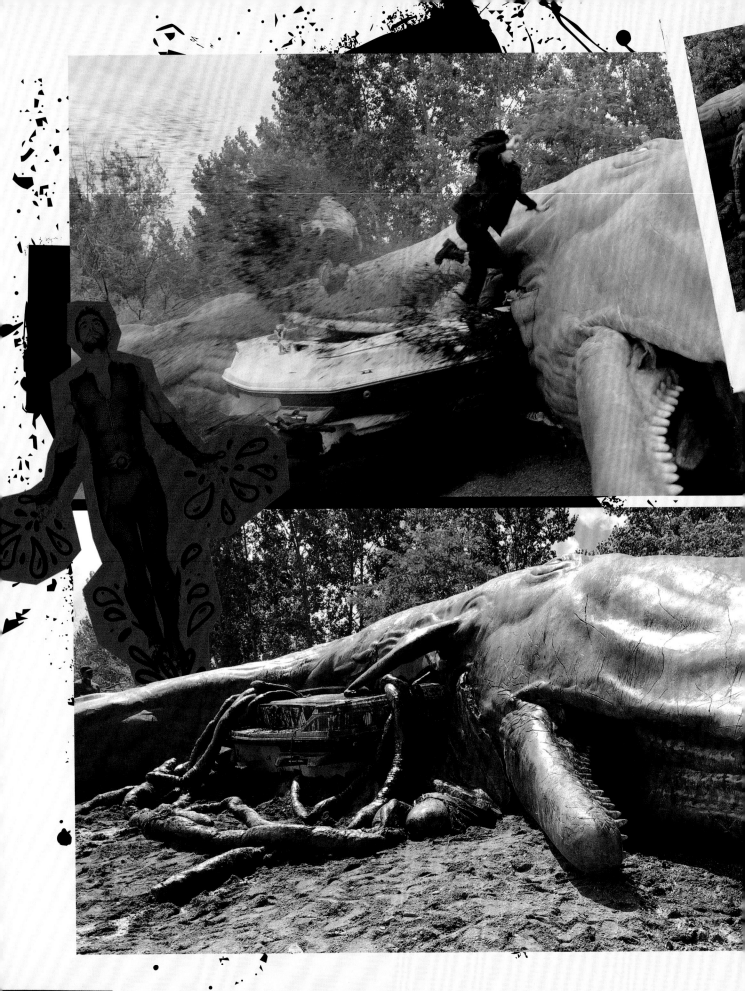

Fuckin' Diabolical!

Fong describes the practical side of things: "The apartment fight scene, to me, was the tent-pole showpiece of action for the season. We never got bigger than that. I shot a really detailed pre-vis so that everyone else could have a clear idea of how that's gonna look in the end. By using practical effects for these superheroes to interact with, like crushing someone's head or crashing through a real wall, there's just something about it that will always sell better [than CG]. Audiences are quite sophisticated nowadays, and they can spot when you're cheating things a bit. I think they appreciate it when we go through the effort.

"It starts with a 20-foot ratchet of our Kenji and Kimiko doubles through the air, which we did on location, a real housing project in downtown Toronto that's scheduled for demolition. The crashes through the walls—breakaway cinder blocks and plaster—we stitched together with a set we built at the studio. Stormfront throws Kenji through another wall. To show Kimiko's power, she recuperates after being hit by Stormfront and knocks her into the wall—so, more collapsible cinder-block walls and a wire ratchet for our Stormfront double. We go to an exterior shot with a drone climbing up the side of the building. We did practical stuntpeople flying out of the candy-glass windows, as well as practical explosions (propane poppers), all enhanced by VFX. We didn't actually destroy that building, but it certainly looked convincingly like we did.

"That takes us to the Kenji leap. It took three days of bringing in a many-ton crane, not for the weight, but for the reach: you were reaching above a six-story building to create a pendulum, crossing a 45-foot gap, onto the rooftop of a three-story building. Then, of course, Stormfront killing Kenji, which was a little bit of prosthetics and a little bit of VFX to finish that off."

That brutal scene not only exposed Stormfront as a ruthless villain to be reckoned with, but also served a gut punch to Kimiko. "Loss was a huge part in exploring Kimiko in Season Two," says Karen Fukuhara, "but also the hate coming from Stormfront. Our show does a great job of showing the privileged and the powerful through superheroes. She's grown up with this power, and she doesn't use it in very good ways. That sort of Asian hatred, that racial hatred, that comes from her, and seeing that energy go towards Abraham [Lim], who plays Kenji—witnessing that, and that causing his death. It was a challenge."

THIS SPREAD: The moment of impact and the aftermath.

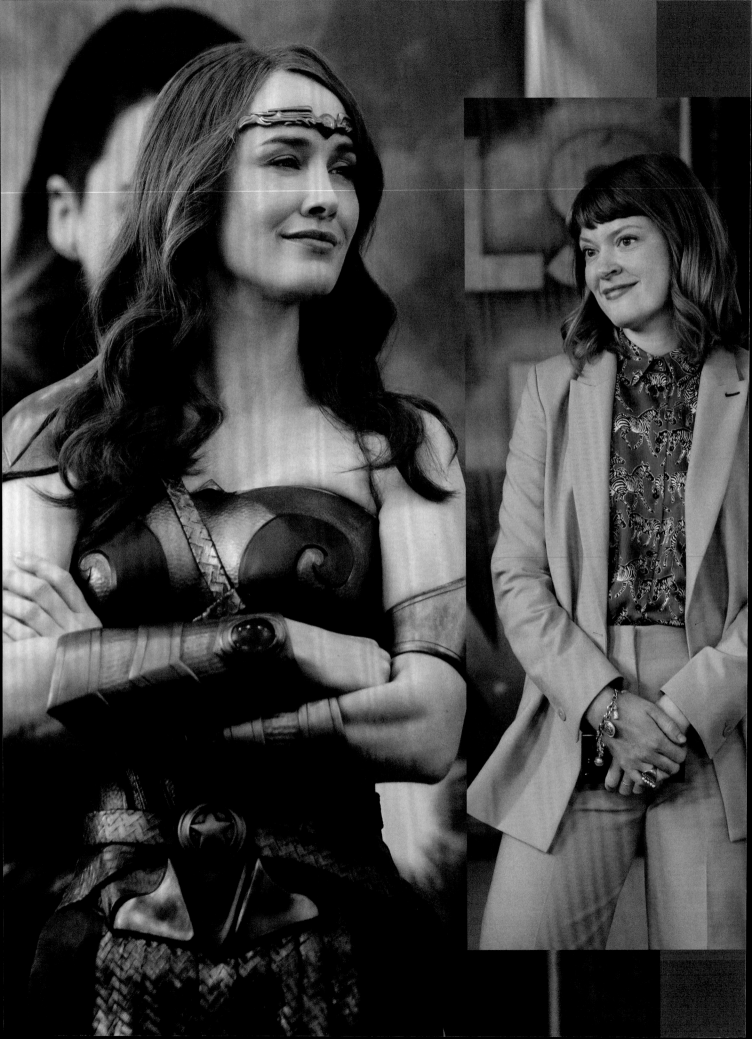

Bony blonde supe

GIRLS GET IT DONE

STORMFRONT GETS STOMPED

Kimiko's revenge on Stormfront would have to wait for the second season finale, when she has help from Starlight and even Queen Maeve. (Oh, and Mother's Milk, Frenchie, and Hughie are there, too.) "When you write a fight scene, you have ideas, but really you're trying to convey the tone of the fight: Is it a messy fight? Is it a slick fight? Is it people showing off?" explains writer Rebecca Sonnenshine. "This fight in particular, what we wanted was a cathartic stomp-down, basically. 'Girls Get It Done' was this marketing slogan. It was a response to this, 'Isn't it cool that girls fight?' but it's such a commercial concept, and Vought is trying to capitalize on that. What you wanted in this one is, it's just a fight. There's nothing pretty about it. There was real anger there. They wanted their due, their revenge. They all had different reasons for doing it. It just became very visceral."

It starts with Stormfront tossing aside the SUV Mother's Milk, Becca, and Ryan are trying to escape in. "We wrapped the SUV in cable, rigged to a pickup truck on a pulley system,

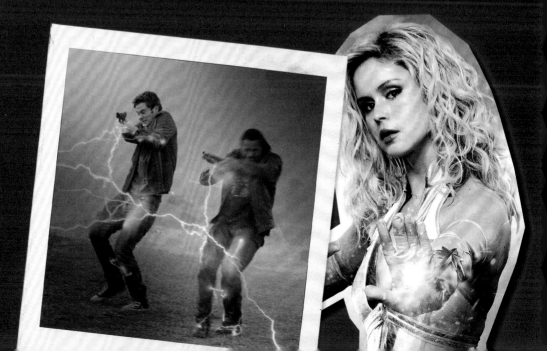

GIRLS GET IT DONE

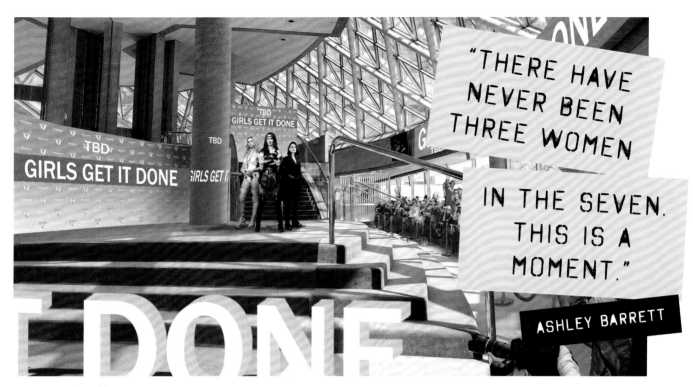

"THERE HAVE NEVER BEEN THREE WOMEN

IN THE SEVEN. THIS IS A MOMENT."

ASHLEY BARRETT

THIS SPREAD AND PREVIOUS: Ashley and Vought marketing push a message of female empowerment.

so when we pull the cable the SUV gets unraveled like a yo-yo," says SFX set supervisor J.R. Kenny. The Boys had pinned their hopes on fighting back with heavy weaponry stored in the Quonset hut, but that gets blown up thanks to Stormfront's lightning—and Kenny's pyrotechnics. "Using trap mortars, they're sort of a trapezoid shape. We put the explosives in the flat bottom and the explosion is directed out of the 'V'. We've got a mix of black powder and what we call "turkey bags," which is pretty much a plastic garbage bag full of gasoline. The black powder explodes through the bag of gasoline, spreading the gas out, igniting it on fire, creating that giant Hollywood fireball everybody loves. And then we've got the high detonation det cord, that when it explodes it creates a shockwave," Kenny explains.

But before the melee can begin, there's... laughter? From Kimiko of all people? "It's such great moment," says Antony Starr. "You just hear this little chuckle come from off screen and it's like, 'Wait, what?' And then you see this cheeky little thing finding herself and having

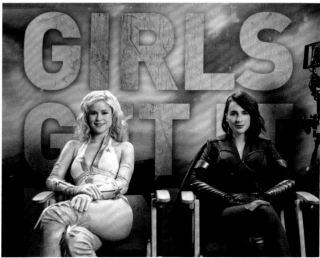

all this stuff going on. It's great."

When battle is joined, however, the laughing doesn't last long. "Stormfront breaks Kimiko's neck—that wasn't in the script, but I put that in there because I wanted to up the ante, shock the audience, and motivate Frenchie," says Fong. "Of course, the surprise is when Kimiko self-heals and jumps back into the fray. After that, it's just a gritty and physical stomp-down.

We put some sandbags down on the ground, so the actors had something physical to stomp on. Then shooting an up angle, with the cameraman lying down on the ground, to see them all stomping down in towards the camera." And then Stormfront flees into the sky, eventually to get fried by Ryan.

One person not sorry to see Stormfront get her just deserts is Aya Cash, but she's quick to

remind us that the Aryan influencer is not unique. "Obviously, she's a horrifying villain, but we have seen so many examples of her in the real world that it almost doesn't feel shocking anymore. It's much more terrifying to me in real life than it is on the show. If Stormfront brought anything to the show, I hope it's that we can say, 'Nazis are bad!' I don't know how that is a controversial statement in 2021," she says.

RACE

AN AGE-OLD PROBLEM

The Black Lives Matter protests of 2020 coincided with the airing of Season Two of *The Boys*, but it's not as if the writers got shots of Compound V and somehow became prescient. Structural racism is a pervasive and age-old problem in America, and so we can expect to see it rear its ugly head occasionally on the show.

"Those things have been problems in this country for two hundred years," says Kripke. "We're not talking about anything new. When we have a scene about an African-American kid getting pulled over by Liberty—who turned out to be Stormfront—and brutalized, that's a problem a hundred years ago, and that's a problem today, and it's

THIS PAGE: Vought's history of cover-ups goes way back.

8 news /Section 2

Sunday Report

Soldier Boy Cleared of Wrongdoings in Death of Queens Family

By John Cooper
New York Courier

After more than a month of investigation into the deaths of five members of the Milk family of Jackson Heights, officials have concluded that the incident was an accident, and that Soldier Boy bears no liability. The announcement was made at a press conference yesterday afternoon by the Mayor, several ranking city and law enforcement officials, Vought representatives, and Soldier Boy himself.

Last month, four men smashed their car through the entrance to the Jackson Heights branch of the District American Bank as an overnight cleaning crew was working inside, nearly killing a janitor. Once they'd gained entry to the bank, they forced the security guard on duty to give them access to the cash drawers. They fled the scene in the same vehicle.

Soldier Boy, who happened to be in the area, heard the emergency call over the police radio and quickly caught up with the suspects. The superhero managed to head them off as they attempted to turn onto a

side street, causing the car to crash, headlong, into a lamp post. A scuffle ensued, during which the suspects attempted to flee. Soldier Boy subdued them, but one of the suspects was able to restart the crashed vehicle. According to the official account given by Soldier Boy, the suspect attempted to run the superhero down with the car, forcing Soldier Boy to deflect the oncoming vehicle, which caused it to crash into the Milk's family home. Louis Milk (57), Walter Milk (35), Lucy Milk (32), Elizabeth Milk (19), and Albert Milk (13) were killed.

However, the Milk family has disputed Soldier Boy's account, insisting that he had acted recklessly during the course of his arrest of the suspects, and that he didn't deflect the car, but rather picked it up and threw it into their home. Investigators found no evidence to corroborate their claims.

The resulting investigation into the incident, launched by the District Attorney's office, in coordination with local law enforcement and Vought, took over a month to complete. "We examined the events of

that night closely," a DA spokesperson said at the press conference. "We received full cooperation from Vought as well as from Soldier Boy. Our conclusion was that, based on the evidence and the facts at hand, there was nothing Soldier Boy could have done differently."

"I deeply regret the deaths of those innocent people," Soldier Boy said at the press conference, with Vought attorneys at his side. "Unfortunately, cold-blooded criminals like the robbery suspects I stopped that night have no regard for human life. It's because of them that those people died."

"As hard as this has been for everyone, it's time to let it go," a somber Mayor said, concluding the press conference. "Soldier Boy is an American hero. He puts himself in harm's way every single day to keep Americans safe. This was a tragic accident, and it's best for everyone if we find closure now and move on."

The Milk family has vowed to sue Vought for damages, and to seek justice for what they insist was reckless endangerment on the part of Soldier Boy.

Rise and shine at our Weekend Brunch!

What a great way to start a glorious weekend morning! Just pile the kids into the car and let us be your morning hosts.
The time - 9:00 am to 1:00 pm
The price — $ 8.75 plus tax —
$5.00 children under 12
The Brunch — Scrambled Eggs, Bacon, Sausages, Ham, Chicken, Chicken Fingers, Sliced Fresh Fruit, Fruit Cocktail, Danish Rolls, Muffins Juices, Coffee

Commissioners plan workshops

City councilor Barbara Agbaje is happy with the numbers presented by city staff

In July, councilor Agbaje stated her concerns about the use of seniors parking

look into the numbers of passes being issued. The numbers were presented at Monday's council meeting and Agbaje said they didn't reflect what she thought was going on.

flack over this. The seniors are alive and kicking," she said.

The number of seniors parking passes issued were at it's highest in 2005 at 407 and the lowest number issued was in 2007 why

going to be a problem six months from now." And guess what? Supes are not immune.

We've seen that A-Train treads lightly in the Seven, hoping to retain and then regain his position in the organization, but even he gets followed by a suspicious store security guard when he's not in his supersuit. He tries a new costume that speaks to his African roots in Season Three, but how sincere or how successful this re-branding is remains to be seen. Even Black Noir wasn't allowed to show his face as a Black man when he was a member of Payback in the 1980s—back when he had a face worth showing.

When Mother's Milk, Hughie, and Annie take a road trip down to North Carolina to track down Liberty, they meet Valerie, the sister of the kid the Supe killed. But the frightened and suspicious woman won't give them any information until Mother's Milk connects with her, telling her how the stressful

fight against Vought killed his father. "That was something that was very collaborative," says Laz Alonso. "Eric wrote the beginning of the monologue, and I added stuff that I felt, culturally, really hit certain points and certain notes. I got so many texts about that line that Mother's Milk says, 'Vought had their knee on my father's neck.' And that was 2019 when we shot that scene. And that's just a saying we say, 'Yo! Get your motherfucking knee off my neck!' And it's crazy how 2020 unfolded."

Alonso goes on to say, "The scene between Valerie and Mother's Milk was a scene that I feel was very, very familiar to most Black people in general, but specifically African-Americans, who come in contact with each other... I may not know you personally, but I feel you and I know what you go through because it's probably very similar to my experience. And that's what we captured in that scene."

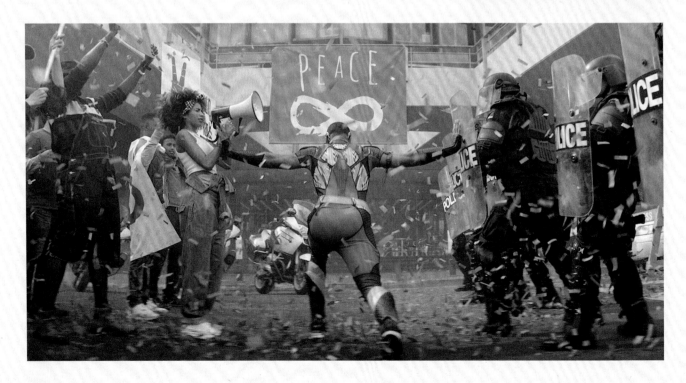

CELEBRITY WORSHIP

THE RISE AND FALL OF "HEROES"

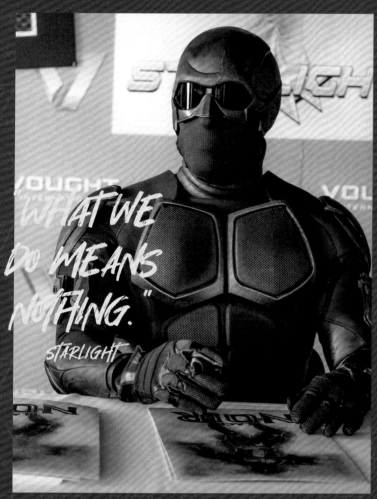

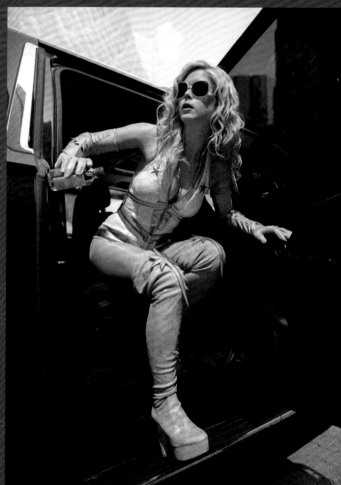

THIS SPREAD: (Left) Concept for the newly "woke" A-Train. (Above) Super celebrities.

Vought and its Supes are obsessed with poll numbers and Q ratings. Luckily for them, they have the ace marketing team of Seth and Evan (no relation) working to manipulate the media and twist popular opinion. No tale is too tall to tell. Translucent gets ignominiously blown up by C4 up his ass? Nope, he died heroically in combat with a supe-terrorist named El Diablo. Compound V is leaked to the press, and heads in Congress explode for no apparent reason? Uh, that was all Stormfront! Yeah, and we totally took care of her! Nothing to see here!

"I love playing people who don't know what's wrong with them. And that's why I love that character, because I think he doesn't necessarily know all the ways and reasons why he's kind of an asshole. And that's fun," says Malcolm Barrett, who plays the dickless Seth Reed. "If you're going to play a really bad person,

EXPERIENCE. TRUST. TRADITION.

THE CAMERON COLEMAN HOUR

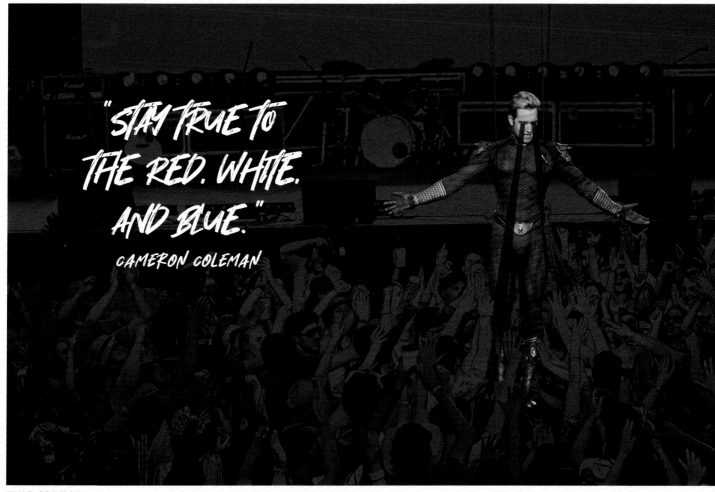

"STAY TRUE TO THE RED. WHITE. AND BLUE."
CAMERON COLEMAN

THIS SPREAD: If you control the media, you control the message—just ask Cameron Coleman (Matthew Edison).

you don't go, 'Hey, I'm a really bad person.' Most people don't think like that. Most people think they're doing good, even when they're doing very bad things. And so I just did my best to tap into that."

And thanks to the Vought News Network (VNN) and dedicated anchors like Cameron Coleman, viewers can be sure they're getting all the information they'll ever need—unlike the fake news you find in the lamestream media. "I think misinformation is so dangerous and cynical," says Kripke. "It's so obvious that they're willing to actively harm people. I mean, look at all this shit about the vaccine cynicism. These kinds of networks are outrage machines that specifically slant information in an inaccurate way. Then there's bigger ratings, and then they make more money. It's so wildly irresponsible and destructive to civil discourse, and it's straight-up propaganda. That's another big issue of something that we thought richly deserved ridicule."

NEVER TRULY VANISH

Even Starlight plays her part in the hero factory, belting out a heartfelt song of praise at the memorial for the fallen Translucent. That she was doing it as part of a survival mechanism doesn't diminish the fact that she killed it.

"I got an email from Eric probably about six months before they started filming Season Two," says composer Christopher Lennertz, "and he said, 'You should probably take a look at the script, because I need you to write a song, and it needs to be like Celine Dion meets Adele.' It's a pretty fantastic thing as a composer to get that. A lot of pressure, but everyone wants to write that classic power ballad. I got a script that had a couple of stanzas written by Michael Saltzman (one of the staff writers). I knew it needed to have

THIS PAGE:
Remembering Translucent the way he'd want to be remembered.

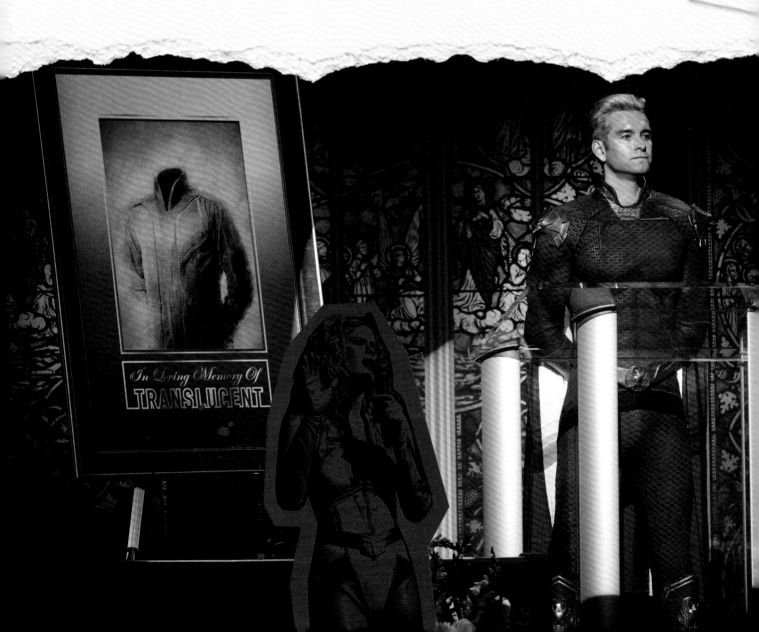

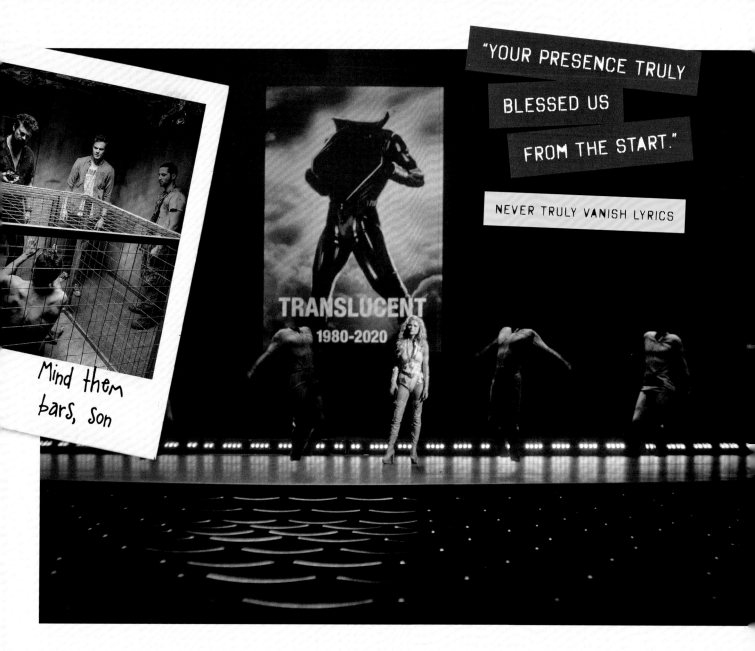

TRANSLUCENT

1980-2020

Mind them bars, son

a big, sweeping, epic chorus to remember, a big bridge build that all power ballads have. I knew the scene was going to be a funeral where she was going to raise her hands and they were going to glow, so I needed to make sure there was a big moment to sync in with that. I wrote that first demo, and Eric loved it.

"The great surprise was Erin had mentioned to Eric that she had sung in high school—she wasn't a professional singer, she hadn't sung in a studio before—but she was up for it. I talked to Erin by phone, got a sense of her range, and we tailored the song to let her voice shine. Once she got in the studio, she blew us all away. She not only sold the notes of the song, but she also knew how to get the most humor out of it, and that was by playing it super straight. She's doing her duty as a good member of the Seven, when in actuality she's getting ready to out Compound V and basically expose the whole thing. It was the beginning of her character shift.

It was important that the power of the ballad and the power of the way she sang it would let the audience know this is where we are now. It was fun to tell that story while people are cracking up at a floating yarmulke."

The music video that was eventually produced for "Never Truly Vanish" did not disappoint. "My jaw was on the floor when I finally saw what they shot," Lennertz says. "I was like, 'This is better than it read in the script.' And it read great in the script."

"THERE AIN'T
NO DAY LIKE A
RACE DAY."
FASTER LYRICS

FASTER

Similarly, when A-Train is slated to retire from the Seven, Vought decides a musical tribute in the form of a rap song would ease his departure and help sell it to the public. Lennertz recounts that it was intended as a one-scene joke. "The crazy thing when I got the script, it said that we're going to cut to me—with my name in the script—rapping an original song that I haven't written yet, and I have to be terrible," he says. "I started cracking up. I'm like, 'I guess I'm in the show.' I need to be so bad, when A-Train sees it, he literally just shakes his head in disgust. He can't believe he's being forced out like that. At that point, we didn't know that Jessie was ever going to do it. We just knew we needed a bad rap song—not a bad song, but a terrible rap performance, which I knew I could do. I am not a rapper, and happy to be the butt of the joke."

But the results turned out to be undeniable. "We ended up writing the whole song, and everybody loved the hook of it," says Lennertz. "Eric said we should really do a full version, and let's see if we can get Jessie to do it. (Usher) was like, 'Yeah, I totally rap. I would love to do it.' He came down to my studio, and he just nailed it. It was so good, with so much swagger. We decided to do the video and have it be part of this in-world universe Eric's creating. I saw the video and couldn't believe how good it was, how fantastic it looked. Aimée Proal, who sang the hook in the middle, had such a great, soaring voice. She's fantastic. It became what it was supposed to be, which is this anthem about the sun setting on A-Train's career in the Seven. Of course, when everything went to hell at the end of Season Two, he ended up back in the Seven."

THIS PAGE: A-Train raps about life and loss in the music video for "Faster".

VOUGHT
ANNUAL
REPORT
2022

EVERYTHING'S FOR SALE

THE SUPERHERO BUSINESS

It should be obvious to anyone with eyeballs (or ears) why image and branding are so meticulously safeguarded at Vought. Apart from pharmaceuticals and contracts for crime fighting and military ops, consumer goods and media are a huge chunk of the company's profits. There is hardly a product on the planet that Vought doesn't produce or whore its Supes out to shill. One needs only to look around to see the mask Vought presents to the world...

"Vought owns this world. They're everywhere. They're in your supermarket, they're in your drugstore, they're inhabiting restaurants, they're creating their own theme parks," said production designer Arv Greywal. "We have to generate all of that imagery from scratch. It starts with a photo shoot with the actors, some sketches of the characters. If we're doing the Vought theme park where The Deep ends up, we have some cartoon characters that kids would enjoy.

We've done bags of peas that you'd find in a grocery store. Noir's selling razors... Vought CDs, Vought posters, Vought superhero books, coloring books, that sort of thing. It's fun to think up all the things that you could do. Everywhere from the pawnshops, to the streets where you might see billboards everywhere—including online media—so when Stormfront is holding her camera phone up and she's seeing all this media of people commenting on what she's doing, every single

piece of that is generated. It takes literally a little army to generate all that stuff." The fulltime team is 14 members, expanding to 25-30 with freelancers and specialized artisans—such as those that produced the Soldier Boy statue outside Vought Tower.

A "super" fun place audiences get to experience in the latest season is Voughtland. "Voughtland is really a chance to do what I call a world-building piece—a show piece that really hits home what Vought is about and what *The Boys* is about," says Season Three production designer Jeff Mossa. "Everywhere you look is a chance to buy some more Vought product. Every ride is just another version of the old Vought story just amped up into the new Vought story. If there's something to be taken advantage of, they will take advantage of it.

It's over the top, in your face. The tone and aesthetic is a combination of [the happiest place on Earth] and [that place with half a dozen flags]—but take those and mash them together, and throw in a good heaping pile of shameless corporate self-promotion from Vought."

But these aren't just visual jokes. Some of these products and images are Easter eggs and foreshadowing. "We love dropping in these little clues," says Kripke. "When Hughie walks out of the thrift store in the beginning [of Season Two], he passes a poster for Liberty, who's advertising a feminine hygiene wash from the '70s, and then three episodes later, Liberty's a character. Or, when Hughie gets on the subway with Annie, there's a Church of the Collective poster in the deep background, advertizing

their book that they give to The Deep later in the episode. It's those kinds of details that Arv did so brilliantly, and just made it come alive."

Kripke adds, "We always really try to ground the media, and the art, and the branding of Vought with real-world examples. It's Arv and his art department, who are all geniuses, it's them who say, 'Okay, if this was a real campaign, how would it really look? What would the logo of Girls Get It Done be?' for example. 'What is the logo of *Dawn of the Seven*?' Everything from memes, to movie posters, to commercials. The main thing I tend to push on everybody is, 'No, no. That's a real movie, and that's a real movie poster.' Not just, 'Here's a piece of art or a product.' How did it come to be? What meeting created that?"

THIS SPREAD: From credit cards to commie-punching cinema, Vought's got you covered.

She's the "COUNTESS" you can count on!

...using the Fire of Freedom to Fight the Commie Machine!!

"Crimson"

Arv Greywal presents
A Best International Picture

"Crimson"

starring
THE CRIMSON COUNTESS · JEFFREY T. JEFFRIES · PAMELA CHOW · CURTIS HUANG · and TONY SCHLENK

Produced by Josh Greenberg • Written and Directed by John Slope • COLOR by Moviestock

feel the liberty of freshness

LIBERTY

presents
autumn breeze

vought feminine products

autumn breeze is every womans perfect insurance against intimate odours

Who are you looking at, cunt?

MEDIA IN WORLD AND OUT

"One of my personal favorite things about the show is the way it uses the media as a character," says co-executive producer Michaela Starr. "Whether it's breaking news on VNN or NNC (National News Channel), a live social media report, a new music video for Starlight or A-Train's latest hit single, a commercial for Kuddle Buddiez, or a star-studded porn DVD. We take our in-world media seriously on *The Boys*. Check out our extended content and deleted scenes on X-Ray and YouTube!"

Fan demand has been such that additional real-world content was inevitable, despite the challenges faced. As Starr explains, "When Sony and Prime Video pitched the idea of doing an aftershow for *The Boys*—in the middle of a pandemic—we were all a little confused. But with the help of Embassy Row (*Talking Dead, Talking Bad*) and a completely virtual set inspired by *The Boys'* Haitian Kings basement hideout (and ace host Aisha Tyler), we were able to pull it off—and dive deeper into the behind the scenes development and production of the show."

LIFE AFTER THE SEVEN

THE DEEP AND A-TRAIN DEAL

Sometimes, however, all the PR in the world can't fix broken. If you've been outed as a sexual predator, or even if you just can't hack the physical demands of the job anymore, perhaps it's time to step back from the limelight. At least for a little while.

When Vought exiles The Deep to Sandusky, he can think of little else besides getting back into the Seven. "I think he wants back in under any circumstances," says Chace Crawford, Lord of the Seven Seas. "I think he would be Homelander's assistant at this point. He misses that fame lifestyle. He thinks he was way wronged, and that his punishment was over the top. When we first see The Deep again in Season Two, he's like, screaming and drunk at a children's water park in Ohio. And then he sort of hit rock bottom."

"I desperately miss having someone to kick around," says Homelander, er, Antony Starr. "Everyone needs a lackey, right? But who knows? Vought might need a new shoe shiner, so there might be an opening coming up."

As for A-Train, his short expulsion from the majors prompted a lot of hand-wringing, but no great desire to get out and do good. "I can't even remember the last time A-Train saved somebody. It's all about money and status. If you think about Season One 'til now, you haven't seen A-Train save anybody," says Jessie Usher, dismissing any talk about A-Train pulling that train. "It's not like the train was full of passengers in danger. He was training, so he wanted to look good with his shirt off," he says.

THIS PAGE: After being booted from the Seven, The Deep and A-Train find a temporary home in a shady organization called the Church of the Collective.

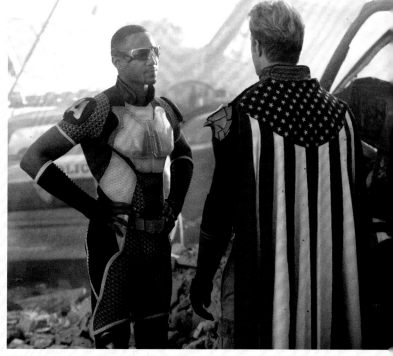

WANNABES

NEVER WERES, HAS BEENS, AND OUTCASTS

Some Supes have their time in the sun, but vanish and are never seen again. We've witnessed them reduced to survival mode, selling their bodies or hawking signed headshots at conventions. Another example in Season Three is the former top dogs at Vought, the Supe group Payback, surviving members of which are cashing in on what remains of their fame. "B- and C-list celebrities are even funnier for me than the A-listers," explains Kripke. "That's why every season there's one or two faded celebrities making borderline porn, like Season One had Popclaw. Or, Mesmer and his kid cop show. There's something funny and heartbreaking about those characters—people fighting to get back into the spotlight after the spotlight has left them."

THIS SPREAD:
(Clockwise from left): A-Train and Popclaw (Brittany Allen); Popclaw on the cover of some softcore porn; Lamplighter (Shawn Ashmore); Eagle the Archer (Langston Kerman); Mesmer (Haley Joel Osment); Young Mesmer (Aram Avakian).

"I DON'T BITE."

POPCLAW

THE WANNABES

And then there are other Supes that never should've seen the light of day to begin with (and if Vought had had their way, they never would've). We're speaking, of course, of the patients at the Sage Grove Center, a psychiatric hospital <cough, Supe prison, cough> located in Pennsylvania. Vought has experimented on these unfortunates, trying to perfect a formula for Compound V that will work on adults. They've had mixed results, shall we say. When the Boys investigate a lead there, they encounter Lamplighter, hard truths are revealed, and all hell breaks loose.

"It was a fun episode, but there was so much emotion around that section of the script, like it was missing a bit of our signature crazy. It was too long on just melodrama, and we needed to break it up," says Kripke. "All the Supes that escape have credible and creepy powers, but we wanted one insane left turn. We had always wanted to get Love Sausage in. In the comic, he's got this huge penis and that's why he's called Love Sausage, but it's not this prehensile tentacle, so we gave him that power."

Karl Urban recalls when they learned about that scene: "We got the first draft of that, and there was no penis around M.M.'s neck. And then at some point we got a rewrite, and we're all sitting in a van about to do a scene, and Jack's like, 'Yo, did you see the rewrite with the dick around your neck?' And because we'd been playing practical jokes on each other, Laz was like, 'Naw, you guys are messing with me. That's not a thing.' And we're like, 'We're not! It's true!' And so he went out and got the First A.D. (assistant director), 'Can we get a script over here?' He flips through to the end—the horror that came over his face when he saw that there was going to be a dick wrapped around his neck... It was just shock. He was like, 'Man, what'd I do to Kripke? I didn't deserve this! What did I ever do to him?' And he thought I'd put Kripke up to it, it was a conspiracy." For his part, Kripke refutes that it was Urban's idea, but he does note, "I just want to be clear that I only wrap ten-foot dicks around the people that I love."

Fuckin' Hell

THIS PAGE: Fan favorites Love Sausage's schlong and Cindy (Ess Hödlmoser).

Tig Fong describes the action on the day: "Our actor who played Love Sausage looks quite a bit like the character in the graphic novel. The penis required an actual, physical, ten-foot, prosthetic penis, supplied by special effects, as well as a shorter one that would've been about two-and-a-feet long that you put your hand into, to reach in through a slot in the door and physically grab Mother's Milk. That's assisted by VFX to give it a more snakelike movement." And of course Alonso sold it. "When we were shooting my coverage and my reaction, I remember the director saying, 'Um, do you think you'd be that freaked out?' I'm like, 'Do I think that I would be that freaked out?! Do you realize what just happened here?'" Alonso says.

Luckily for M.M., Kimiko is there to punch out that dick with a multi-fingered ring that reads, "BOSSY". "I love that ring," says Tomer Capone. "I'm sad that Love Sausage got out of jail after, who knows, the first woman who ever touched him was Kimiko, The Female, with her ring. And that's a statement, too! A big penis trying to get us, and she's just bossing him out, right?"

One especially frightening inmate escapes during the confusion: a Supe named Cindy who can squish you with her mind. Where has she gone? "There are no hard and fast plans yet, but I have a feeling she's too popular not to show up again. In the writers' room we have a board of outstanding stories we want to get back to. Cindy is near the top of that list, for sure," says Kripke.

"JESUS-THUMPING ELASTIC BASTARD." BILLY BUTCHER

RELIGIOUS HYPOCRISY

BELIEVE EXPO & SAMARITAN'S EMBRACE

Here, for a few measly thousand dollars, you can meet Ezekiel, the amazing elastic Supe and organizer of Capes for Christ. He's also an ordained minister (as is Homelander!) and runs a Christian charity called Samaritan's Embrace. Yet, despite his sanctimonious rhetoric condemning homosexuality, Ezekiel has been the meat in a manwich more than once. Oh, and his charity? It runs Compound V all over the country for Vought, disguised as shipments of polio vaccine.

But Believe Expo is where two of our real heroes stand up for themselves, possibly for the first time ever. Hughie survives a harrowing baptism by Homelander, but more importantly, he successfully blackmails Ezekiel for information using a phony story—something he never would've tried a few weeks ago. And Starlight, for whom the expo was meant to be a sort of homecoming, essentially declares onstage that she's mad as hell and she's not going to take it anymore. "She

starts to realize there's underlying themes of discrimination and homophobia and sexuality suppression," says Erin Moriarty. "It just clicks in her that there are so many contradictions, so many hypocrisies in the adult world right now. She just says, 'I'm done. I'm done taking bullshit. I'm done enabling this.' And I respect her so much for that, for her ability to stand her ground and speak up. It's a level of boldness that I've never quite had, so it's fun to play that through a character."

"PEOPLE WHO HAVE FAITH

THOSE ARE MY PEEPS Y'ALL."

EZEKIEL

THE CHURCH OF THE COLLECTIVE

When a drunken and raving Deep is arrested at a water park, Eagle the Archer bails him out and introduces him to Carol, part of a group of Fresca devotees called the Church of the Collective. They give him a copy of their ur-text to study: *Destinations: The New Science of Self-Renewal*. Maybe they have the answers he's seeking? Maybe joining a shady, cultlike organization and having a heart-to-heart with his gills (voiced by comic actor Patton Oswalt) will turn things around for him? "The spiritual, psychedelic mushroom journey—that was a lot of fun. I tried to play it as layered as possible. I like when they dip a little into the darkness and the self-loathing and this pathetic sort of fragile man that he is," says Chace Crawford. The Deep even recruits A-Train into the Church. Hell, he'll marry the wife they pick out for him if it'll get him back to Vought Tower.

But it seems the Church just likes collecting Supes, their money, and the dirt on them, without really delivering on the many promises of enlightenment and power that it's made. Ultimately, Eagle, A-Train, and even The Deep abandon it. As The Deep screams at Alastair Adana at the end of Season Two, "I signed over my bank account to you! I filled out all those fucking children's workbooks! I married some weirdo who gives terrible blowjobs! I did everything you asked! And when I found out we're all just fucking space spores, I didn't laugh! I did everything you asked! Because you said you'd get me back in The Seven, you fucking promised!" He then adds, "Fuck Fresca."

"I loved the opportunity to explore cults and the impact of organized religion on wayward souls like The Deep," says Michaela Starr. "We'd been looking for a way to work with Goran (Visnjic) again (he played time-traveling terrorist, Garcia Flynn, on *Timeless*), and Alastair Adana felt like the perfect role for him."

THIS SPREAD: Eagle the Archer (Langston Kerman) and Carol Mannheim (Jessica Hecht) introduce The Deep to Alastair Adana, the Church of the Collective, *Destinations*, and Fresca.

SEX & POWER

SEXUAL ASSAULT & HARASSMENT

As mentioned before, the ink on Starlight's contract with the Seven isn't even dry before The Deep pressures her into a disgusting #MeToo moment. When she finds her voice and calls him out on it, Vought does what so many other responsible organizations do when credible allegations of sexual assault come to light: they slap the perp on the wrist and sweep the scandal under the rug. Banishment to Ohio is obviously not enough.

"Clearly, he should be serving some prison time on some charges," says Chace Crawford. "But guys like that, I feel like they go through with the apology and they're, 'Well, I did it. This should be squashed.' But he got punished, and clearly needs some more soul-searching."

Given the current climate in Hollywood, depicting that incident was controversial. "As we were evaluating the shot pilot, the #MeToo movement had begun to

pick up steam, and I remember there was a general nervousness from the powers that be about including the scene where The Deep assaults Starlight," explains vice president of television for Point Grey Loreli Alanís. "But the producers felt very strongly about keeping it, because it exposed exactly what the movement shines a light on: systemic abuse of power. I thought it was really smart to show the sequence through

THIS PAGE: The Deep discovers there are consequences for sexual assault—just not very many or very serious.

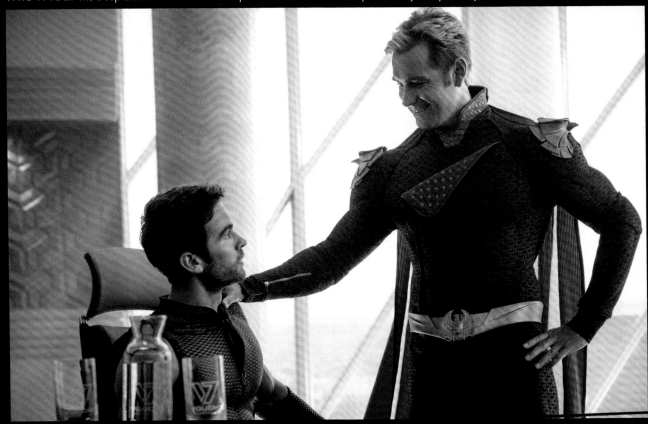

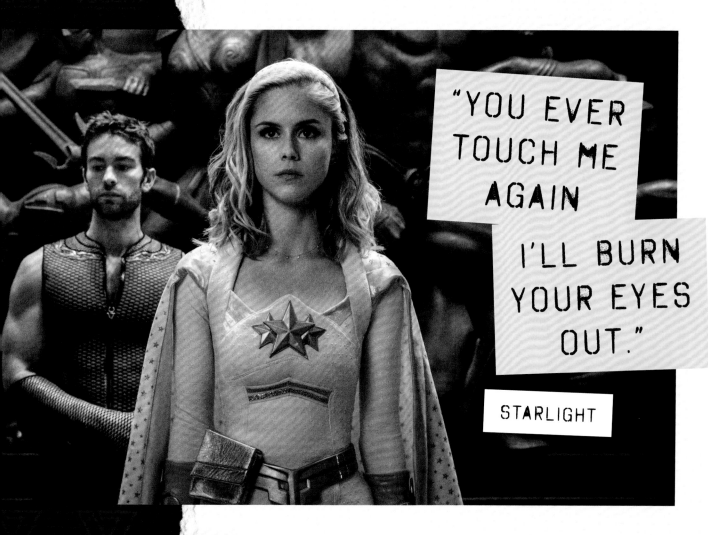

> # "YOU EVER TOUCH ME AGAIN I'LL BURN YOUR EYES OUT."
>
> STARLIGHT

Starlight's point of view and then track the fallout as it forever changes her, because it allows the audience to understand—and for many, to directly relate to—the long-term impact of that type of abuse."

Initially, even Erin Moriarty had her doubts: "Viscerally, I probably winced and cringed. But as I kept reading it and I saw where it was going, and how it was going to abruptly set Starlight on an interesting, but ultimately empowering trajectory, I got really into it. She's able to make the world of Vought a better place, because it happens to her and because of the way she responds to it publicly. So, ultimately I was

really proud to be the actress they chose to be in this storyline. I was super into depicting it."

And as for The Deep, at least he gets a small taste of his own medicine when a fangirl he brings home makes unwanted advances to his gills during heavy petting. "For the fingering scene they made a torso of me with actual body hair," says Crawford, "and I'm laying like this <lays back>, got the fake torso on top of my torso, and the camera's right here, the director's in my face, [prosthetic artist] Paul [Jones] is right behind me, pumping away at the air pressure to make them move. It was disgusting. I couldn't get out of there fast enough."

> *"IF THEY WANT A LESBIAN KEN DOLL, THEY CAN FIND SOMEONE ELSE."*
>
> *ELENA*

PINKWASHING

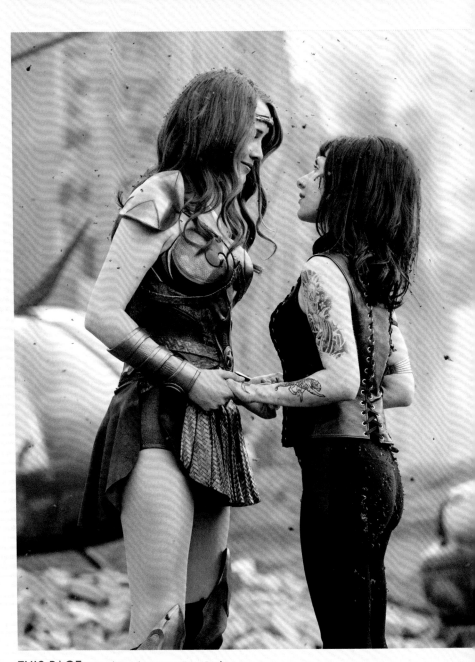

THIS PAGE: Vought cashes in on Gay Pride.

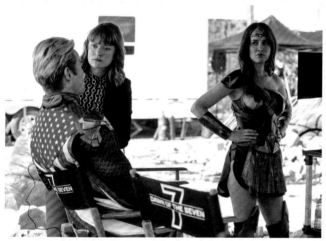

Vought is not a fan of its Supes coloring outside the lines. "Across the board, Vought has a say in everything: what you wear, who you hang out with, where you go, what you do, how you look, if you want to change your hair color," says Jessie T. Usher. "Your sexual orientation? If you want to do something they've not pre-approved, you have to do it in the shadows. If you want anything to be in the forefront, you almost have to ask them first." Of course, if Homelander outs you without your permission, like he did to Maeve, Vought won't just roll with it—they'll capitalize on it. Cue the Brave Maeve Pride Bars and vegetarian lasagna! Break ground on her Inclusive Kingdom at Voughtland—Coming Soon!

But Usher's not surprised, and doesn't think you should be fooled, in the Vought universe or out. "That's Vought. That's their M.O. That's how they've always been. For anyone to think that that scenario would be any different, it's just foolish. Everything that's happening feels so un-genuine. It's hard to believe a company will support Pride because they want to. What it really feels like is that the masses are telling them, 'Hey, if you're not going to show support, then we're just going to 'cancel' you." And Vought is not one to leave a buck on the table, even if it's rainbow colored.

HOMELANDER'S MOMMY ISSUES

Homelander has deep feelings for Madelyn Stillwell. He isn't capable of fully understanding them, but they go far beyond attraction, and they last far beyond her death. For example, he develops a taste for a particular form of dairy he finds in Madelyn's office mini-fridge after she's gone. "For Homelander it's a way of reconnecting with the person he was closest to in a lot of ways—who drove him nuts—but was his number one ally as he was coming up in the superhero business," says Antony Starr. "And I think breast milk is just a lonely, tragic man's way of connecting to the woman he loves."

Presumably after his milk supply runs out, he finds another way to connect to Madelyn, with the help of Doppelganger. The

You are one sick cunt.

THIS SPREAD: Madelyn Stillwell (Elisabeth Shue) and Homelander's unusual relationship awakened complicated feelings in him after her death.

shapeshifter is happy to be of service—until Homelander loses his temper. As VFX supervisor Stephan Fleet tells it, "The Homelander/Doppelganger character morphing is one of the hardest things I've had to tackle on the show. It's very difficult to make it look real. We did a couple of interesting techniques where we overlapped the shadow from him blocking the light onto his face, and we were able to have them touch each other by splitting color and not actually

split the screen. But ultimately, an incredibly rewarding day because Antony Starr is amazing."

Kripke explains that Doppelganger's morphing into a copy of Homelander hit just a little bit too close to home for Homelander's liking. "Stormfront's conversation is ringing in his eyes: 'Why are you so weak and pathetic? Why do you need other people's love?' He just can't handle that, and so, he has to murder that particular side of himself. But he did

not kill it permanently. He's far too needy." He adds, however, "If you ask me what was one of my top five regrets of the season, things I wish I could've done different, it would've been Doppelganger as Homelander actually going through and sucking Homelander's dick. I feel like we left money on the table with that one. 'Cause he's right there! And you're like, 'Oh my God! He's gonna do it!' but then we pull back. But the money move would've been to really do it. And then kill him. Of course."

SUPE SEX

BUMPING UGLIES WITH THE GODS

Given the egos and muscles involved, Supe sex is rarely gentle. (Except for Annie and Hughie; she goes easy on the big lug.) In fact, it's often deadly—just ask Popclaw's landlord. (You can't; she crushed his skull while sitting on his face.) That's why it's so gratifying when Homelander and Stormfront get together. Here are two people who were almost literally made for each other, who can just cut loose and bang like there's no tomorrow. (Like there was no tomorrow for

that criminal in the alley, whose corpse they had sex over.)

Erin Moriarty, for one, is a fan of what that freedom represents. "I love the tits lasering moment. I love that Stormfront is just standing there—that's the moment that he kind of falls in love. He's like, 'Oh my God! I finally met my match! I can finally laser someone's tits!' I loved that. I loved the music, it was to Aerosmith, the whole thing. As fucked up as they were as a couple, I'm so into it."

THIS PAGE: Storyboards for Homelander and Stormfront's sex scene.

Shooting a no-holds-barred sex scene between horny Supes can be as challenging as staging a full-on battle, such as the time Homelander and Stormfront destroy her apartment in Vought Tower while doing the nasty. "We played out the dialogue scene first," said Arv Greywal, "then my crew and I revamped the apartment so that we could have fake walls, lightweight bookshelves, a chandelier that dropped down, tables that got smashed up, and we rigged all that together. There's a tremendous amount of rigging to throw people back and forth. We actually had to cut holes in walls, cut through ceilings, cut through glass at one point to accommodate the wire work."

In Season Three, however, we witness a consensual supe-on-normie sex act that goes all kinds of wrong. Let's just say that miniature men in urethras should lay off the coke. "We have to keep track of the scale of this guy shrinking and growing. He actually grows to three different sizes throughout the course of this entire sequence," says Stephan Fleet. "In what we're calling the 'alien landscape,' when he shrinks down on the table, he's three one-hundredths the size of a human. He's about seven millimeters—super small. It's crazy to do the math with cameras and stuff, and figure out how that's going to work, and look seamless, and photo real."

"I TOLD YOU... I DON'T BREAK EASILY."

STORMFRONT

Need a giant penis for a little man to climb into? Call the folks who built the whale! "Ron Stefaniuk and his gang are just fabulous," says episode director Phil Sgriccia. "They built a 25-foot-tall penis, with a 40-foot-long urethra connected to it. Brett Geddes, our Termite character, was naked most of the time he was on set. He was such a trooper. You couldn't ask for a better guy to jump into this sort of thing. The urethra was amazing, because it was glistening and we had movement inside—projectors on the outside showing blood movement in the urethra. We're going to add little touches in visual effects, but mostly that whole thing was foam and rubber molded to look like the real thing."

Fleet walks us through the process to make it look as realistic as possible once Termite sneezes: "We had one of our companies, Pixo-Mondo, do a moving concept piece for how this guy blows up out of his boyfriend's body. It's not really an explosion like a bomb blowing off in someone. It's literally something growing out of someone, specifically out of the belly in the front area. It would block a lot of blood in the back, there's a trajectory to the body; the organs would drape down like a waterfall of guts, which is what we call it. We won't do too much green screen—that would maybe

look a little more fantastical."

Then the mighty Termite gets into a fight with Frenchie and Kimiko, and things look dire. Only inside-the-bag thinking by Butcher saves the day. "One of the big things was just making sure the coke looked believable, whatever the size," says SFX supervisor Hudson Kenny. "Art department used a lot of rock salt and water softeners, the kind of big, cube, white pieces. But whenever the coke was actually

interacting with the talent, we used the starch snow we use for snow dressing. It's biodegradable and actor friendly. It can actually go in his eyes and not hurt him. He was covered in blood for most of it, so we kind of tarred and feathered him with the coke. It was wild. We basically just mimicked a coke bag to scale. He was actually jumping on a trampoline for those bits, and we had a bar on top that we moved up and down to mimic

Butcher shaking the bag. And we just got him to go crazy in there. We were telling him to do flips, and it was kind of freestyle."

Despite how awesome the scene turned out, Sgriccia laments, "I think Kripke is trying to turn me into a porn director. Last season all of the porn that Lamplighter was watching, I shot all of that stuff. Kripke tells people, 'I've got a porn director on my staff.' That's a new feather in my cap, I guess."

THIS SPREAD: Concept art and on-set green-screen photography for Termite's ultimately tragic urethral odyssey.

"DON'T STOP. GET TO THE PROSTATE."

PETER

SEX & VIOLENCE

KIMIKO'S DILDO BATTLE

The setup is simple: Kimiko has to battle against overwhelming odds using only dildos. Yes, dildos versus knives and guns. Of course, Fukuhara gets some help from Fleet's VFX wizardry. "In a lot of ways, this is almost like a traditional visual-effects-meets-stunt sword fight. A lot of the gags are the same. When you're doing sword fights and you're stabbing through people's mouths or through their chests, they always have fake swords that are cut in half. The computer will make the CG part that goes into the body. So, instead of swords, it's dildos. There's a lot of people running around with these half-cut versions

of those dildos, and we're putting trackers on them. We'll swap out in Karen's hand from the full one to the half one," Fleet says. (Fun fact: custom, high-end prop dildos were designed and manufactured for each of the Seven!)

"Yes, it's a crazy, ridiculous, insane fight, no doubt," says Season Three supervising stunt coordinator John Koyama. "But they ground it, in that the real meaning behind this is women empowerment, because she's fighting them and killing them, and freeing the sex-trafficked girls. Karen Fukuhara, honestly, she's amazing. She's incredibly

talented—as good or better than a lot of the stuntwomen or stuntmen, actually, that I work with. Once you teach her, she just makes you look good. Her dedication to the craft... If it's scheduled for an hour, she'll stay two. Scheduled for two, she'll stay three. She's that kind of perfectionist, and it shows. She's killed it, like every piece of it. She hasn't missed any beats. Timing is perfect. Hits are perfect. Choreography is perfect."

And, just to be clear, female empowerment is not simply an issue to be mined for story potential. The show has practiced what it's preached all along. "I'll never

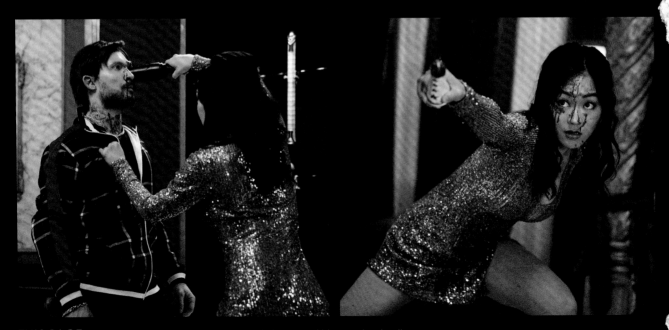

THIS PAGE: In the right hands (and with some VFX help), even dildos can be deadly.

forget filming the 'Girls Get It Done' press junket scene [early in Season Two]," says Michaela Starr. "It was a send-up of world premiere press tours, but there was this moment where I looked around video village and it was all women at the monitors: female director, female writer, female producer, female script supervisor, and female still photographer. It was definitely an empowering moment realizing that there are so many girls working on The Boys. From our writers to actors to executives to producers to crew, I'm proud to be one of "The Girls of The Boys" and agree with Frenchie—Girls DO get it done."

HEROGASM

A highly anticipated location from the comics makes its appearance in Season Three: Herogasm, the hedonistic getaway for Supes who want to let their freak flags fly. Switched from a remote island to a secluded mansion for story reasons, the sexy shenanigans on tap will not disappoint the fans. "We're likely to see some of the craziest stuff that you've ever seen on television: sex on the ceiling, superheroes with body parts that should not necessarily be shown on TV, but are going to be, doing things that are somewhat unmentionable," says production designer Jeff Mossa. "The location we got is spectacular, and it feels like the sort of place that a swingers' group might have holed up in the '70s. There's a certain vibe that comes along with that, and as soon as we're in those scenes, you're going to feel it."

Will there be fights? You betcha. "Kripke and Evan brought it up to me way before even prep," says John Koyama. "So, this was a big deal, a huge deal. And we had to create something special. Everyone's been waiting for it. Everyone in this fight performed 100% of all their fighting. The only time we used a stunt double was for the wire gags. It's a testament to them, their dedication, commitment. They just brought their A-game. They learned the choreography extremely fast, and they would take their beats and their acting moments. They were just meticulous with it and didn't want to stop. Just super happy how it turned out."

Kripke can only hold his head in his hands. "There will be no topping 'Herogasm.' Now that I've seen the dailies of this thing, I'm like, 'What have we done? It's just so crazy,'" he weeps.

HOMELANDER VS. BUTCHER

THE SHOWDOWN

Like a couple of runaway freight trains headed straight toward each other, Homelander and Billy Butcher are due for a spectacular collision. Sure, Homelander threw the switch that got them on the same track, but Butcher isn't stopping or backing up anytime soon. Okay, enough with the stupid train metaphors. The point is, these two irresistible forces are more alike than either would care to admit. They've both lost loves. They both tend to disregard the people around them when they have a personal goal to accomplish. But perhaps most of all, they both had shitty childhoods and especially shitty father figures. That has consequences.

"I'd like to start by saying I have a very good and healthy relationship with my father! My father is an amazing man, and has been my inspiration," says Kripke "But it's been my experience, in the nature vs. nurture argument, nurture wins ninety-eight, ninety-seven percent of the time.

THIS PAGE: Butcher and Homelander are locked in a blood feud. Terror has chosen his side.

NEXT PAGE: A rare, civilized sit-down between sworn enemies.

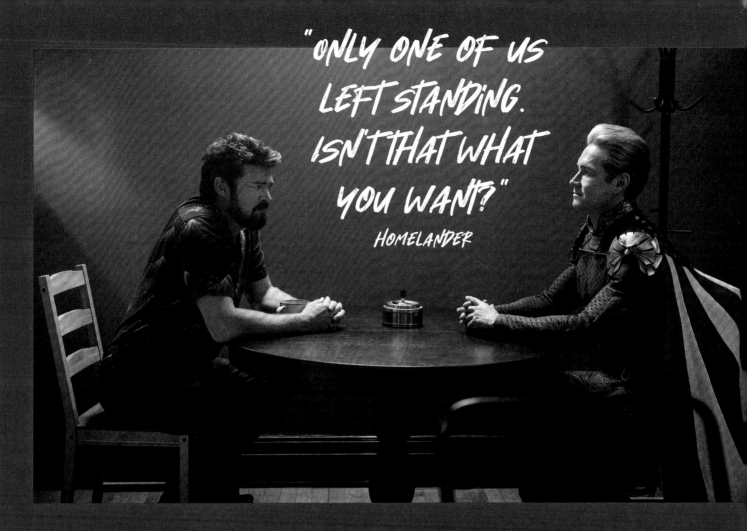

"ONLY ONE OF US LEFT STANDING. ISN'T THAT WHAT YOU WANT?"
— HOMELANDER

When you look at troubled, and dangerous, and violent people—obviously, they deserve to take responsibility for their own actions—but nine times out of ten they had a troubled childhood. This comes through in Season Three, where the sympathetic characters are the ones who were raised right, and the unsympathetic characters are the ones who were raised wrong, like Butcher, Soldier Boy, Homelander. So much of it is about that programming, and whether you can overcome it. Butcher isn't very good at overcoming it."

Homelander was raised as a lab rat by Dr. Vogelbaum, so that accounts for a lot of his dysfunction, but what about Butcher? "There is a monster living within Butcher, and

that monster is his father," says Karl Urban. "I place that squarely as his father's violence towards not only Butcher and his brother, but also his mother. And that is just this ugly being, this beast. And you see that character come out at a couple of different points... That is Butcher at his most dangerous. That is Butcher unhinged. Everything he touches is potentially toxic. He's a danger not only to himself, but to the people around him."

That deep-seated rage and frustration comes out of both men at times when they're under stress. Since Season One, Homelander has been going increasingly off-script during public appearances, growing more and more resentful of the mere mortals at Vought who

dare muzzle him. He even has a CG-laden daydream in which he cuts through a rowdy crowd of hecklers with his laser eyes, like a—well, like a rowdy crowd of hecklers with his laser eyes. It remains to be seen whether he'll go through with his threats to kill everyone on the planet. Butcher, however, is limited to human levels of violence—which is bad enough—until he gets his hands on some Temp V. Then he's able to let his supe-hate flow and put the hurt on like he's never been able to before. Too bad Gunpowder got to be the first to experience it.

"The point we wanted to make, both in that storyline and in that scene, is that the advantage of wielding raw power is often just

"I MADE A PROMISE."

BILLY BUTCHER

one of convenience. You can just do things faster," says Kripke. "It would've taken him weeks or months; but now he's able to take this guy down in seconds flat and feel the bloodlust of the bone breaking under his fist. That's really intoxicating to Butcher, but obviously, that's a really dangerous road.

"That's why we wanted the murder of Gunpowder to be as gnarly as it was. It wasn't supposed to be a moment like the end of *Rocky*, where you're supposed to cheer. You're supposed to be disturbed about this road that Butcher has taken his first step down."

Phil Sgriccia, who directed the scene, says, "The whole time we were with Sean Patrick Flanery, we were saying, 'Why are we killing this guy? He's great.' He's such a great guy, great actor. He and Karl had a great time doing all their scenes together. We like to have the actors do as much of their stunts, as long as it's safe and they can do it. And it was like, 'How far do you guys want to go on this fight?' And they went bananas! Sean was game for everything, and so was Karl. He's basically killing him with his fists, and he gets so angry the lasers slice his head and the car in half. It's pretty amazing what Karl did in there, and also Sean, because he's pleading for his life. It's hard to watch in some ways. But I'm happy with that scene. It worked out just as we planned it, which doesn't always happen. But most of that is on the shoulders of the two actors."

That kindred-spirit need to give into blind rage is something Homelander senses in Butcher, and that's why he goes to have a sit-down with his sworn enemy at the beginning of Season Three. They understand each other like no one else. They also understand that both of them cannot occupy the same world for long. They agree there should be no more compromises, only scorched earth until only one is left standing. The gloves are finally off.

THIS SPREAD: Butcher's Temp V-fueled smackdown of Gunpowder (Sean Patrick Flanery).

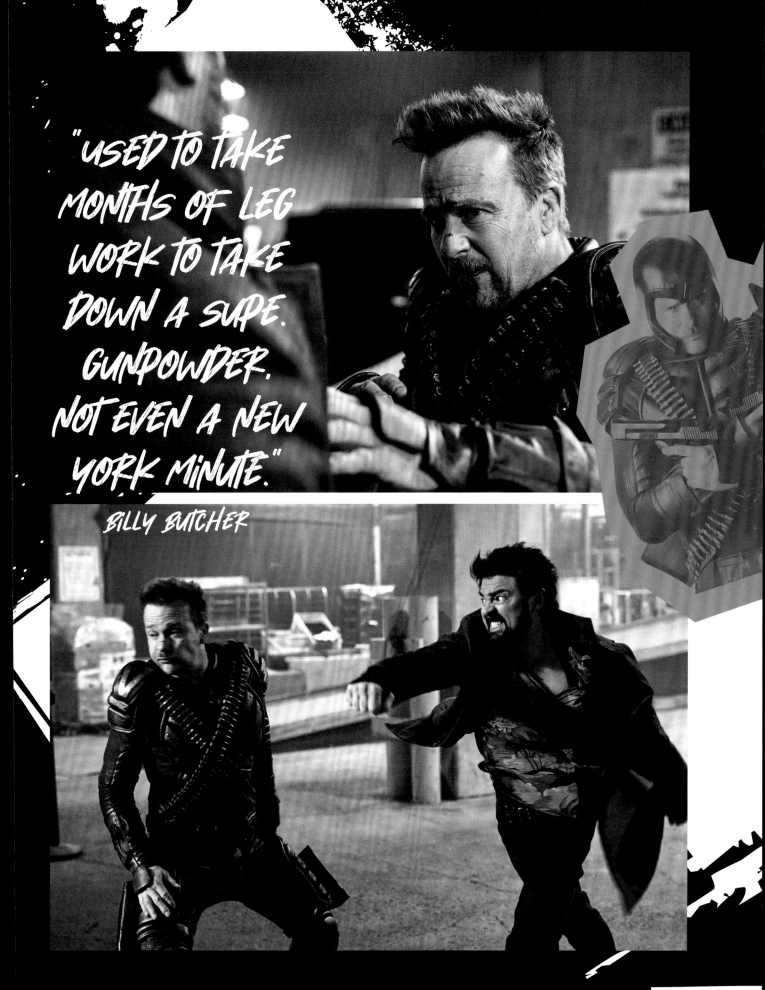

"USED TO TAKE MONTHS OF LEG WORK TO TAKE DOWN A SUPE. GUNPOWDER. NOT EVEN A NEW YORK MINUTE."

BILLY BUTCHER

FAMILY TIES

FATHERS AND SONS

It should come as no shock at this point that the two characters with the worst upbringings get put in positions where they have to be fathers. Ryan has the misfortune to be on the receiving end of both. Homelander, given that he has zero frame of reference for what a family is, fails quite spectacularly. "I think he desperately wants connection in some way, shape, form... but he's just so deeply fucked up," says Antony Starr. "I really hope fathers don't connect too much with Homelander's parenting style. I do some pretty awful things to him with my

egotistical need for him to be a little Mini-Me. It's one of the more enjoyable scenes that I've shot, especially with Cameron Crovetti (who plays Ryan). He's great. It's so much fun being awful. I got to throw a kid off a roof and everybody clapped."

Butcher fares a little better, at least initially, taking things easy and bonding with Ryan over board games. But always at the back of his mind is the fact that, not only is this boy Homelander's son, but also that he caused the death of his beloved Becca. What makes him even try are his feelings for

the family that he's lost: Becca and his younger brother, Lenny. "Becca makes him promise on Lenny's grave to swear that he will protect Ryan, and invoking the memory of Lenny connects with Butcher on a very deep level," says Karl Urban "And then I think it's really quite as simple as being in the moment, when he sees that love of a mother for her son; it's not just Homelander's kid. No, this is Becca's son and she loves him. It's another log on the emotional fire, which prompts Butcher to do the right thing. Which is one of the rare occasions!"

THIS SPREAD: Family bonds, both biological and created, are at the heart of *The Boys*.

Ultimately, that's what separates the Boys from the Supes. They can form heartfelt emotional bonds that pull them through the extreme events they must endure. It's Annie and Hughie's love. It's Butcher looking at Hughie like he's a surrogate little brother. It's Mother's Milk taking care of the crew when he can't take care of Monique and Janine. It's Kimiko and Frenchie's twin flame connection

that only they understand. As Urban says, "The Boys' greatest strength is their compassion for each other."

In the finale of Season Two, this awareness hits home, bringing about a profound change in one of the characters: Kimiko's newfound ability to laugh. "This is the first time anyone hears Kimiko audibly. I struggled with it when I first read the script," says Karen

Fukuhara, "but then everyone's coming together, and she realizes she didn't have to struggle on her own. She's here facing Stormfront and getting her revenge... with her family. I think that's what makes that laugh happen, and that change happen within her." These battered and bruised individuals have come together to discover their own super-serum: a family called the Boys.

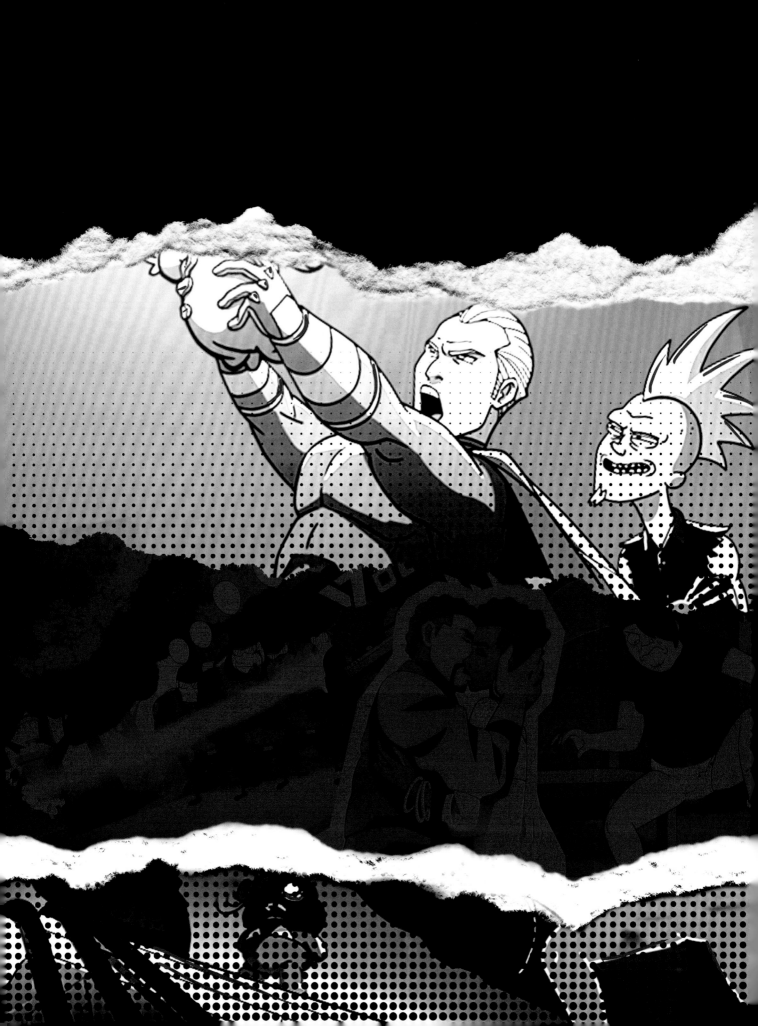

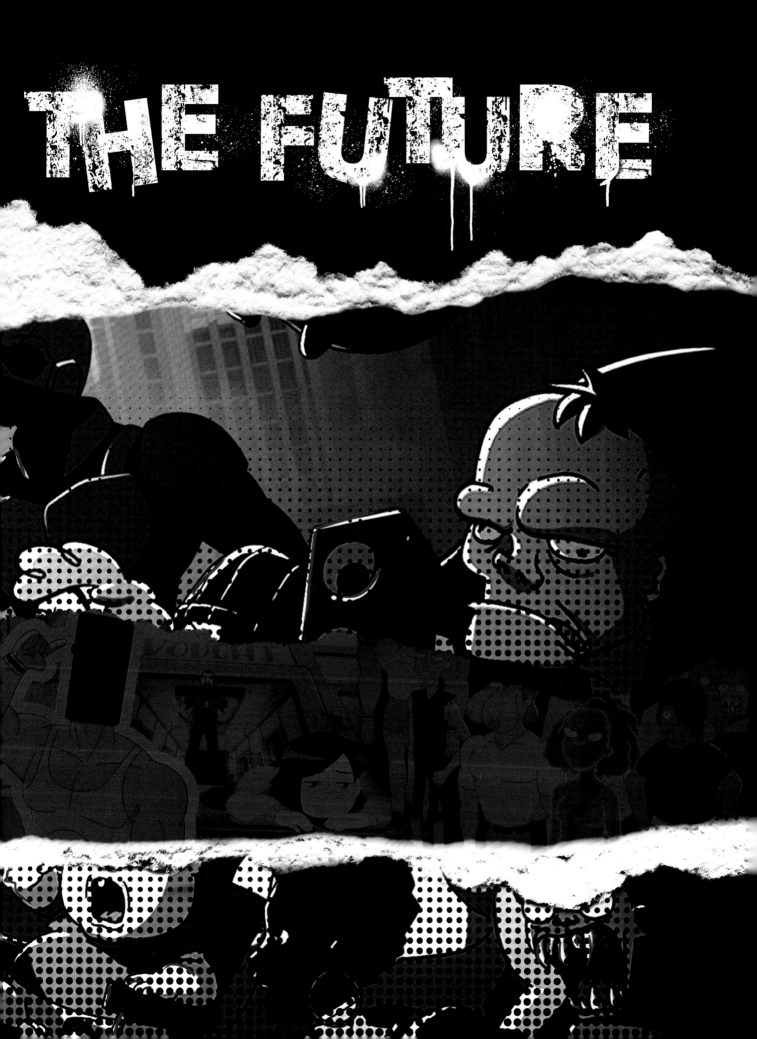

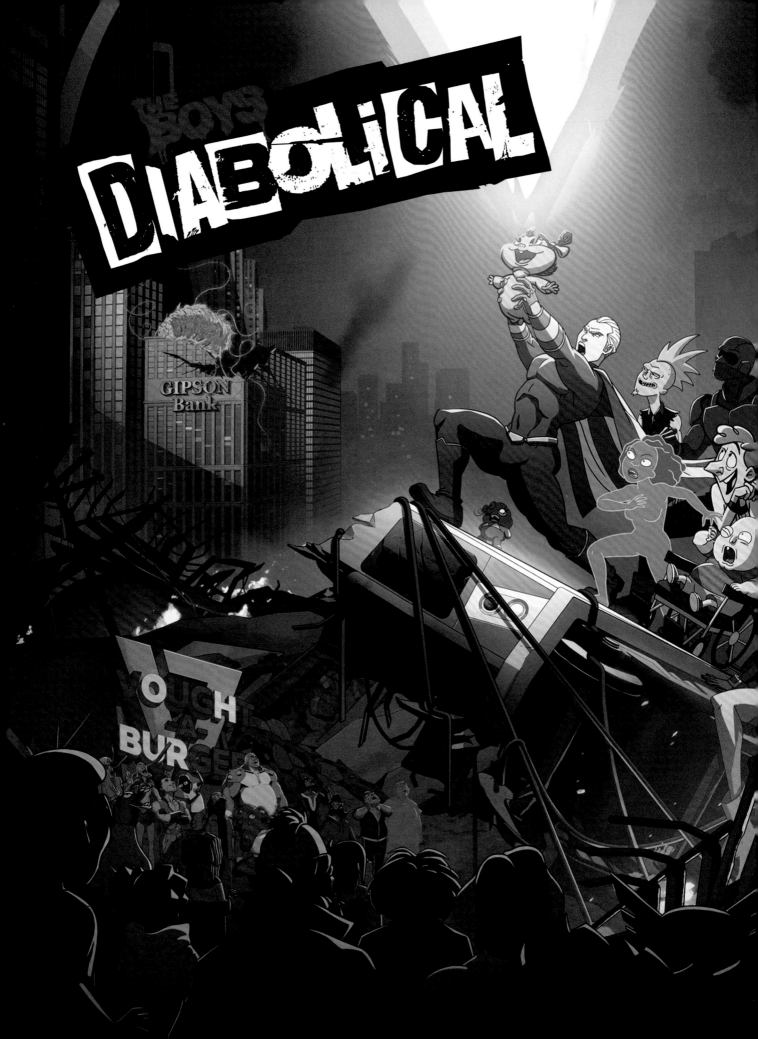

FUCKING DIABOLICAL

WHAT'S AHEAD

FOR THE VOUGHT CINEMATIC UNIVERSE?

Beyond the "mothership" series of *The Boys*, the brain trust at Vought is cooking up other ways for fans to enjoy the insanity of a world transformed by Compound V. Executive Producer Neal Moritz says, "We're trying to create a world that's all interrelated. They all stand on their own, but they are, tangentially, tied into a bigger world, which is really interesting to me, and hopefully to an audience."

Executive producer Pavun Shetty explains that, "With genre shows you get to discuss topical issues without being too heavy-handed about them. And the cranked-up tone of *The Boys* allows us to do that in an even more entertaining fashion. So, within the universe, we plan to explore a lot of different social and political areas that are worth skewering in unique ways."

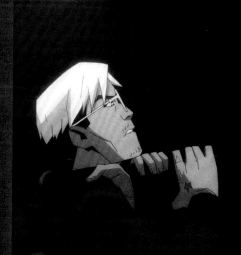

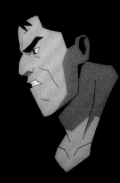

THE BOYS PRESENTS: DIABOLICAL

AN ECLECTIC ANIMATED ANTHOLOGY SERIES

"I was a big fan of *The Animatrix*, which was an anthology that didn't necessarily have to follow any of the main characters, and it could be totally different in tone and style from episode to episode. I wanted to do that here," says Kripke. Executive Producer/Showrunner Simon Racioppa explains, "The episodes are all completely different: it's really eight short films set in the world of *The Boys*. Each one has different vibes. Some are absurd, some are emotional and compelling. Seth and Evan also wanted to reach out to other celebrities, other creative

minds, to see if they would be interested in writing the episodes. The idea to make them all different styles [of 2D animation] came along later, when we decided to swing for the fences."

For Racioppa, *The Boys Presents: Diabolical* has been a dream project, despite the difficulties involved in bringing it to life in the midst of a pandemic. "It's pretty rare getting a blank slate like this, so we decided to take advantage of that and go for broke—resulting in the most challenging show I've ever worked on," he says. "To do

eight completely different episodes, in eight different styles, with eight different directors, writers, composers, etc., and almost a hundred different speaking roles, and all in a *single* year... The fact that they're short almost doesn't matter—the hard part is getting it all together and working. It's like making eight different pilots all at the same time. And it's only been possible because of the incredible (and often unsung) team behind every single frame. Watch those credits at least once please!"

The amount of artistic freedom

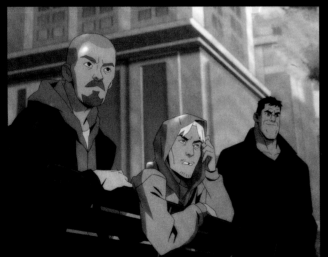

THIS PAGE: (Left) Wee Hughie (Simon Pegg) and Butcher (Jason Isaacs) spike a Supe's drugs in "I'm Your Pusher", featuring Kieran Culkin as O.D. (Right) Nubia (Aisha Tyler) brings the thunder in "Nubian vs. Nubian".

the producers allowed astonished and inspired supervising director Giancarlo Volpe: "Early on, I met with Simon, Eric, Seth and Evan to talk about the overall vision for *Diabolical*. They kept insisting that all eight shorts be stylistically different from one another, which is much easier said than done. I followed up with some nerdy film question about aspect ratio ('Would *Diabolical* have a more traditional 16:9, or 2:39 aspect ratio like *The Boys* original series?'). Eric's response was simply, 'Director's choice.' I don't know if he knows this, but that answer really resonated with me. One so rarely hears a directive like that in this business—permission to shape a project exactly the way one sees fit. I tried to continue that philosophy while interacting with our directors. Yes, I gave advice and guidance when needed, but in the end I heavily deferred to them to get their vision on the screen. I'm especially proud of that."

A FEW HIGHLIGHTS INCLUDE

X "I'm Your Pusher", a brand-new, original story by comic book co-creator Garth Ennis, set in the world of the comic book. Volpe says, "We even got Darick Robertson, the co-creator of *The Boys*, to design the cover of the comic book that the camera pushes into. That was very much designed to be a love letter to the comic book fans."

X "John and Sun-hee", a touching story of an older couple's love in the face of death, written by Andy Samberg, and directed by Steve Ahn with a Korean aesthetic.

X "Laser Baby's Day Out", a wacky short written by Rogen and Goldberg that pays homage to classic cartoons of the 1940s and '50s.

X "BFFs", Awkwafina's tale of a girl and her sentient piece of poop, done in the style of a Saturday-morning anime.

X "One Plus One Equals Two", the canonical inside story of Homelander's first mission for Vought.

Keep your eyeballs peeled for all sorts of Easter eggs!

THIS PAGE: (Left) "An Animated Short Where Pissed-Off Supes Kill Their Parents" introduces Kingdom (Parker Simmons), Boobie Face (Kevin Smith), Ghost (Asjha Cooper), Picante Balls, and Fang (Greg Griffin.) (Right) Sky (Awkwafina) in "BFFs".

UNTITLED: LIVE-ACTION CO-ED SUPE HIJINKS AT GODOLKIN UNIVERSITY

Find out what a pain it can be to grow up super. "After *The Boys* aired and it was a success, Prime Video and Sony let us know that they would be open to ideas to further the universe of the show," says Kripke. "At first, we didn't do anything with that, because if we didn't have an idea that we really love and feel passionate about, then we're not going to do it. But one idea that came up was the spinoff, and it emerged authentically while kicking stuff around with Evan Goldberg and Seth Rogen, realizing there was a whole world of who these heroes are before they get these big-city contracts. How do they get to that point? Who trains them? The idea of doing it as a college show was exciting to us. Michele Fazekas and Tara Butters, who ran *Agent Carter* and a bunch

of other shows, are running it."

Shetty explains that a further rationale for going to college was to cater to the fans: "We learned from Prime Video that the audience for The Boys is very young, which is generally a hard demo to attract to television since there are so many choices of media to consume. So, we figured we should double-down on that and showcase a new young cast, while trying to be as authentic as possible to the lives of the college students that already watch *The Boys*."

"This just feels like a very natural evolution, because it's going to take on college life in the same vein as *The Boys* took on superhero (and celebrity). I think there's a real relatability to it, even though it's going to be set in a superhero university," says Moritz.

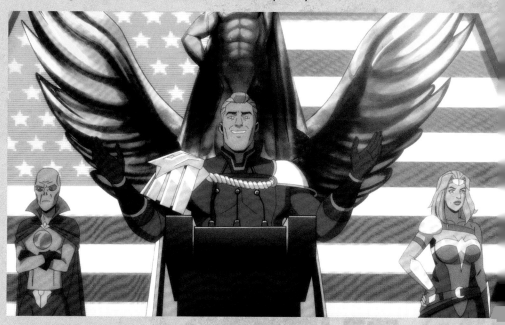

ABOVE: Homelander prepares to introduce Great Wide Wonder in "I'm Your Pusher", from *The Boys Presents: Diabolical*.
LEFT: Production Designer Matthew Davies offers a first look at early concept art of Godolkin University.

HE MOVIE EVENT OF THE YEAR...

When darkness descends on the world, and it seems all hope is lost,
seven heroes will rise. Seven who will stand. Seven who will fight.
Seven who will restore light and hope, and see the sun rise on a new era.

This is the true story of the greatest superhero team the world has ever known.

BASED ON TRUE EVENTS

D A W N
O F T H E
S E V E N

TOWERINGLY POWERFUL

Cameron Coleman, VNN

AN EPIC MASTERPIECE

Hailey Miller, Voices on Voughtify

THE PINNACLE OF HUMAN CULTURE

Tim Scrivens, WVFX

7 Voscar Nominations Including Best Picture!

7 VAG Nominations Including Best Actor—Homelander!

...INVITES YOU BEHIND THE SCENES

192 pages of self-congratulation ● Three never-before-seen behind-the-scenes photos ● Mind-blowing interviews with the Supe cast and creators of the film ● Meet the fans who campaigned to #ReleasetheBourkeCut ● Eye-popping key stunts and VFX explained ● A peek into Homelander's private dressing room ● Foreword written by The Legend ● Scratch-and-sniff elements let YOU smell the action ● 12 different fonts ● A profile of Brave Maeve: a Strong Proud Lesbian ● Up to 99% spelling-error free

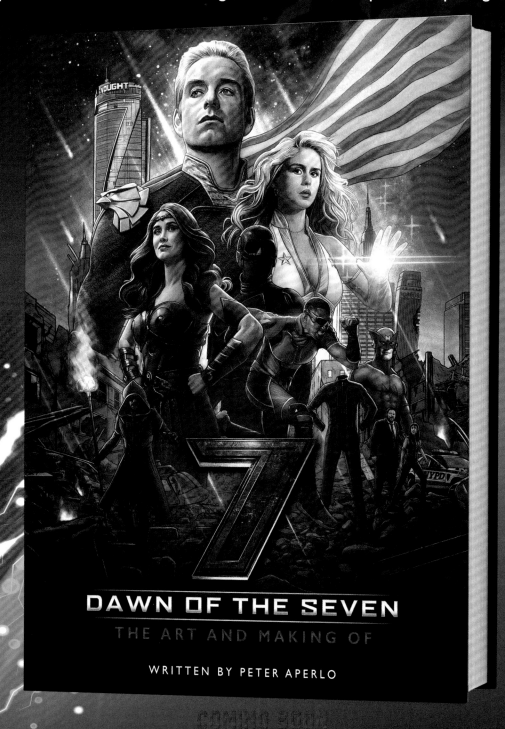

7

DAWN OF THE SEVEN
THE ART AND MAKING OF

WRITTEN BY PETER APERLO

VOUGHT
INTERNATIONAL

ACKNOWLEDGMENTS

I'd like to thank the creative folks at *The Boys* who were so accommodating, helpful, and generous with their time. It was an honor and privilege to be invited to have a look behind the cape. Special thanks go out to Anna Obropta, who wrangled creatives and tracked down obscure bits of trivia, and without whom this book would be much shorter and much less interesting.

Lastly thank you to editor Emil Fortune and his team at Titan Books, for leading the charge; and designer Natasha MacKenzie for infusing the book with her creative DNA.

Peter Aperlo

Titan Books would like to thank the producers of *The Boys*: Eric Kripke, Evan Goldberg, Seth Rogen, Neal Mortiz, Michaela Starr, Pavun Shetty, James Weaver, Loreli Alanis, Simon Racioppa, Giancarlo Volpe, Garth Ennis, and Darick Robertson; the stars of *The Boys*, Karl Urban, Jack Quaid, Antony Starr, Erin Moriarty, Dominique McElligott, Jessie T. Usher, Laz Alonso, Chace Crawford, Tomer Capone, Karen Fukuhara, Nathan Mitchell, Colby Minifie, Claudia Doumit, Aya Cash, Jensen Ackles, Giancarlo Esposito, Elisabeth Shue, Laila Robins, and Shantel VanSanten; and also, Stacey Kerr, Griffin Chin, Stephan Fleet, Rian McNamara, Geoff Aull, Lisa Donner, Stephanie Holden, Ryan Pickens, Jodi Tario-Caney, Tom Fitzpatrick, Alex Polansky, Akiva Griffith, Kristen Hall, Lauren Meyer, Michael Ground, Kim Harkness, Laura Jean Shannon, Sara Mgeni, Jenny Davis-Chen, Gabby Grantham, Anjona Ghosh, and Anna Obropta.

IN LOVING — MEMORY

This book is dedicated to the memory of Arv Greywal.